ONE
LIGHT
FLASH

First published in the UK in 2012 by
ILEX
210 High Street
Lewes
East Sussex BN7 2NS
www.ilex-press.com

Copyright © 2012 The Ilex Press Ltd

Publisher: Alastair Campbell
Creative Director: Peter Bridgewater
Associate Publisher: Adam Juniper
Managing Editors: Natalia Price-Cabrera and Zara Larcombe
Editor: Tara Gallagher
Art Director: James Hollywell
Designer: Emily Gregory
Colour Origination: Ivy Press Reprographics

British Library Cataloguing-in-Publication Data
A catalogue record for this book is available from the British Library

ISBN: 978-1-907579-30-1

Printed and bound in China

10 9 8 7 6 5 4 3 2 1

ONE LIGHT FLASH

PROFESSIONAL-QUALITY LIGHTING ON A BUDGET

JOHN DENTON AND
ADAM DUCKWORTH

I L E X

Contents

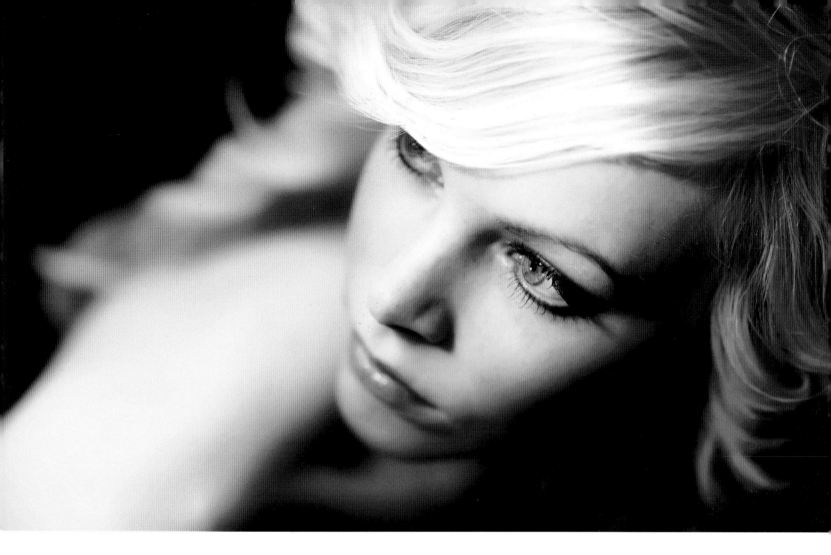

8

NEXT STEPS

CASE STUDIES

Introduction

This book covers a wealth of information on the use of electronic flash units, both on and off camera. However, through these pages it does offer a little more: an insight into the thoughts and processes of creative artists, and how it's easy to use flash to produce beautiful images.

No one technique is so removed from the whole creative process as to be more important than any other. That is why this book will not just look at getting the best use from the little light units that have long been viewed as an essential (yet slightly crude) part of the lighting toolbox, but will also explore how to put a shoot together, find models, understand light, use Photoshop and Lightroom, and team up with other creatives to improve your image-making. In short, its aim is to show how the whole creative process, from idea to finished product, is absolutely vital to producing a final image that makes people say "wow!"

Experiences are what form an individual's view of the world; it is that view that helps compose, light, style, and finish images. At a basic level, composition and light can change the shape of objects, and to most photographers, the process of image creation is fascinating. This quest to take inspiring images has taken the authors to some incredible places across the world and has led to working with some amazing people. Throughout this book we will share some of those images with you and hopefully give a few anecdotes and insights so that this isn't just a dry technical manual. It's a selection of material that will inspire you to get out there and create extraordinary images with your own ideas and worldviews. It's one thing to simply sit, read the words, and enjoy the images, but the aim of this book is for you to take the information presented here and then include it, adapt it, and use it to improve your own workflow and image-taking.

Some people will skip to the practical pages. Others will read the inspirations at the back of the book. Yet others will get excited by new equipment. It doesn't matter what your approach is, but if we could ask one thing of you, it would be to make sure to get a fundamental understanding of the second chapter. Light is essential to photography. Angles and intensities of photons may appear to lack the excitement of working with a model and making them look sensational, but understanding the fundamentals of how light works will improve your photography and aid you in creating more beautiful and interesting images.

The main tools we will be working with are a digital SLR camera, a decent lens, a flash unit, and a means to trigger it while not connected to your camera. While the first three are commonly owned by most photographers, the fourth is often not understood, or ignored altogether. It's scary territory for many photographers, but through these pages you will gain an understanding of the techniques and possibilities available to you. It's not as difficult, or as expensive, as you may have initially feared.

One other common theme in this book is about getting value for money, not spending huge amounts of cash on equipment that isn't necessary. Once you have been in the industry long enough, you get to know a little about what really works and what is just this year's must-have gimmick. This book will share that knowledge with you, and by doing so, hopefully improve the state of your bank balance as well as your photography.

But for those of you keen to invest in kit to open up further creative possibilities and get even more dramatic results, we'll be investigating and explaining that, too. From portraits

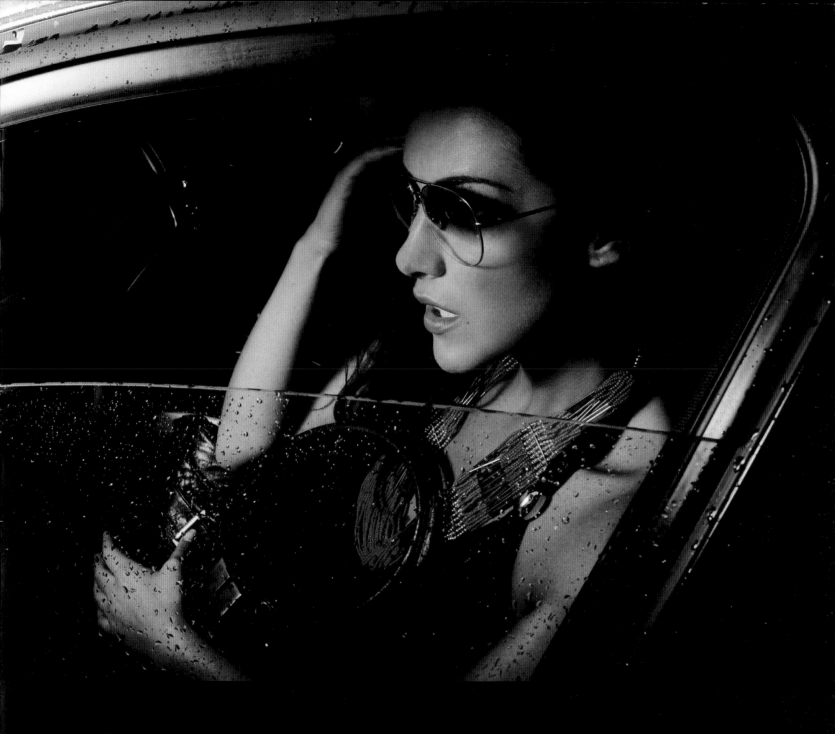

and family groups to still life, action, interiors, and vehicles, there's always a time when flash can lift a picture from the ordinary to something a bit more special. And we'll briefly venture into using more than one flash or even alternative light sources. Once you get used to the results you can get from using artificial light sources, you'll soon be hooked.

More than anything, however, as you read the words remember that they communicate a recipe that can be tweaked, changed, and improved upon at any stage to create a flavor unique to you. This requires action, and needs you to take the skills talked about, put them into practice, and share your enjoyment of image-making with the world around you.

We hope you enjoy your photography and enjoy exploring light.

John Denton & Adam Duckworth

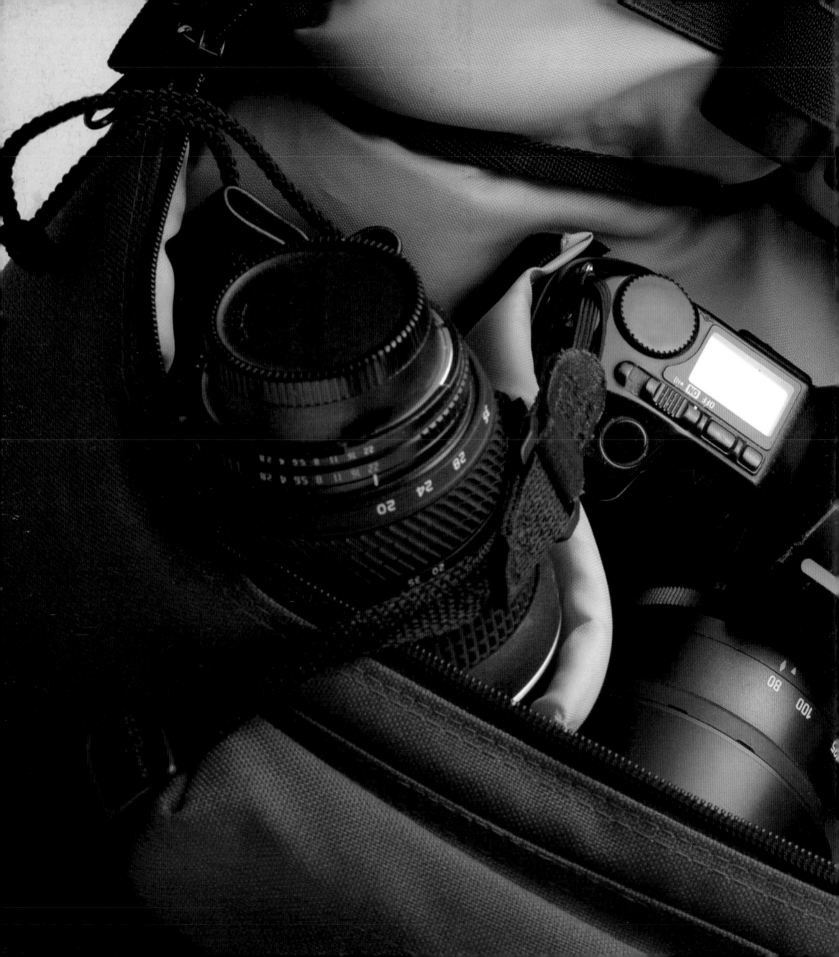

EQUIPMENT

What sort of kit do you need to take on a
photo shoot to create stunning images? Is it
different for indoor and outdoor photography?
What do professionals use to create their
images? This chapter explores the kit I use,
why I use it, and what advantages it gives me.
It will also explore why the most expensive
kit isn't always the best for you.

Camera Bodies

The pixel wars have just about been won for the time being. When digital cameras first came onto the scene, most of the talk was about how many megapixels you could fit on your sensor. These days most professional-specification camera bodies have settled on the 12–24 megapixel level, and what used to be judged a top-notch system can now be accommodated by a mobile telephone.

Now camera manufacturers are looking at all the other aspects of their systems and are putting energy into the construction of the camera, the materials used in manufacture, and other capabilities such as noise reduction and video and sound recording.

That is why before you venture out to buy a new camera body you should do some research. Not just on the units themselves, but on what it is you actually want to do with your camera. Some bodies are better suited to the extremes of harsh outdoor climates, for instance. Some have capabilities that would delight a photographer of fast-moving sporting events but that are redundant for the studio-based fashionista. To get the best from your investment you must always understand what your needs are before looking at the shiny catalogs from the manufacturers.

So, before I purchase a new camera body, I analyze what I've shot recently and what I expect to be shooting in the next twelve months or so. I'm fairly unforgiving with my camera bodies and so if I get a year or two from them I'll always be happy.

It's likely that you'll be looking to purchase a digital SLR. There are other options on the market from compacts to top medium-format digitals and digital backs. However, to maximize your flexibility of working in and out of the studio, it's likely that an SLR will be your tool of choice.

Before buying a digital SLR, research which camera body is best suited to your needs—consider the conditions and type of photography you will generally be using it for.

Full Frame or Cropped Sensor

Some high-end digital SLRs will have a full-frame sensor, the same size as a frame of 35mm film. Others have a smaller sensor that still does the job, but which is classed as "digitally sized." While there is not always a discernible effect on the final image, there is a difference in the way you use these cameras. A full frame will give a true focal length on a lens, while there is always a crop factor when you use a lens on a crop-sensor camera. There are lenses made especially for crop sensor cameras, such as the Canon EF-S lenses, but be aware that the crop factor will still apply.

Your choice may be dictated by already owning good lenses from a particular manufacturer, and therefore carrying on with their bodies seems a logical choice. That's not necessarily the case, however, and it's worth examining the range of lens converters out there, as well as trade-ins, to make sure you get the best option for you.

Personally I advocate the Nikon mid-range systems that have a pop-up flash that can be used as a commander unit for all the flash units you want to trigger. The images in the book have been taken on a variety of equipment, mostly Nikons. From D200 and D300 crop-sensor cameras to full-frame D3S and D3X, plus some photos taken with Canon's full-frame EOS 5D and some on medium-format Phase One equipment.

One suggestion I would make is to get to know your local camera shop. These guys, particularly the small independents, have been a mainstay of the photographic world for many years and deserve our support. They will often try and price-match the stronger Internet-based operations, but more than anything they give you the option of going in, handling a camera, and getting advice about it from a position of knowledge and interest. It is essential that any camera you purchase feels good in your hand, is not too heavy, and has buttons and dials that suit the size and spread of your fingers. The ability to do that alone is worth paying a few pennies extra for. Get the choice wrong and the camera will always feel alien to you and have adverse effects on your photography throughout its lifespan.

If you are interested in using an off-camera flash for the situations described in this book, then I would suggest looking for a digital SLR that is neither the entry level body in a manufacturer's range, nor the high-end flagship. You should look for a model with a built-in trigger system for your flash units that will work well at both ends of the ISO spectrum. It should have a manual mode as well as programmed and other auto modes, and the ability to work with a range of lenses. It should be comfortable in your hand and something that you are able to carry and work with for long periods. Oh, and it should fit your budget. Expensive kit will never make you a better photographer, so don't break the bank just to get your hands on it.

Lenses

The beauty of working with your flash unit off camera is that it can be positioned anywhere to illuminate your subject—background or foreground. That means you can have complete creative control over what lens to use. Just select the one that does the job you want it to, rather than being restricted by the distance the flash unit can project when it is mounted on the camera.

All lenses have different capabilities, and as with your choice of camera, it is important to analyze exactly what you will be doing with the lenses you'll be purchasing.

I often shoot with the aperture wide open and so look for lenses that have apertures of $f/2.8$ or greater. We will see later that these wide apertures work well in combination with flash units that work at high shutter speeds. This allows you to work in the harsh light of midday or enhance very natural-looking portraits.

If you are working with people as your main subjects you will most likely want to work with lenses that have a focal length suitable for the job. A wide lens will potentially distort your subject, whereas a very long lens can flatten their features. Both are something you may wish to do for creative effect, but usually you will be looking to use a portrait lens in the 50mm-to-200mm spectrum.

It's important to be aware that the size of your sensor will have an effect on the operation of the lens you put on the front of the camera. Most lenses were designed for use in a full-frame or 35mm camera—the size of a frame of film in a pre-digital SLR. Modern sensors are often smaller than this and so magnify the focal length of your lens by a factor of around 1.5. So, a 200mm lens can become 300mm, or an 18mm lens a 27mm. Some lenses, such as the Nikon DX range, are designed especially for smaller digital sensors and cannot be used with full frame or film cameras. So long as you understand the effect your camera and lens combination can have you will not have problems, and you can use their different effects to your advantage.

Personally, I pack three lenses in my kit bag on most shoots.

The Nikon 85mm $f/1.4$ lens is a wonderful piece of kit and produces a very shallow depth of field when shooting portraits. It has no zoom and reminds me of the need to move my body to recompose images, not to just zoom in and out.

The second of the trio is my trusty Nikon 70–200mm $f/2.8$ lens. It was one of my first significant investments when taking up professional photography and has been well worth the expenditure. Its ability to render a subject pin-sharp and then throw the background out of focus is superb, especially at $f/2.8$ using the full 200mm zoom.

My third lens illustrates my belief that so long as a piece of kit does a job for you it doesn't matter what it is. This lens is a Nikon DX 18–70mm $f/3.5-f/5$. It's not a pro-specification lens, it came in a kit with a D70 that was bought as a play camera some years ago. However, I love it for its angles; it's generally sharp, and if I want to place a figure in a wide landscape it's perfect for the job. If space is tight in a location, I can still get a shot with the lens without having to walk miles back as I do with the 70–200mm. It's not perfect and its lack of ability in low light frustrates me at times, as does its variable aperture when zooming in and out. The thing is though, it works, and so long as it does then it will retain its place in my bag.

It's worth getting the best lenses you can as they will last you long beyond the lifetime of any particular camera body. However, don't break the bank in the expectation they will make you a great photographer! The camera manufacturers do produce outstanding lenses for use with their bodies. It's also worth exploring some of the third party lenses out there, as many are superb quality at very affordable prices.

Off-camera flash units allow for greater freedom when choosing which lens to use. Be aware of the effects that different camera and lens combinations can have on your images—you can usually turn these to your advantage.

Flash Units

Welcome to the "New World." For so many years, photographers, at least those who wish to produce fashion-styled imagery, have been strapped to a studio or a huge set of lights, generators, and battery packs. Now, while those lights still have a place for their power, please allow me to introduce you to the world of lighting you can carry in your camera bag.

Portable, easy on the shoulder, small-sized . . . this is the world of the flash unit—external flashes that you can pop into your armory and whip out to great effect whenever needed. The modern flash, or EFU (electronic flash unit), is so much more than a simple light provider. It has the capability to be aimed, zoomed, diffused, flagged, and twisted, and essentially covers all the lighting angles you need.

Better still, with a mix of modern flash units and cameras, you can work with TTL (Through The Lens) Metering, Slave, or Manual modes. TTL has the great advantage of a super intelligent processing unit that does all the clever mathematics and, usually, produces a top-notch exposure for you. Manual settings have the benefit that in those tricky situations where the obvious answer isn't the correct one, you can tell the flash unit exactly what quantity of light you want it to pump out. Slave is superb for adding multiple flash solutions to a situation, as once one flashes the rest will follow.

The major manufacturers of the camera world have their own-brand flash units and rightly so. They are finely tuned to the specifics of their camera bodies and react well according to their instructions. You set the image up and they do all the heavy calculations for you.

There is a good range of alternative suppliers coming into the market who can supply a flash unit for your camera body. Do not underestimate these suppliers, as there are some quality third-party products on the market.

Whether sitting on your camera or off it, a flash unit needs to be a key part of your photographic kit. On camera, the flash can give you instant light in reportage situations or can be modified for some nice effects. It's when the flash comes off camera, though, that really creative things start happening.

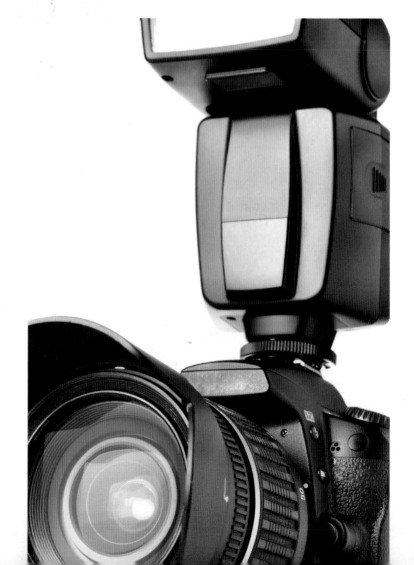

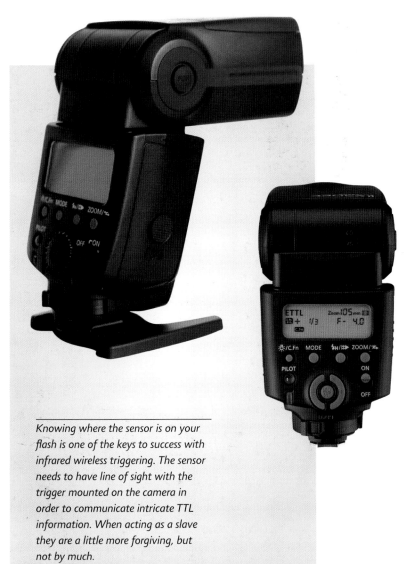

Knowing where the sensor is on your flash is one of the keys to success with infrared wireless triggering. The sensor needs to have line of sight with the trigger mounted on the camera in order to communicate intricate TTL information. When acting as a slave they are a little more forgiving, but not by much.

A good flash unit is composed of a number of elements. The flash head will have the facility to zoom in and out, to widen or tighten the spread of light. The power output can be adjusted up and down in a range of steps. The flash head can be tilted and turned. It will have the ability to be triggered both on camera and off camera through infrared or radio triggers.

Personally, though, I'm a Nikon shooter through and through, and love the impact of their SB Speedlight flash units. They can be triggered from my camera, be directed remotely and directly, and can also act as slaves to my larger studio heads. Importantly for my style of shooting, I can control them in TTL mode directly from my camera body. I will try not to be too Nikon-centric in this book as all the principles I'm demonstrating apply across all the systems.

Whether acting as main lights, sidelights, backlights, or hair lights, the flash unit can raise your photographic game and be your friend both indoors and outdoors. They can overpower the brightest of daylight, give you accents in difficult circumstances, light a wedding party when you need it most, and work seamlessly with the available light.

All in all, this is why I love the flexibility of a flash unit system, providing it's set up correctly!

Triggering Your Flash

When we start thinking about triggering flash units it brings us to the crux of this book. I'm not totally against using a flash unit mounted on your camera. There are many times when it's expeditious and works just fine; we'll explore many of these within these pages. However, it is full of limitations too. Especially when you want to start creating more artistic images, compositions, and styles.

The first problem with an on-camera flash is red-eye. It's noticeable from the minute you pick up your first point-and-shoot camera, and yet many photographers would rather spend time on the computer rectifying it than eliminating it at source.

Red-eye is caused by light bouncing back in the direction it's projected—light bounced from the blood vessels in the eye straight back into the camera. The instant solution is to put your flash slightly to one side of the lens, so that the angle of light is across the lens rather than straight from and back into it.

One solution is a flash bracket, the traditional option for many wedding and event photographers. It's a physical separation of the flash unit and lens linked by a cable. The cable can transmit full TTL or manual information from the camera to the flash unit. Any link that can provide TTL information is desirable, in that it allows the computing power of your equipment to optimize the light for you. With manual capability, you have to make the decisions. There are situations in which both are desirable, but the TTL decision-making of most modern cameras is superb and worth working with.

Flash brackets eliminate red-eye by directing the angle of reflected light from the flash across the camera lens instead of head-on.

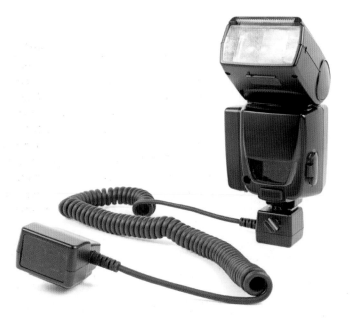

TTL cords give you more freedom to adjust the height and angle of the flash.

If you want to take your flash unit a little further from the camera then a TTL cord is worth investing in. These are generally longer than the simple cords used with brackets and can allow you to raise or lower your unit and change the angle relative to the subject. If you want true flexibility though, you have to get the flash unit right away from the camera body. In modern cameras that is achievable through infrared or radio communication.

For a few years now the Nikon Creative Lighting System (CLS) has reigned supreme as a means of triggering flash units through infrared technology. It allows multiple units to be commanded through TTL, Slave, or Manual mode. There are similar systems for Canon cameras that haven't proved quite as reliable. The main problem with both systems is that they have to have a line of sight between the camera and flash unit. The CLS is largely considered superior, as it can occasionally bounce its signal off walls and ceilings to "find" the flash unit, whereas the Canon system is renowned for being weaker in output. Both suffer to differing degrees in bright light and ultimately both systems limit where you can place your flash units.

The best solution to the problem is a radio transmitter mounted on the camera and a receiver unit on the flash. If those units can transmit TTL information too, then they are truly the most desirable objects in the world of off-camera flash photography. At the time of writing, Pocket Wizard units have been licensed for Canon and Nikon, whereas previously RadioPoppers were the only units that worked on both. Using RadioPoppers and Pocket Wizards allows you to hide a flash unit wherever you want and trigger it remotely every single time.

Personally, I'm a fan of the RadioPopper PX System. The radio signal carries for more than 300 ft. and is unaffected by weather conditions, the strength of ambient light, or physical obstructions. I recently tested one of these by putting the flash unit and radio trigger inside a bunker that had been built to withstand a nuclear strike. The walls were massively thick and there was no window. I then ran outside, stood on the side furthest from the door, fired a frame, and the flash still triggered! Now, obviously this is a useless trick as the flash didn't then project onto anything I could see, so was practically pointless, but it indicates some of the creative possibilities of these units. Better still, the information passed to them is true TTL information and every bit as good as the existing Nikon CLS. Additionally, you can use them to control an unlimited number of other flashes to really maximize your creativity.

Radio triggers are the most flexible of all off-camera flash triggers, able to carry strong radio signals and transmit TTL. This PocketWizard model is a good option.

FLASH UNIT OUTPUTS

While there are a number of different output modes designed for flash units, there are essentially three that really matter:

TTL

In this mode the flash takes information from the camera and designs its output around aperture, shutter speed, ISO, and the distance to the subject. It can be varied by using flash compensation to raise or lower the power.

Manual

You choose the power that you wish the flash to output. A professional-quality unit will generally vary from 1/1 to 1/128, with the former being full-power, and the latter the weakest. A light meter is a useful accessory when working with manual outputs.

Slave

Both the former modes are triggered by a direct communication from the camera, either corded or wireless. One work-around is to have a flash unit in Slave mode and use an on-camera flash to trigger the off-camera unit. It's called "slave" because as soon as it's told to do something by the flash of another unit, it triggers too. You cannot use TTL flash with slave units, as the TTL will issue a burst of light just before it fires to test the distance to the subject; this is strong enough to trigger any slave units and they won't register on the camera exposure.

Modifying Your Flash

A flash unit provides a certain spread of light. Most external flashes offer the ability to zoom the light from a widespread area (say 24mm) to a tighter spot (around 105mm). This facility is useful, but not perfect at putting the light just where you want it. Those little photons of light that are kindly set free by your flash unit do, unfortunately, seem to have a mind of their own, and often refuse to do what you want them to. That's where a flash modifier comes in.

A good modifier can change the shape of your light source, make it hard or soft, and alter its color, intensity, or size. You can make your own or choose from a wide range of suppliers. I've tried most options over the years, from grids made of cardboard and black drinking straws, to top-notch collapsible softboxes. Of all the options, it's the Strobies range from Interfit that I advocate most strongly. They sit nice and securely on your flash unit—don't fall off if you sneeze—and do exactly the job they're intended to.

A Flex Mount from Strobies.

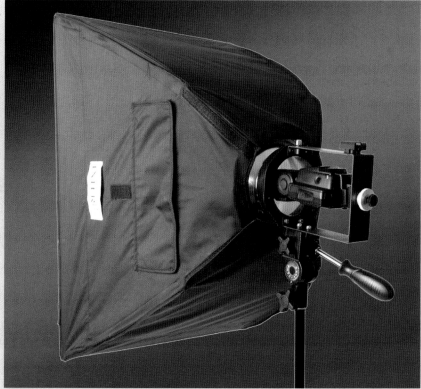

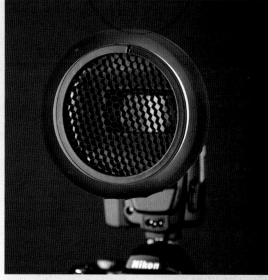

Softbox

Whether it's a dinky little softbox to fit directly onto your flash unit or a larger one mounted on a light stand, this modifier's job is to diffuse the light source and produce a soft, even spread of photons. It's a very flattering light to use on your subject and is generally reminiscent of soft, diffused window light.

Grids

A grid is defined by its degree of spread. You will hear photographers talk of a 20° or 30° grid. Put simply, the smaller the number the tighter the spread of light. The grid itself is a honeycomb pattern of tubes, which channel the light into a tighter pattern and soften it. Grids can be used as a main light modifier or for sidelighting or backlighting.

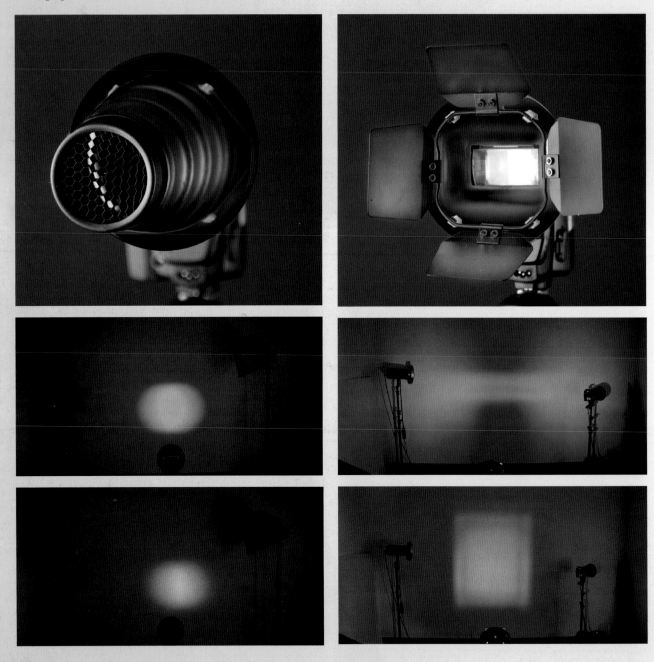

Snoots

A snoot will channel the light down a slim tube and spit out a round spot of light. These modifiers are perfect for creating spotlights on your subject or throwing a slant of light across backgrounds. You can also add a grid to the end of the tube to further focus down that spot of light and soften it a touch. It's a very flexible tool and an essential addition to any lighting bag.

Barn Doors

These doors are four flaps that can completely cover your light. Each flap can then be opened individually to allow a little of the photon stream to pass through. They are ideal for producing a thin sliver of light directly onto your subject, to the background, or as a side light or hair light. When you want to produce a strong and directional lighting effect then this is your friend.

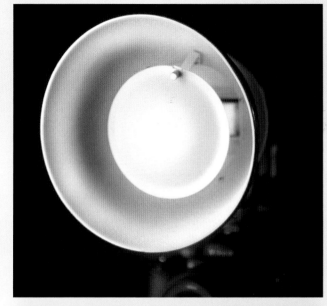

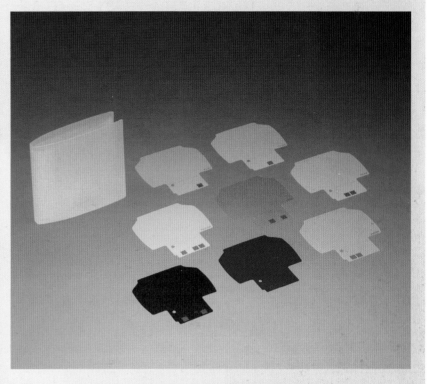

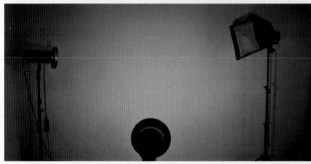

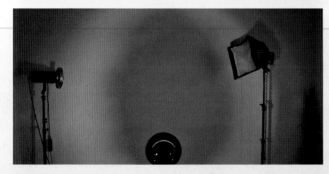

Gels

A flash unit gel is little more than a colored piece of plastic and yet their ability to affect an image cannot be understated. They can be used in two ways. If you're shooting in a room that is lit by fluorescent strip lighting you will notice a greenish tinge to your images, which is the color of the light generated by the lights themselves. If you set your camera to a fluorescent white balance then that color cast would be corrected, but if you then used flash it would appear as blinding white light in the image. If you slip a little green gel over the flash unit, the flash can sometimes be balanced to fluorescent tones, though modern flourescents have a wide range of color temperatures and this may not always work. Alternatively, you may wish to create a colored light in your image, to make a white wall red, for instance. There are great creative possibilities to be had from experimenting with gels and mixing light of different temperatures.

Beauty Dishes

The dish itself is a reflector that throws a hard beam of light at your subject. Set within it is a removable disk that blocks and softens the light. It does exactly what the name suggests, casting a beautiful light on your subject. Use it effectively and your clients will love you.

OVERVIEW

So you can see there are many different ways of changing the way your flash unit appears. That's what makes this form of lighting so exciting and ensures you as the photographer have total creative control.

Other Lighting Essentials

Once you become captivated with the possibilities of off-camera flash, you will suddenly realize that you have entered a true paradise for gadget lovers. Not only are there the essential units themselves, there are the range of modifiers and also the supporting kit; the stands, brackets, clamps . . . truly the list is endless. But first of all, let me try and take you through some of the most practical accessories.

Lightstands

These come in all manner of weights, heights, and qualities. It's worth investing in a couple that are heavy enough to be stable but not so heavy they'll break your back while carrying them, especially if you work out on location. Generally the heavier the stand the more stable it will be, which is particularly important if you want to use umbrellas or softboxes outdoors, as the slightest breeze can have you chasing them down the street. For stability check out how far apart the legs can be placed. There are many times when you'll want to get your light up high, so check on the number of telescopic segments in the stand and also how tightly you can lock them in place. If you have a flash unit and dish high above your model you certainly don't want it crashing back to earth. It's also worth looking at how low you can make the stand. Many don't go much lower than waist height, which isn't always desirable.

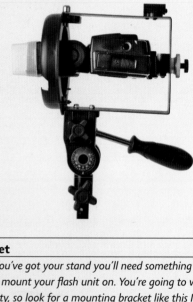

Bracket

Once you've got your stand you'll need something to put on top of it to mount your flash unit on. You're going to want maximum flexibility, so look for a mounting bracket like this Interfit Strobies XS model that will tilt and turn, enabling you to point your unit in any direction you wish. Also think of the modifiers you're going to want to put on the flash and make sure they actually fit and do not jam against the bracket itself. If you are going to use umbrellas then you will need to ensure that you have a compatible mount. This will be a hole angled down to ensure the flash unit can be directed to the center of the umbrella, with a screw at the side to secure the shaft of the umbrella in place.

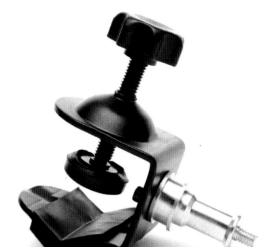

Clamps

A bit like a bracket in that it gives you something to mount your flash unit onto. A clamp will allow you to fasten your light to a whole variety of other objects with little fear of it dropping off and spilling expensive kit onto the floor.

Reflector

An absolute essential as it can help you out when working with natural light and with flash. If you have your flash unit projecting light from one side of a subject, then not all the light will be blocked by the subject themselves. Place a reflector on the far side and all those precious photons that slip by will be bounced back, thereby turning one light into a main light and its own fill. More on this technique later, but in general it's best to get a reflector that's quite large, with silver and gold sides for warm and cool lighting options.

Bag

It sounds obvious but we're talking about accumulating all this equipment so you do need something to carry it around in. A good bag with several different pockets to separate different items is invaluable. Make sure it's not so heavy that when laden you won't be able to lift it, and also make sure that it has a range of straps so that you can carry it by hand or over your shoulder. There are plenty of options around from a rigid-sided case—heavy but very protective for your kit—to a backpack or canvas holdall type. I favor a bag I've had for many years made by Billingham. It's made of strong canvas and has one large, hold-everything compartment and several smaller ones. It means that I can work quickly and have ready access to all my stuff.

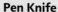

Pen Knife

Another vital piece of kit that is often underestimated in its importance. Beware of local laws on carrying knives, but it's so useful for cutting your gaffer tape, removing tags from clothing, getting rid of obstructive foliage, and removing stones from horses hooves. Actually, I've never needed to do the last one, but with the knife in my bag I'm ready if the need arises.

Gaffer Tape

No camera bag is truly complete without a roll of the black stuff. Useful for all sorts of applications, from taping flashes to trees to holding a model's dress together. If you haven't got one in your bag already then it's one of the cheapest kit investments you'll make, but so worthwhile.

OVERVIEW

New bits of kit are constantly being developed, which is what makes any photographic trade show a voyage of discovery for the true lighting connoisseur. Keep an eye out for what is new to the market, but always ask yourself "what job is this piece of equipment going to do for me?" That will help you make a wiser decision on your purchases rather than being seduced by promises of better images courtesy of the latest wonder kit.

LIGHT:
Where Science Meets Art

This is the part of the book that gets a little
scientific. It's the bit that explores the physics
of light, how it moves, and how it adapts to
influences in its path. You do not have to be
a scientist to be a photographer, but a little
understanding goes a long way.

What is Light?

As photographers we need to understand all aspects of the craft. The main ingredient of any image isn't the model, the location, the camera, or our creativity: it's light.

Light frustrates us and delights us in equal measure. We complain when there is too much of it, panic when there is too little of it. We can get confused trying to add electrically generated light to that beamed down from the skies. Even a basic grasp of the fundamentals of light should go a long way towards improving your photography.

Light is a form of energy. It's a form of electromagnetic radiation that can be viewed directly by the human eye. It's a stream of particles called photons that move in waves. The height of the wave from midpoint to peak is called its amplitude and defines how brightly the light will appear. The length of the wave, the measure from peak to peak, defines the color that we perceive the light to be.

So, light is a stream of photons projected from something, and we only see another something if it gets in the way of

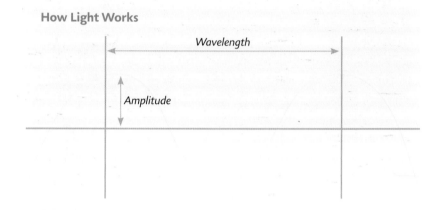

How Light Works

Wavelength

Amplitude

that stream. When it does, the photons bounce off it, enter our eye (or camera) and we can see it. All easy so far, how do we complicate it?

Usually things get difficult because we fail to visualize how the light is going to interact with our subject before we start shooting. If we understand a few basic rules though, this gets a lot easier to do.

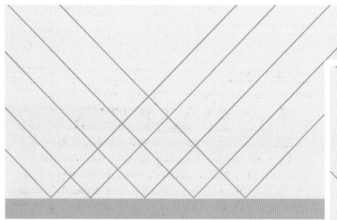

With a smooth surface all the photons bounce off in an equal direction giving a specular highlight.

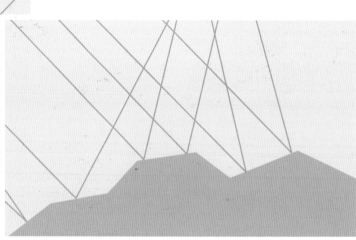

With an uneven surface the photons always behave the same, but the angles of their bounce are dictated by the surface.

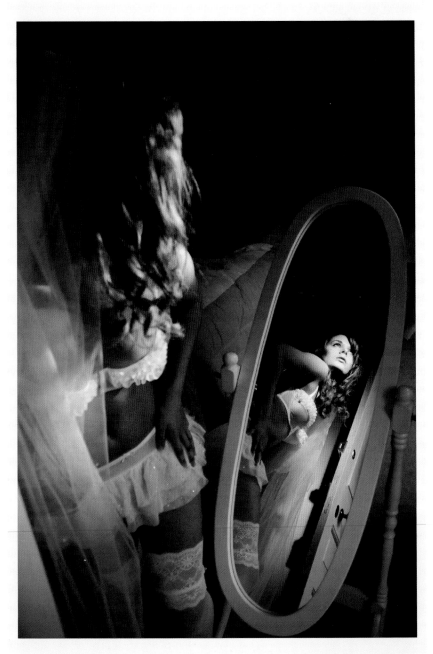

FIRST RULE

Light travels in straight lines. It has much in common with myself in that it seeks the path of least resistance on its travels and will only deviate if it encounters an obstacle. The main difference being that I don't always deviate from my path. Photons do however, and that means you can anticipate where they will go. Even more so when we consider rule two.

SECOND RULE

The angle of incidence will always equal the angle of reflection, which basically means that a photon will hit an object, then bounce off, at the same but opposite angle. If the photons hit a smooth surface like a sheet of metal, then you get what is known as a specular reflection. If it hits an uneven surface like a face, then you get a diffused reflection. As photographers, that means that specular reflections will be consistently bounced back to the camera and therefore will be concentrated in light, and you can blow them out to pure white. Diffused reflections merely illustrate objects!

Having looked at angles, colors, brightness, and bounce, we really only need to know about one final rule, that of reflection.

THIRD RULE

Mirrors and other reflective surfaces offer great creative potential to photographers. So an understanding of the law of reflection is important. If you have a flat surface then the light comes off the subject, hits the reflective surface, and bounces off into the eye according to rule two. The difference here is that the eye can also see a virtual image in the reflective surface. It's the same distance behind the mirror as the subject is in front of it. In photography terms that means adjusting your own position relative to your subject until you get the strongest reflection possible in your eye (or viewfinder).

Zoe was posed so that the tungsten-gelled flash hit her, bounced into the mirror, and was captured by the sensor. The position of subject to reflective surface to camera was key for this image.

How a Camera Records Light

Although cameras are incredibly sophisticated, in many ways their basic principles have remained unchanged since the first image-making devices were created. The very first "camera obscura" was developed when people realized that light would travel through a pinhole or small aperture and create an image on a screen on the other side, albeit an inverted image.

Experiments making the aperture larger and smaller were carried out and the simple devices began to develop. It was found that the smaller the aperture the sharper but dimmer the image became. As technology progressed simple lenses were added to enable a larger aperture. This created a brighter image and also allowed for focusing of the light.

Eventually the idea of placing a light-sensitive surface behind the aperture was developed. This allowed the image to be captured and was the birth of modern photography. First, experiments were conducted with bitumen, which hardened where the light hit it and allowed for the unhardened areas to be removed, giving an impression of the subject. This was back in the 1820s and shows that the advances in our art and equipment have been extremely rapid.

The next major advance was the placement of a plate in front of, or behind, the aperture that could be opened and closed to allow light in and then be cut off. But for the fact that the aperture is in front of the the shutter in a modern camera, that model is pretty much how we understand a camera today. A lens, a shutter, an aperture, and a light-sensitive surface. We've complicated things further by adding mirrors and electronics into the mix, but the basic principles remain the same.

Nowadays we have the advantage of variable shutter speeds to allow less or more light into the camera body. We can change the size of the aperture to allow less or more light, but also, as was noticed by those early pioneers, to make the whole image sharp or selectively sharp. This is the effect now known as depth of field. The latest advance has been to remove the light-sensitive surface and replace it with the electronic magic that is the modern CCD (charge-coupled device) or CMOS (complimentary metal-oxide semiconductor) sensor.

We also have the advantage of being able to vary the sensitivity of the sensor to light. Changing the ISO setting on our camera makes the sensor more or less sensitive to light. There is a trade-off though. At ISO 100 the sensor needs lots of light to render the image, but does so beautifully with a great quality. An ISO of 3200 can virtually take an image in the dark, but the trade-off here is that the sensor is working so hard it will also produce digital noise, which can detract greatly from the image. High ISO film has grain, which can look good, high ISO digital noise does not have that same effect and so has to be controlled.

Relatively speaking, the basic structure of a camera has not changed that much over the years.

Playing with depth of field can give a lovely impressionistic effect to images.

So our aim as a photographer is simple. In order to get the camera to obtain an image we need to balance all the elements within it. We set the ISO according to the amount of light present. We set the aperture as we require for the amount of the image we wish to be in focus. Finally, we set the shutter speed to allow an optimal amount of light onto the sensor to create a lovely picture. Simple really.

One final word: do you remember changing the film in a camera whilst huddled under a coat to keep dust and light away? Well, treat your sensor with the same level of respect and it will last you a lifetime. Small particles of dust can look like baby elephants rampaging across your images if you're not careful, especially if you are shooting at small apertures, such as $f/22$. Portrait photographers get a lot more latitude, as wide open at $f/2.8$ or more the dust doesn't register as readily. So keep your lens changes to a minimum if you can and when you're in a dusty environment do things quickly to stop particles entering. Send your camera to be cleaned once a year and you'll have a friend for a very long time. Oh, and always send the camera away. I know you can do it yourself, but if you're at all ham-fisted like I am then a very small movement can cause serious damage to your sensor. So let a professional do it for you.

Camera Settings

Modern digital cameras offer the photographer a whole range of options that are designed to assist in capturing the perfect image. Some offer special settings that are said to be ideal in certain situations. You'll find settings for kids, portraits, pets, beaches, snow, and even underwater. You'll find settings that select what the camera considers to be best ISO for any situation. The camera will select the optimal shutter speed and aperture for you, it will set its own color tones, or put flash on if it thinks you need it. Basically, these little machines we carry around can analyze the whole world for us. So why is photography still considered a skill?

Because good as they are, cameras are not perfect. They make dumb decisions, and if you want total mastery of your image then you've got to take control.

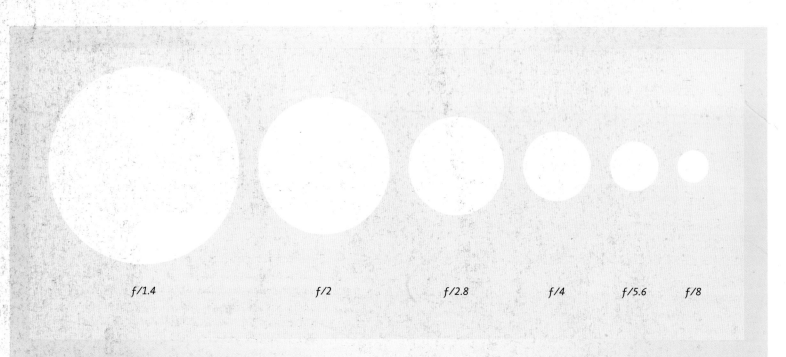

f/1.4 f/2 f/2.8 f/4 f/5.6 f/8

DEPTH OF FIELD

This is why I consider aperture to be the starting point in deciding your exposure. Defined by f/stops, a lower f/number indicates a large aperture and shallow depth of field. Conversely, a larger f/number indicates a small aperture and large depth of field. Is it important to understand what f/numbers mean? Nah, just remember that a big hole has a small number and a small depth of field, and a small hole has a big number and a big depth of field. I like the simple life.

Here are the modes of a typical camera and how best to use them.

Fully Auto

In a programmed auto mode you can set the ISO and then the camera will give you an aperture and shutter speed it considers optimal for the scene you have put in front of it. Generally it does so quite well and gives you a reasonable image. Auto modes are useful in that you don't have to make decisions and if you are trying to take pictures in a rapidly changing situation, such as at a wedding or of your friends on a night out, it will give you a reasonable image. However, all creative possibilities are removed as you are totally dependent on the camera.

Shutter Priority

When you give priority to the shutter speed you set how fast you want it to operate and the camera will set the aperture required to give you an evenly exposed image. This is useful if you are working in a very fast-moving environment where you need to freeze movement, such as at a sporting event. If you are trackside at a motor sports event, for example, you'll need to maintain a shutter speed in the 1/1000ths of a second to capture a sharp image of the fast-moving vehicle. By locking in the desired speed you can ensure it won't drop and create blur. A problem is that you have to keep an eye on the ambient light. If it gets too dark for your largest aperture and shutter speed you will need to raise the ISO to keep up.

Aperture Priority

In this mode you make the creative decision about how much depth of field you want and set the aperture accordingly. For portraiture a shallow depth of field is often desirable to concentrate your attention on the subject and blur the background. For landscapes where you want foreground, mid, and background all sharp, then a larger depth of field is desirable. The camera will select the shutter speed that, when matched with your chosen aperture, gives you an optimal exposure. Problems can arise here when the shutter speed drops so low that you cannot safely handhold the camera without getting movement and you don't notice.

Manual

In Manual mode you make the decisions. You can set the aperture first and then move the shutter speed until you have the exposure, or vice versa. You can also ignore the in-camera metering systems entirely to get just the effect you want. This gives you total creative control of the exposure.

OVERVIEW

Each mode has its advantages and disadvantages. I use Manual for the vast majority of my images, but sometimes when working at a wedding, or perhaps taking reportage images at a drinks reception, I will pop it onto Aperture Priority, with a little flash, and just work the room without having to worry about making any exposure adjustments.

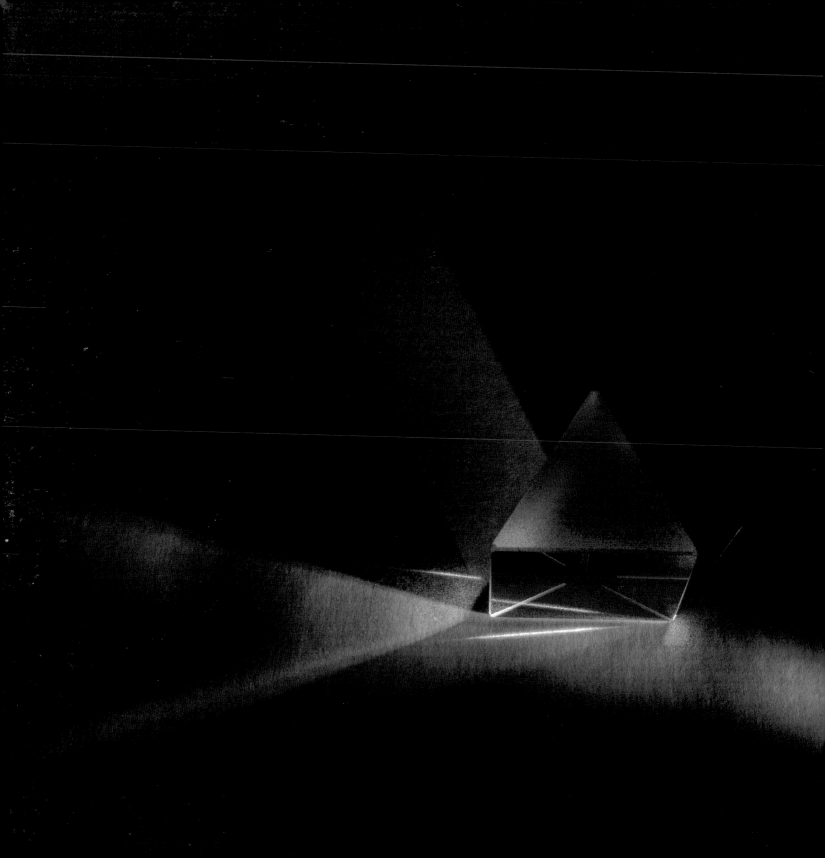

Perfect Exposure

Perfect exposure in camera is key to getting a good image. Get it wrong and there are a million ways to correct it later in Photoshop, but why should we have to? Get it right first time and all that time spent behind the computer becomes your own, and much more profitable.

The exposure of an image is a tricky balancing act between the amount of light that is allowed into the camera, and the duration it is allowed to gain access. The aperture defines the amount of light, and the shutter the duration.

There are a number of other considerations when determining exposure. This really boils down to recognizing what it is you're trying to take pictures of and then deciding what's important.

If you're photographing a fast-moving event, such as a race, then it's generally important to freeze the movement and keep the runners in focus. So the first consideration is to have a shutter speed that is fast enough to do just that. Working in Manual mode you can dial in a suitably fast speed, say 1/250 sec, and then adjust the other options to optimize the exposure. If you're taking a portrait, then the aperture may define the starting point of your exposure. If you require a shallow depth of field, you dial in $f/2.8$ and then adjust the shutter speed to produce the exposure. If that shutter speed is too slow then you can change the ISO to make the sensor more sensitive to light.

It is also important to think about what the camera is trying to do once it is presented with a particular scene.

Firstly, take into account that your superb digital camera, with all that range of tones and information, actually sees the world in monochrome. That's right. Black and white is the mode of preference for this ultra modern, color-rich image-making machine. They see all these superb colors and then try to render them in shades of gray.

This may seem like a drawback, but so long as you understand it you can help your camera to see the world accurately.

The camera tries to see the world in a state of 18% gray. It's a great color, but the world doesn't always present itself in the same state. The key to reading exposure effectively is to get the metering right, so follow on to pages 36–37.

An 18% gray card is a very useful tool for difficult metering situations.

Never be afraid to experiment with unusual objects, as in this image of a prism lit by a laser and a shaft of directional light.

Metering

In days of old, photographers would insist on handholding a light meter to their subject, to the background, and all points of interest within the image. Then they would get out a slide rule, work out the results in a notebook, and finally take an image of their thoroughly bemused subjects. The inbuilt computing technology of modern cameras can take away this dependency. Modern digital cameras generally incorporate three modes of a built-in light meter and offer a one-stop shop to analyzing light. Although terms will differ, most cameras will offer a Spot, Center-weighted, and Multipoint Metering option to assess light.

SPOT

Spot Metering is just what it says. Take one spot, analyze the light at that spot, and if you are working in auto modes the camera will decide on exactly the shutter speed and/ or aperture necessary to produce a quality image. In manual modes, dial the needle into the middle and you have the exposure for the aperture and speed you have chosen. If you are working with incredibly strong light and wish just one area to be detailed then this is the mode for you.

CENTER-WEIGHTED

Center-weighted Metering makes that area of responsibility a little broader. Now you are not just looking at a single spot, you're looking at all the area around the center of interest and averaging the information the camera interprets.

MULTIPOINT

Multipoint means that the camera takes a variety of points around the frame, looks at the light that is there, and averages the overall exposure. It will look for the areas that are the darkest, the mid tones, and the lightest, and work an exposure accordingly.

Regardless of the metering mode used, what the camera is attempting to do is give you what it considers to be a great exposure. It does so by trying to even out all the tones it's looking at until they become gray—18% gray to be specific. The meter system only sees the world in monochrome and it will demand more or less light depending on whether it considers the spot(s) it's looking at to be brighter or darker than gray. If we understand this we can work out why our pictures don't always look as we expect.

For example, if I wish to take an image of a pale-skinned bride in her beautiful wedding gown against a white wall I am looking at a mass of light tones. My camera will look at this and try to give me its idea of perfection. Firstly I decide on my aperture. Usually I work with my aperture wide open at around $f/2.8$. That gives me a shallow depth of field to focus attention on the main point of interest, my bride. I work in Multipoint Metering so my camera is looking at a large number of points across the image. If I dial in a shutter speed that puts my meter needle right in the middle then the camera is happy. It has looked at all those lovely bright spots in the composition and rendered them to gray. This means that when I look at the image on the back of the camera I'm not happy—my bride looks dull and lifeless compared to the vibrance my eye witnessed. So, I work in manual mode, I analyze the scene, realize that it's bright overall, set the needle to the middle, and then slow the shutter speed down a little to allow more light in and get the brightness back. How much I slow it down is done totally by guesswork, interpretation, and experience. All cameras are slightly different and over time you become accustomed to how your equipment functions and how to get the best from it.

The converse situation would be a black bridegroom in his dark suit in a dark room. Again I'd set the aperture wide open, set the needle in the middle by adjusting shutter speed, then curse when my guy looked gray. The solution in this instance seems slightly counterintuitive in that even though I'm photographing a dark subject in a dark setting I need to speed up the shutter speed above what the camera is suggesting in order to get a good exposure and maintain those wonderful dark tones. Again, it's only experience and looking at the back of the camera that can tell you how much it needs to be speeded up. On my camera it's a wheel by my thumb that I use to adjust shutter speed. It clicks as I turn it and so I now tend to think in terms of "Yes, that's a two-click adjustment."

The large amount of white in this picture will lead the camera to expose incorrectly, as it will assume the image is composed mostly of midtones.

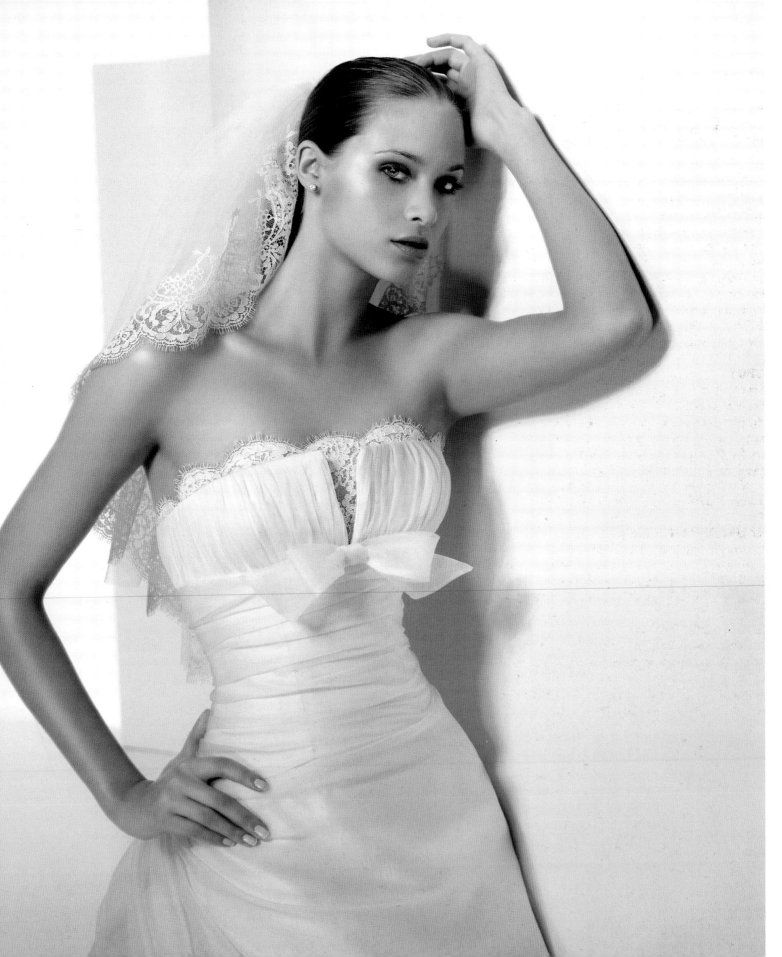

White Balance

If you understand the temperature of light you can really start to have some fun. Light does not just have a strength and direction, it has a temperature—that is what defines the color it renders inside the camera. You can use this information creatively in a number of ways.

The temperature of light is measured in Kelvins. To understand the scale, think of a horseshoe being prepared by a blacksmith. It starts dark and dull as a raw piece of iron. Its temperature is low. If the blacksmith starts to heat it in a forge it will start to glow red. As the heat increases, the horseshoe moves through a spectrum of colors, glowing red, to yellow, to blue, to its eventual pinnacle when it is literally white-hot. In that time it has moved from around zero to 10,000 K and that is what you are looking at with regard to white balance.

Think now of a traditional household lightbulb. It's a tungsten light that emits an orange-colored light. Shine it directly on your skin and you acquire an instant fake tan. That light is measured at around 3,200 K and is very warm in appearance. If you don't want the fake-tan look you can set the camera to counter it by choosing the Incandescent or Tungsten white balance (usually represented by a little lightbulb symbol). That tells the camera to cool down all the color tones in the image so that the orange skin starts to become normalized. The creative advantage here is that any natural light in the image will also cool down and take on a blue tone. This can lead to some fantastic images. Here are a couple of examples that illustrate the point.

Typically your camera will have an Automatic white balance setting, a range of options including Fluorescent, Incandescent, Cloudy, Sunny, Shade, and Flash, and a Custom white balance setting. Auto settings can work well and setting your own will guarantee accuracy. However a quick tip is to work with the cloudy setting. I do for around 90 percent of the time and it tends to guarantee me beautiful skin tones and a world that looks just the way I like it. Try it and you'll be pleasantly surprised. Weddings are the one situation where it doesn't always work, particularly in churches that can be a mix of all sorts of light temperatures with fluorescent lights fighting with tungsten, candles, and natural daylight. On these occasions it's sometimes desirable to carry a gray card to set a custom white balance, or, if the worst comes to the worst, produce a beautiful set of monochrome images for the final album!

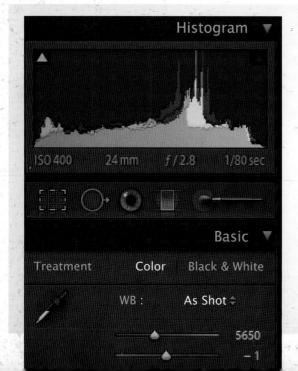

SETTING A CUSTOM WHITE BALANCE

Remember the 18% Gray color mentioned in the pages on exposure? If you place that gray panel in a scene being photographed, ensure that it fills the majority of the camera screen, and take an image, it provides the perfect way to render the white balance of the scene. Providing the lighting isn't altered, then all images taken in that setting will require the same white balance. This is ideal for working on a range of images. Back in the studio, open up the images in your software, select all the images taken in that setup and use the White Balance Eyedropper to click on the gray in that first image. You can also buy 18% gray cards for the same purpose. They come in a range of sizes, and the smallest can easily fit into a pocket or a camera bag for portability.

Color Temperatures in the Kelvin Scale

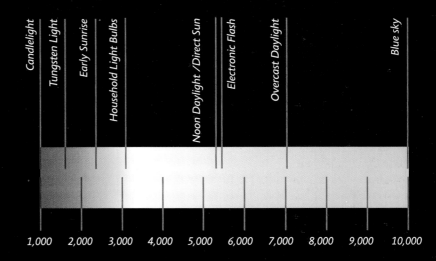

| Candlelight | Tungsten Light | Early Sunrise | Household Light Bulbs | Noon Daylight /Direct Sun | Electronic Flash | Overcast Daylight | Blue sky |

1,000 2,000 3,000 4,000 5,000 6,000 7,000 8,000 9,000 10,000

In this first image the model Vivienne is being lit by a single flash to camera left. It is gelled to project a tungsten light (orange light) onto her. Also to camera left is a window allowing natural light to enter the room. The tungsten light is focused tightly onto her face and shoulders. The white balance in camera is set to Incandescent and renders the skin tones naturally, allowing the window light to cool and render as blue. A beautiful and simple effect all produced in camera.

In the second image I turned Vivienne into the light from the window and angled the flash to light the wall behind her. This time I wanted to preserve the overall warmth in the image, and so changed my white balance to a Cloudy setting. This gave me warm skin tones and enhanced the orange color of the light behind her. Once again all done in camera and very simple to do, but very effective in producing a vibrant portrait.

Manual Flash Settings

Did you ever have to stand in a group for a seemingly endless period of time while a photographer paced from the camera to the group and back again, all the while muttering to themselves and doing calculations on their fingertips? I certainly did, and never appreciated why until I took up photography myself.

In flash photography the distance from the flash unit to the subject is one of the key criteria in determining the settings required to get a perfect exposure. Our little flash units have a limited amount of light they can throw, even at their full power. This maximum is referred to as their Guide Number, or GN. Now, this is about as technical as it needs to get, but the higher the number, the brighter the light that is being thrown by the unit. The brighter the light is, the further it will travel from the unit. However, as discussed in a couple of chapters' time, that light is subject to a phenomenon known as the Law of Inverse Square. In simple terms, as it moves away from the unit the lovely bright light starts to get dim pretty quickly.

There are a few things you can do to help the flash out. You can work at higher ISO if the subject is a long way away (so the aim is to throw the light a long distance). You can focus the flash unit itself. Most modern units have a zoom facility typically in the range of 14mm to 105mm. Just like a zoom lens, if you are at 14mm the view or light spread is wide and therefore diffused. At 105mm it is tighter and more concentrated. So for the light to travel, you can focus it in and give it more possibilities of reaching the destination.

If working with manual settings on the flash unit, you don't just have the option of zooming the focus of the flash to effect how much light reaches the subject. You can also vary the amount of light that comes from the unit. This is written as a fraction, 1/1 being full power and generally reducing to 1/128 at its weakest setting.

A lightmeter can be a lifesaver in a difficult lighting situation.

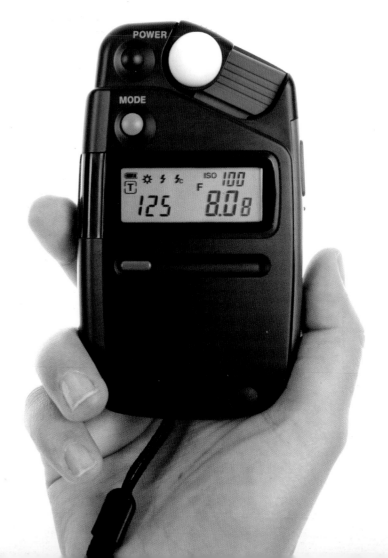

HOW DO YOU KNOW HOW MUCH LIGHT YOU NEED?

Quite simply, you don't. One option is to use a light meter to accurately determine the level of light needed in any situation on the subject. However, this takes time and can be an arduous process as it means triggering individual flash units and taking readings, then adjusting the power and aperture to suit. So when working with manual flash I take advantage of one of the major benefits of digital photographic technology: the screen on the back of the camera.

You may be familiar with it already, but here I am referring to the principle of "chimping." In any group-shoot situation you will see this principle in action. It occurs when the photographer raises the camera to their eye, fiddles with the settings for shutter speed and aperture, and then previews the images they have taken.

Personally, using the LCD screen is fundamental to my photography. For example, I walk up to a scene and assess how much ambient light I want in the image. That determines the exposure in my camera. I then decide where I want my flash unit(s) in order to add light and shade to the image. I then guess how much power I want them to output. This is dependent on many factors, but usually how far away the unit is positioned from the subject is key. I then take a picture and check it. If it's too bright I turn the power down a bit; too dark and I turn it up. It really is that simple. I sometimes have the "blinkies" turned on—also know as the Highlight Warning feature. These flash when parts of an image are totally overexposed. I rarely use the Histograms as they can complicate things too much, though it is also a good guide to the accuracy of the exposure—the right hand side of the graph will be clipped if any of the highlights are overexposed.

Incidentally, although chimping is a modern occurrence brought about by the advent of digital technology, Albert Einstein used similar simian-based terminology when he dismissively referred to photographers as "lichtaffen" or "light monkeys." I love this description, and see myself as a playful soul who monkeys around with light to create my work. And on that note, LightMonkees.com is a great website that is well worth a visit.

An LCD screen is a very useful tool for checking exposure.

One other setting to think about is when to trigger the flash. Should it trigger at the start of the exposure or the end? Much of the time it doesn't really matter, as the flash works its magic in a tiny fraction of a second and is over by the time the shutter closes. However, consider a typical challenge for a wedding photographer: the first dance of the newly wedded couple. It's usually quite dark by that time and the flash needs to balance with other lights, for example those from the DJ. That usually means a slow shutter speed to allow the ambient light in, and then a burst of flash for the couple. If the flash fires at the start of the exposure, then the couple will be frozen and any movement during the rest of the exposure will create strange patterns on the image. In this situation it is better to set the flash to fire at the end of the exposure, so that the movement builds and is then frozen.

This is called rear sync flash and is great for shooting moving objects at slow shutter speeds. Personally, I usually leave my flash on this setting as it has no effect at fast shutter speeds, but works wonders when life slows down.

Manual settings used with a little interpretation from the photographer can produce stunning images, not to mention some fantastic interactions between the photographer and the model.

TTL and HSS

Fun as "chimping" (see pages 40–41) can be, there are other avenues open to photographers with modern cameras. The world of "through the lens" information (TTL) and the incredibly sophisticated computing power built into cameras and flash units allows them to make pretty reasonable guesses at the amount of light you're going to need.

Although different manufacturers would have us believe that their system is special, the basics of TTL technology are the same. When you press the shutter release the flash fires a sharp burst of light. This hares off to find the subject. When it hits, it bounces straight back to the camera. It passes through the lens into the camera body and is interpreted by the sensors within. They then determine how much flash output is required to light the subject given its distance from the camera and the ambient light conditions. It's all clever stuff and for much of the time very accurate.

If the camera should get the calculation wrong then you can use flash compensation (flash exposure compensation on Canon models) to add or remove a little power. This is usually shown as TTL + or TTL -, with increments measured in thirds (+0.3, +0.7, +1.0 etc.) up to around +/- 3.0. The degree of variation needed is once again an inexact science. You could use a handheld light meter, but some photographers much prefer to look, assess, and amend on the spot if required.

TTL takes much of the guesswork out of flash photography, allowing you to work with the camera settings you choose for the ambient light, using the flash to light the subject or background as you wish. It's brilliant technology, but it's not the most exciting part of modern photography with small flashes.

For instance, when I used to work with big studio heads I got frustrated that I couldn't work at the widest apertures, as the flash was too bright and the shutter speed couldn't be pushed beyond the synchronization speed of the camera (usually around 1/250 sec). Go any faster than that and the shutter would register in the image as a dark band across the bottom. That denied access to incredibly shallow depth of fields and limited what styles could be explored. Now small flashes can compensate for this in the form of High Speed Synchronization (HSS).

Using HSS, or Auto FP as it is sometimes known, means that you can work at very high shutter speeds and the flash will still fire within the time the shutter is open. You can work at thousandths of a second, at $f/2.8$, and override the ambient light totally, allowing you to produce moody skies, for example, or just work with flash and shallow depth of fields as desired. It is an incredibly creative area to work in.

These two images illustrate the advantages of High Speed Synchronization. The below image of model Jenny was taken at the sync speed (1/250 sec) at $f/4$, ISO 200. Flash was fired as fill from the camera left to give her a little punch, but the sky behind is blown-out and devoid of interest. Compared with the opposite image that was taken at all the same settings, but with the shutter speed raised to 1/3200 sec, the detail in the sky now frames her beautifully and makes for a much more satisfying and interesting composition.

How to Influence Light

You don't need to be the most technically perfect photographer, but there are some "laws" of lighting that cannot be overcome, or indeed overlooked. With a little understanding, however, they can be bent to your will when you need them most.

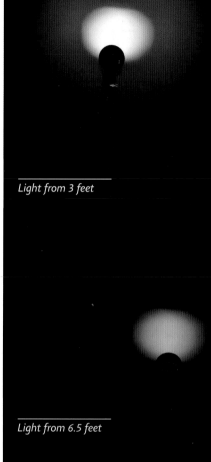

Light from 3 feet

Light from 6.5 feet

Inverse Square

This is one of the most widely quoted and often least understood of all laws of lighting. Essentially the law means the further away a subject is from the light source, the larger that light source appears, but the weaker its strength. In mathematical terms it says that an object which is twice the distance from a particular source of light will receive a quarter of the illumination. Practically, this means that we can understand better both the output and the spread of our light sources. A most interesting and useful side effect is that the distance your light travels to the subject is roughly the equivalent of its diminishing distance. That means that the position of your subject from the background is critical as your flash will go to the model and about the same distance beyond. Very useful stuff.

In simple mathematics a subject twice as far from the light source will receive a quarter of the light due to the spread of photons.

Background A Background B

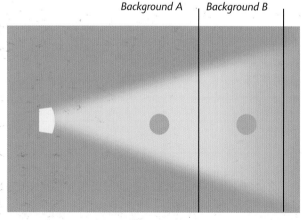

Now imagine the subject stays in one position but the backdrop is moved between shots. At position B it will be much darker than at position A due to inverse square.

Apparent Size

If you imagine your flash unit as a single head that radiates light beams from it then you will observe that the further you move the flash from the subject the "larger" it becomes. That's important as it allows you to move your flash unit with confidence, visualizing in your mind how the light will appear on your subject. In the two examples here a snooted flash was positioned first one meter then 6.5 feet from the wall at the same power output.

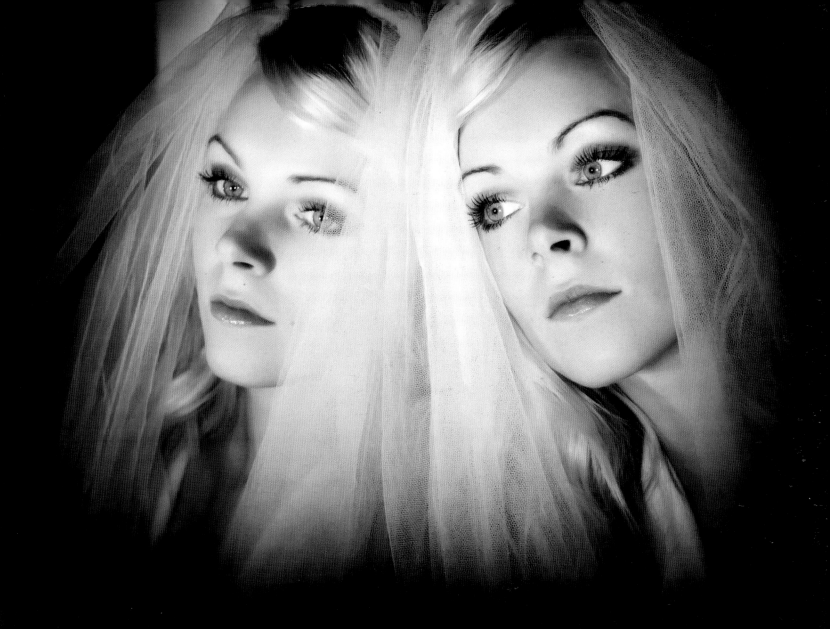

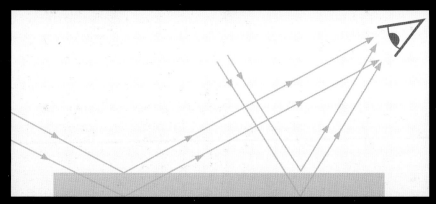

Bounce

Remember your very first school lesson on "The Physics of Light?" Firstly, light travels in straight lines until something gets in its way. Then it will bounce at an angle of incidence, which equals the angle of reflection (see pages 28–29). Quite simply it means that if you throw your light at a reflective surface, it will bounce off at an equal angle. That's particularly relevant for photographers looking to light large groups, a fact that's explored later (see pages 92–93).

Reflections

Building on the laws of bounce, you can see that the closer you get the camera to the reflective angle the stronger the reflection image will be. Reflections are a great way of adding a contemporary edge to your photography and well worth experimenting with.

Posing your Subject

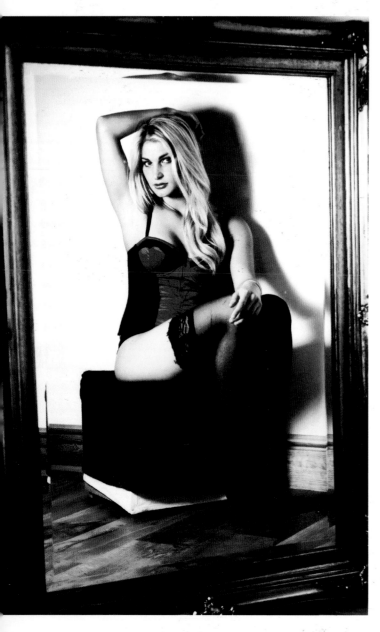

With a nervous subject, the mirroring technique—where you ask the model to mirror your movements—can be a simple way to help them relax.

When I'm running workshops it never fails to surprise and amuse me how many photographers are superb technicians, but fall apart when a live body is placed in front of their lens. Their natural personality seems to get absorbed by the camera, all power of speech becomes removed, and their attention appears to be laser-focused on the twiddly dials and buttons of their kit rather than channeled into an interaction with the fellow human being in front of them.

As photographers of people it's so important that you have complete mastery over techniques and your kit so that you can concentrate on the "soft skills" of image-making: relating to the clients.

For me, posing starts well before I actually pick up a camera. When a client or model arrives at the studio I spend time talking through their shoot, planning the styles, and going through the wardrobe of outfits they've brought with them or had supplied. This is vital time that allows me to understand their objectives for the shoot and where their limits lie. Are they willing to go outdoors for instance? Do they wish to shoot in jeans, smart outfits, lingerie? All important and perhaps obvious points, but essential if you are to have a clear and coherent shoot. More of this process is explored in Chapter 7, but here the focus is on practical posing.

The time spent talking to clients allows you to observe your clients, look at their faces, and start to read their features. By this I mean looking at the way they hold themselves: which is their dominant side? Are they left or right-handed? And importantly, is their body symmetrical?

If you look through a fashion magazine some of the most beautiful and well-paid models are those whose features are pretty similar on both sides of their central line. Most of us are pretty similar, one eye on each side, one nostril, half a mouth and so on, but it's how much these are in balance that can subliminally effect how much we perceive the "beauty" of an individual. As photographers, if you can read a person's features effectively you can produce "beautiful" images of them that much more easily. For instance, I have uneven eyes. My right is larger than the left. Therefore, if being posed, I would place the smaller eye nearer the camera and the larger one furthest away. That way perspective would iron-out the differences and even I could look that little bit better!

When posing your subject, start with a simple pose, a head shot, and then work up to a full body shot. This allows the client to get used to being directed by you, and you to discover how they respond to your directions.

Tanya (far left) and Marika (left and below) both have incredible features. Analyze them effectively and you will see that Marika is almost perfectly symmetrical while Tanya has a slightly larger eye on her right. This simple knowledge helps me pose them effectively and both are superb models to work with.

The key to successful posing is to talk often. Quietness, especially with a nervous subject, can kill the mood and therefore all chance of getting a great image. You've probably seen an overblown comedy pastiche of a photographer telling his—and it's usually a him—model that they're, "gorgeous, looking fantastic, beautiful darling!" Well keep that in mind, underplay that role slightly, and gradually—even though you are thinking about f/stops, shutter speeds, and flash strength—you will keep your subject reassured that they're doing things right and looking good.

Some photographers will pose their subjects by walking up to them and physically shifting parts of the model into place. While that approach has its merits in some circumstances, it doesn't work for me. One, I often work alone with people I don't know very well and the last thing I'm going to do is invade their personal space and start manhandling their limbs. Two, if I am stood right up close to someone, I cannot see the effects of any changes that I'm making.

For that reason, I use the mirroring technique when posing. I will ask my subject to mirror what I do, or turn their heads as I move my finger. As I make the movement I can see how the light is changing—where the highlights, midtones, and shadows lie—and will stop the movement just as the light is perfect. To practice this technique stand in front of a mirror yourself, hold a torch to one side of your face and watch your features change as you turn into and away from the light.

Classical Lighting

It is often said of art that in order to break rules competently you have to understand them first. That's particularly true of photography. There are many rules out there that I don't always follow. However, I know what they are and when I choose to ignore them I do so for a reason.

The classic styles of lighting exist for a reason. They have arisen from creative people studying the way that light interacts with objects over the years and working out how to get the best from their subjects. That's why you can learn much about our work as photographers by studying some of the old masters of painting, drawing, and sculpture, as well as those of our own craft.

So play around with light on the axis of the nose, light off to one side, on the same level as the face, or above. Discussed here are a few different styles. The first is the foundation of much of my image-making: short lighting.

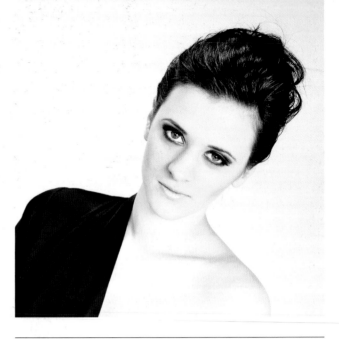

Broad Lighting

The converse of short lighting is broad lighting. In this image you can see that the model's face appears a little fuller than in reality because the side that is presented to the camera is fully lit, and the shadows that define the form of her face are on the far side. This is useful for very thin faces and is also better suited to male subjects.

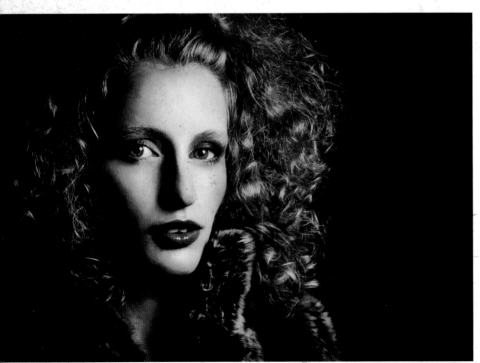

Short Lighting

In this style the position of the subject relative to the light source is absolutely critical. You can see in the model's eyes roughly where the light source is. It's lit by a flash to camera about 45° to the right of me. The light and shade define the shape of the face. The placing of the nose's shadow has to be done carefully so that it shows that the face is three-dimensional, but doesn't cut back into the cheek. Taking the picture from the shadow side can make a round face look slimmer and show that this two-dimensional representation is actually a living, breathing three-dimensional subject.

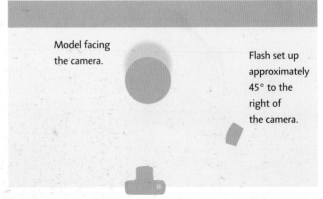

Model facing the camera.

Flash set up approximately 45° to the right of the camera.

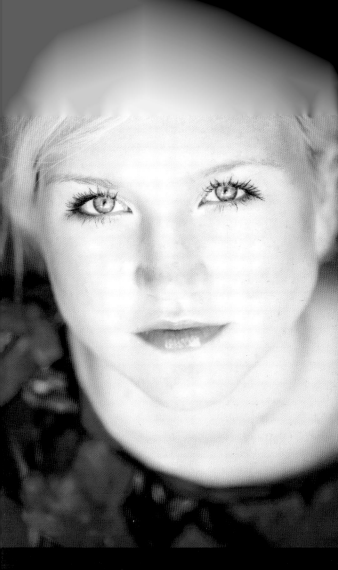

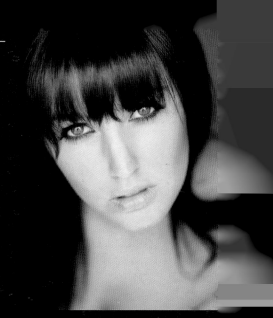

Beauty Lighting

If the light source is moved directly in front of the subject then it will produce very flat and even lighting. It is very flattering for the subject, in that pores and imperfections are minimized, but this style does not reveal any character in the face and can result in a face appearing much fuller than in reality. Sometimes this look is produced with two flashes, one high and one low, so that the face is washed in light and no shadows are formed. This is also known as beauty lighting.

Paramount/Hollywood Lighting

Using beauty lighting where the light is the same height as the subject, we can create a little more depth to the image by moving the light a little higher than the subject. This is called Paramount or Hollywood lighting, as it is a classic light pattern for movies as well as stills. The light is still on the same axis as the nose, but angled down to create shadows under the cheekbones and a small triangle under the nose.

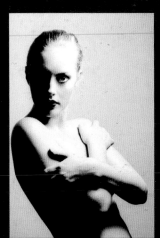

Split Lighting

Split lighting is another favorite style of mine for adding drama and intrigue to an image. In the first you see just a hint of light bridging the nose into the eye nearest camera. It is a very masculine form of lighting and can reveal "ruggedness" in complexion or beard growth as the light crosses the face. However it can also be used with female subjects to produce dramatic portraits.

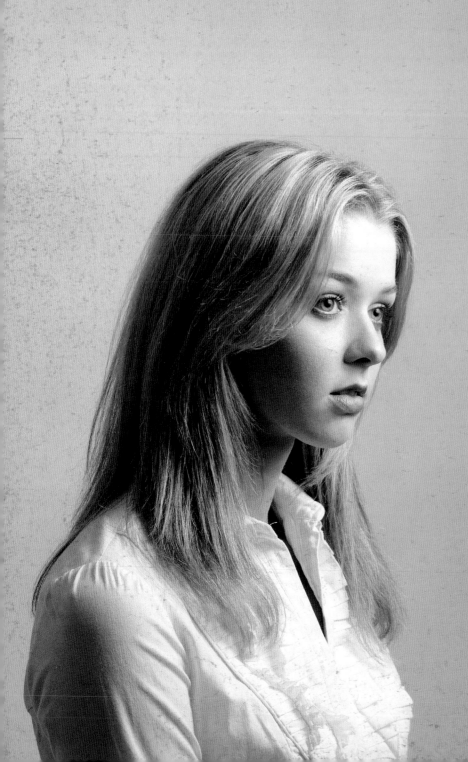

INDOOR LIGHTING

To make life easier we can start our exploration of the practical use of light indoors. At least indoors we can choose to use ambient light or not, flash or not, and have a little more control. That's not always easy outside and so practising your skills in a studio or your own home is a great way to start understanding light better.

Head Shots

I have a confession to make. Something that I feel I now need to share with my artistic friends. I love head shots! There, I've said it.

I could take them all day at the exclusion of any other form of image. Whether using good quality natural light or flash, I am addicted to that moment of looking deep in my subject's eyes. Seeing all the beauty in their soul and then the fun of showing them on camera how fantastic they look.

It is an addiction that I have to actively stop myself from indulging in during the course of a photo shoot and move on to other poses, but I always come back to my first love after a while.

It is often said that the eyes are the windows to a person's soul and that's how I feel. I tell my students that whether your subject is male, female, young or old, you have to fall in love with them for the duration of your shoot. That way you will do your utmost to make them look spectacular. That process starts for me at the moment I look into their eyes, study the shape of their faces, the strengths and weaknesses, and decide how to capture their portrait to maximize their own particular beauty.

My lighting for head shots falls into two basic categories: they will either be beauty-lit with light cascading over the subject from above and below, or they will be lit from the side, casting shadows over the face to define shape. These considerations are the same, whether I'm using natural light, flash alone, or mixing the two.

When using ambient light it's easy to see exactly where the light is hitting or missing your subject. If you imagine your flash unit as a torch and shine it at your subject, you will be able to visualize where light will hit and miss the face. You will also be able to determine where in the eyes the reflection of your light will appear. These reflections, or "catchlights" as they are commonly known, are key to making eyes come alive in a head shot.

Nikon D300
ISO 400
f/1.4
1/4000 sec

This is a slight cheat in that no flash is involved in this image. However, it shows the effect of beauty lighting your subject perfectly. Here natural light is shaded in the doorway, but lights the model's face beautifully. A reflector on the floor is bouncing light back under her chin to soften shadows there and she looks amazing. The catchlights are provided in this instance by the reflector, although on occasion I will use a weak burst of on-camera flash, just to put a touch of light into the subject's eyes.

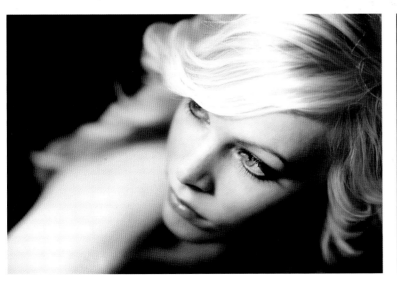

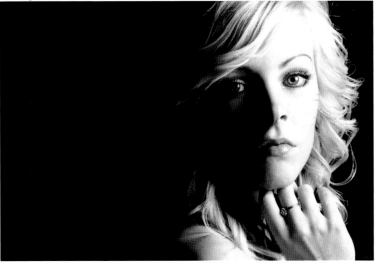

Nikon D300
85mm lens
ISO 400
ƒ/8.0
1/250 sec

My alternative to beauty lighting is to use the light to sculpt the face, which can be very forgiving with larger subjects. Natalie is anything but, however these two images show a couple of different approaches to this type of lighting. Both used a flash unit mounted in a softbox and an aperture of ƒ/2.8 on a D200. The only difference is the angle of the flash in relation to her head and the shutter speed used. The shutter speed dictates how much of the ambient light is allowed to register on the sensor. In the first, this was set at 1/80 of a second. In the second, it was set at 1/3200 of a second.

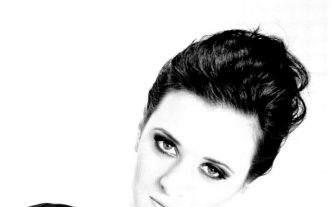

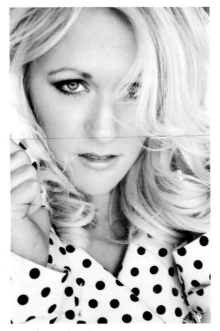

This final image combines flash with natural light. The light is coming in from a doorway behind me and I used a flash unit behind the model's head to add a little corona of light around her hair. This is also a good technique if the subject is against a dark background and has dark hair that merges in. This little burst of hair light can add definition and depth to the image. Here it adds a little sparkle to the picture.

Nikon D300
56mm lens
ISO 500
ƒ/4.5
1/250 sec

This image shows the same look as the one on the far page, photographed in the studio. A reflector was placed on the model's lap with the silver side facing upwards to give a crisp light under her chin. The flash was provided by an SB800, high and to the right of camera, pointing down across her face and bouncing back from the reflector. The flash was mounted in a beauty dish to soften, focus, and crispen it. A little natural light is coming from a skylight window on camera left.

OVERVIEW

So experiment—play around with head shots and have fun. Whether it's flash or natural light, or a combination of both, you will get some spectacular results that will make your subjects feel wonderful about themselves.

Three-quarter-length Portraits

The three-quarter-length portrait is a staple image in any model's portfolio, whether it's a lifestyle shoot or a commercial image. It allows the photographer to fill the frame with the subject without having to include too much background detail.

The description "three-quarter" is slightly false, in that the subject is actually cropped around mid-thigh level, so more accurately it's a two-thirds portrait, but let's not fight convention. If the crop was made lower, below the knee for instance, then you'd be breaking one of the long-standing rules of portrait photography. If you crop below a joint, go all the way to the end of the limb. I'm a great believer that rules are there to be broken, but this is a valid one. Play around with different crops and you will see what works and what looks downright weird.

In lighting terms you are presented with a greater challenge than the head shot, in that you may have to make the flash work harder. If you require an even spread of light over the subject, then the flash has to be moved further away, requiring more power to produce the necessary light.

Because there are now limbs coming into play, you have to consider their placement relative to the flash with a little more care. Light travels in straight lines, which means that as it hits an object it will produce a light side and also throw a shadow behind it. It's important to have this in mind when posing people in front of a flash, as you can create strange body shapes and patterns if you don't take into account the fall of shadow.

Your flash unit can be used on a three-quarter-length portrait in a variety of ways. It can be the main light used to illuminate the subject. It can be an accent light used to throw a little interest onto hair, for instance, or you could use natural light on your subject and the flash to illuminate the background.

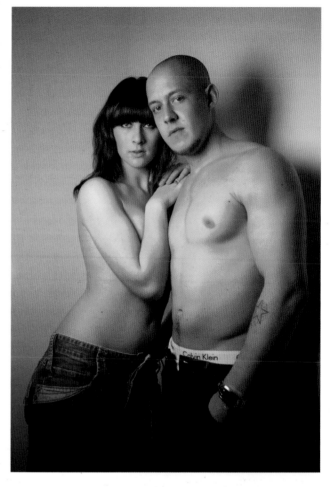

Nikon D300
ISO 800
f/4.5
1/320 sec

I needed a soft but fairly focused light source for this image, so I placed a flash on a stand high and to my left. The light was modified with a tight 20° grid. This hit the couple on their face and upper body and was starting to fade by the time it hit their thighs. The angle of the light was crucial to provide modeling on their faces and bodies, as shooting front-on can make people look chunkier than in real life.

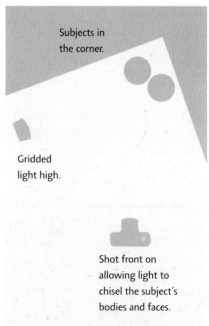

Subjects in the corner.

Gridded light high.

Shot front on allowing light to chisel the subject's bodies and faces.

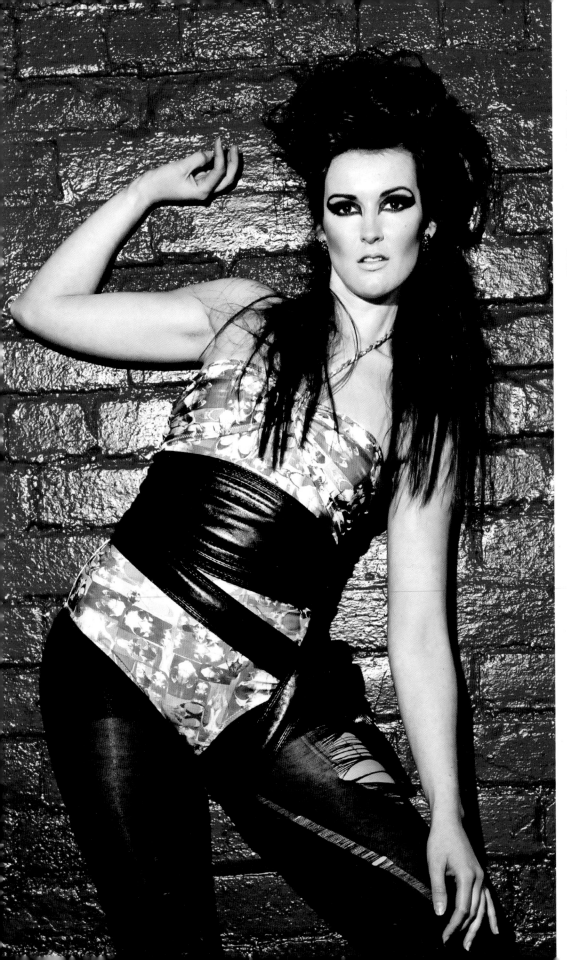

Nikon D300
ISO 800
f/4.5
1/320 sec

Model flat
to the wall.

Camera
position
flat on to
subject.

Flash unit on stand
slightly higher than
subject to put shadow
lower than limbs.
Open beauty dish to
focus light but not
soften too much.

*I wanted a hard and crisp light on the model
that lit both her and the red brick wall to
emphasize the texture of both. I removed the
inner diffuser from the beauty dish and threw
light from a single SB800 straight at her. The
flash was on a stand and slightly higher than
her so that the shadow dipped slightly below
her limbs. Although pretty much hidden by
her body, it provides a little separation from
the wall behind. The overall effect is similar
to that of a ring flash.*

Nikon D300
44mm lens
ISO 1250
f/7.1
1/160 sec

In this picture I wanted an even light across the couple. There was a small window to camera right that was allowing a little light in, but it meant that her feet were brighter than anything else in the image and he was very dark. I decided to meter for the light coming through the window so that the overall image looked natural and not "flashed." I then pointed my flash towards the ceiling, set it to TTL -0.7, and took the photo. The resulting image has its shadows produced by the natural light, but is lifted overall by the flash bounced from the ceiling. Had I pointed the flash straight at them it would have destroyed the delicate shadows on their faces.

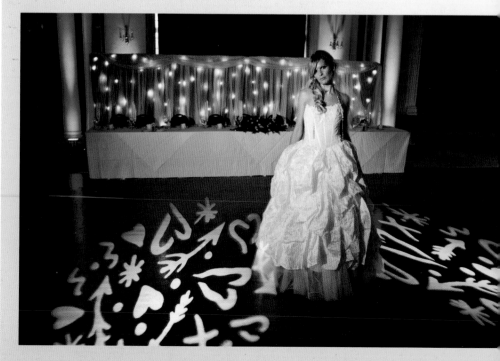

Full-length Portraits

Taking pictures of the full length of a person's body can be more problematic than it sounds. If they're stood by a window then the chances are that their face will be lit better than their thighs, and certainly better than their feet. If you move them away from the window the light starts to even out but gets weaker, and may not be good enough to get the image you want. Doorways are a good solution in that the light will usually be consistent down their length, however, if you are shooting from outside then you'll end up with flat light that may not add drama or interest to the image. This is where flash can be your friend and savior when working indoors.

This applies even more to small flash, because as already discussed, you can use the small flash with a wide open aperture to throw any cluttered background into a diffused abstract which frames the subject nicely.

When considering a full-length image using flash as a main light then you have to take into account not just the light on the subject, but where their shadow will fall. If you get the light placement wrong then the shadow will be very visible behind them and can become a major distraction to the image. However, a little thought and you can use it to your advantage. Here are a few examples that talk through the techniques.

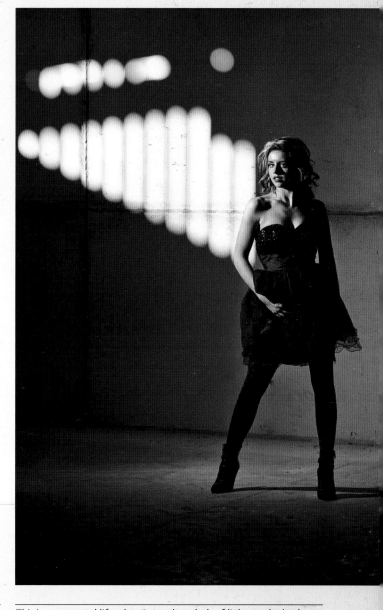

This was another challenge in blending all manner of ambient light and eliminating shadow. The DJ had put together a fantastic light show for this wedding which had patterns projected across the floor, lights on the walls, and the star-studded cloth behind the top table. I set my exposure so that they registered in the image and then set the flash to TTL -0.3 to light the bride. As I didn't want her shadow to fall across the floor lighting, I positioned the flash on the same axis as her nose and a little higher than her, so that the shadow was blocked by her body.

Nikon D200
82mm lens
ISO 200
f/3.2
1/125 sec

This image started life when I saw the splash of light on the back wall coming from sunlight shining through a slatted window. I liked the way the pattern formed and so set my exposure for it. That gave me a shutter speed of 1/125 sec at f/3.2, ISO 200. I then positioned Olivia so that she was at the end of the pattern. Unfortunately that meant she was in darkness, so flash was essential. I positioned one flash unit to my left as I wanted quite a hard light on her, but no hard shadow on the back wall. You can see this position from the pattern of highlights and shadow on her body and the floor. The flash was in TTL mode and lit her just as I wanted. I adjusted the height of the flash so it was roughly in line with her middle and turned the head so it was in portrait orientation. This meant that the light spread equally from top to bottom across her body.

Having looked at three examples of eliminating shadow it's worth looking at another where I wanted to emphasize it. Here I wanted the angular pose to be echoed in the shadow on the wall behind the model. I placed the light above her, as if it had been on the same level or below her, the shadow would have been raised and looked more like a scene from a film noir or horror movie. The exposure was set to eliminate much of the ambient light and the flash gridded to give that pool effect on the backdrop. At ISO 800 this gave me 1/30 sec at f/2.8. This was just enough to freeze the motion of the lights on the floor and handhold without blur.

A final example is another use of bounce flash. In this instance I wanted to capture the model walking down the stairs. The staircase was dark although there was a window behind me that allowed a little natural light in. Had I bounced my flash from the ceiling the light would have been lost in the large void above me. If I'd bounced it from the walls it would have produced unnatural shadows, given the natural light coming in behind me. So the solution was to turn the flash head all the way around and bounce it off the window behind me. Despite the glass being see-through it still bounces flash light and that is what is providing the majority of the light in the image. The wall light at the bottom of the stairs produces a nice focal point for the eye and twinkles in the image, although it is not contributing light to that on the subject.

OUTDOOR LIGHTING

We started simply by using the light available to us indoors. It gets a little more complicated as we move out of the studio into the great outdoors where you have limited control over all sorts of factors, only one of which is the ambient light available to you. This section looks at a range of different locations and how you can overcome some of their challenges and optimize your images using just your camera, your creativity, and a flash unit.

Overcast Conditions

When working with flash light you spend a lot of time modifying it in order to diffuse it and make it softer. Overcast conditions offer all the benefits of simple diffused lighting without having to modify it in any way. The downside is that often the results can look a little flat and lack punch. That's where the flash unit can be your best friend.

I often remark that I use flash to make my images darker rather than light everything up. That is particularly true when faced with overcast conditions—it can put a little depth into a flat and boring sky, light the background, or just "ping" the subject from the background.

This first image was taken during a workshop in London on the embankment of the River Thames at midday. It was a cold and dull January day. I wanted to take a fashion image that included elements of the street furniture and looked a little more dramatic than an image taken with purely natural light. The light was extremely dull and gave an ambient reading of about 1/60 sec at *f*/4 and ISO 400. As I was looking for inspiration I noticed the street lamps and the small lights on a rope stretched between them, and decided to base my exposure on them. I wanted them to glow as though it was evening time. In this respect the overcast light was a bonus as it didn't need a very quick shutter speed to darken it. I ended up dropping my aperture slightly to *f*/3.5, sacrificing a little depth of field in order to allow a little more light into the camera. The shutter speed went up to 1/4000 sec with an ISO of 400. This final combination of settings wouldn't overstress the battery, which was important as I was teaching, and so a number of the students would be using my flash too. Had I been on my own I would have opted for a smaller aperture and a long depth of field.

The flash was on a stand, roughly six feet in the air and gridded. I wanted to put a pool of light around Vivienne, the intention of the image being that the observer would see the young woman standing in a pool of light by a street lamp, anxiously scanning up the street for her lover. (I try to come up with stories that help communicate my vision to the model.) The flash was on pure TTL and gave me just the light I wanted. I took two images, both worked in Lightroom, and flipped one on its horizontal axis. I'm still undecided as to which I prefer. Any thoughts? Drop me a line.

When shooting this pair of images, using pure TTL flash gave me an excellent result.

Nikon D200
22mm lens
ISO 400
f/3.5
1/4000 sec

Nikon D3X
70mm lens
ISO 200
f/5.6
1/250 sec

Sometimes if it's really overcast and gray, it's best to underexpose and turn the sky almost black. In this case the light is provided by a flash shot through an umbrella.

Nikon D300
175mm lens
ISO 200
f/2.8
1/100 sec

Caroline was placed in beautiful even light, but her dark hair could easily have merged with the dark background. I could have lit the background, but it was a clutter of junk and so I chose to light the back of her head instead. The snooted flash was fired at TTL -1.7, just adding that bit of backlighting to her head at the sides and top.

While previously we had a classic example of using one flash in overcast conditions as a main light, I will often use it as an accent light to add separation of a body from a background or as a hair light.

I use a snooted flash to add a hair light to my subjects. Seated or standing in a doorway, overcast natural light casts a beautifully soft light on them. It's ideal for head shots. However, add a little light from the back and it will separate them from the backdrop and create accent in your head shots. Whenever using snoots remember that they do channel the light tightly, and so when working with TTL flash you are going to have to dial the power down. A starting point of TTL -1.3 is usually a reasonable guesstimate.

Sunny Conditions

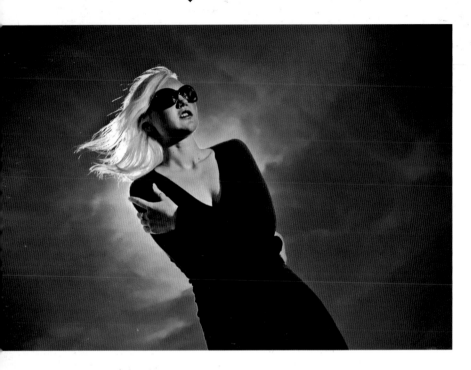

In this image the flash is to camera right and has a beauty dish attached to focus the light onto Marika. I was lying on the floor, with her directly blocking the sun. I had metered for the bright sky and underexposed it slightly. The flash was set to TTL, and due to the intense light had been powered up to TTL +0.7. The bright sunlight meant that even at ISO 200 I had to be at 1/8000 sec to get any detail in the sky, so the flash was working really hard to give me the light I needed.

Have you ever been on your way to take some pictures, camera in hand, when somebody has looked into the sky, seen an endless blue void punctuated only by a searing ball of burning gas, and remarked, "Good day for photography?"

The truth is that the sun in its rawest state, unmasked by cloud, mist, or foliage is a hard light source that burns the eyeballs of your subjects if they look at it, blows out detail, and casts strong black shadows. It is in fact one of the hardest set of conditions to work in. You are imbued with a desire to seek shade in photography. From your earliest outings with a camera you get used to looking for soft, even light. Why? Because it flatters subjects and, above all else, it's easy to use! It doesn't create big shadows, it doesn't reveal textures—it's gorgeous. There's a real challenge to using hard sunlight, but a single flash unit can assist you greatly in that.

So, when the weather is fine and you can reasonably expect good sunlight, have a think about what time of day you want to stage your shoot. That will largely be dictated by the style of image you want to capture. Strong sun early in the morning will produce warm tones, and perhaps a little haze in the air will add an atmosphere to the image. In the late evening you'll get a similar warmth to your tones and long shadows stretching out from your subject. However if you venture out at anything but these two extremes of the day you'll be stretched by all the problems of that hard light source. With a little creativity though, you can turn it to your advantage.

In this first situation the sun is high in the sky and it is used to backlight the subject. Usually when doing this I will position myself so that their head is directly in line with the sun. This creates a beautiful halo of light around the hair, but also means that you have to get lower than your subject. This is why I am quite often to be found lying at the feet of my models. If they stand tall then the problem of converging verticals can present itself. It's the same as when photographing tall buildings in that the lower part will look broad and converge to a tight point. This is somewhat problematic with buildings, but if you give your model a broad lower region and a tiny head you are heading for trouble and possibly hospital. Fortunately, models have something that buildings don't offer, and that's the ability to move. If you ask your subject to lean forward from their waist then you can shoot a half-length portrait with dramatic light.

Nikon D300
ISO 200
f/2.8
1/2000 sec

For this image of Marika I wanted a much less obvious look to the flash. Even though the conditions were fairly similar in terms of the amount of light hitting the back of the model, I changed her body angle relative to the sun so that I didn't have to overcome all that hard light. By her, low down, the strong sunlight provides backlighting. A little burst of flash from the front provided fill on her face, and this time, rather than a dish, I used a softbox as a modifier to add soft light to her features. I sometimes use a reflector to provide this type of fill, but in this situation the light was so intense a reflector would have burnt her eyes!

In the above image I've included an example of a cross-lit image to show how you can use flash to eliminate hard shadows. The sun is dipping towards the horizon on the right of this image. Had I taken this image in the same place but just using the light then you'd see shadows cast across Catherine's body. This may be desirable at times but I decided to use flash to eliminate them. I set the unit on a stand to my left and fixed my trusty beauty dish to it, my intention being to throw a soft and concentrated light onto her body to fill the shadows. I adjusted the exposure to the hot spots on her right side and then set the flash to TTL -0.7. At 1/320 sec and ISO 200 this gave me the effect I was after. I then tweaked the pose a couple of times to get the shadows where I wanted them before being satisfied with the images. The telltale signs of cross lighting are the hot spots on the outside of both arms and the shadows inside. Not a natural phenomena, but not so distracting to the eye as to look bizarre.

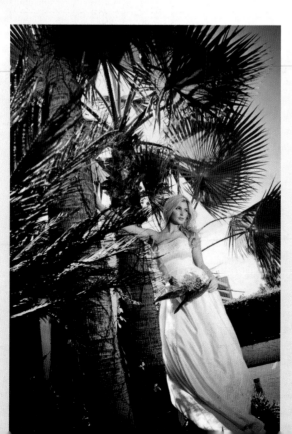

Nikon D300
ISO 200
f/4.5
1/800 sec

A variation on the theme is to use an object, in this case a palm tree, to block the hard sun, and then use the flash to light the scene around the subject. This again shows the power of one small flash unit to provide very natural-looking location lighting in harsh conditions. The flash was at TTL with no modifier.

On the Beach

The environment and lighting on a beach can be particularly challenging for the photographer. So it's important to plan before you set off for your shoot.

Firstly, think of the security and safety of your equipment. Sand gets everywhere and can play havoc with lenses and sensors. Only take what you intend to use on a trip to the seaside. I reckon—mainly because I'm clumsy with my kit—that any item could potentially be dropped in the water or sand, so I only expose the bare minimum to danger.

Think about the number of times you need to change lenses. If you have multiple camera bodies, minimize the opportunities for sand to enter your equipment by attaching lenses before your trip, meaning you won't have to change them *in situ*. A bag with a flap over the main compartment is useful in beach conditions, as is a towel and a can of compressed air for cleaning away any stubborn grains of sand.

So, with kit secured, you can consider when and where you want to conduct your shoot. The quality of light on the coast is different to that found inland, in the countryside, or in an urban environment. It's worth consulting a map and working out the orientation of the beach. Which side will the sun emerge? Where will it pass over? Where will it disappear? Use this information to determine when you'll have the right light for your needs.

The power of the midday sun is not to be underestimated. it can be a powerful ally or a darned nuisance, particularly as the sand and water will both act as reflectors, bouncing light back onto your subject. Aim to get to your location at least an hour before sunrise or sunset and you'll benefit from stunning light, but only for a brief window.

Beaches tend to be public places, so plan your shoot around the angles too. If you want a view without people in, you may have to make an early start or consider a late night. Photography, particularly when working with a model, will always attract interest, so be prepared for an audience.

Think too about your shoot plan. Save shots with your subject in the sea or covered in oil to make their skin shine until last—the sand will stick to them thereafter. Think about styling and makeup. Can you get a car close to the location or is there a public changing area? If not, you may need to invest in portable mirrors and a big towel, at the very least, to give your model a modicum of privacy.

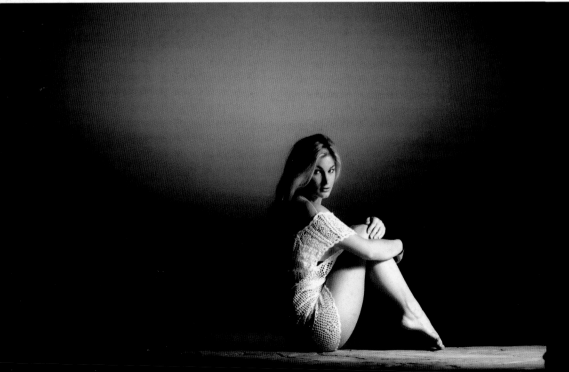

One

When we started working, there was just a thin band of color on the horizon. I set an exposure in camera that would register that and then used a single flash unit firing into a silver umbrella to light Vivienne. Umbrellas produce a beautiful softness of light and are very effective in this sort of setup.

Nikon D200
ISO 800
f/2.8
1/25 sec
SB800 fired TTL

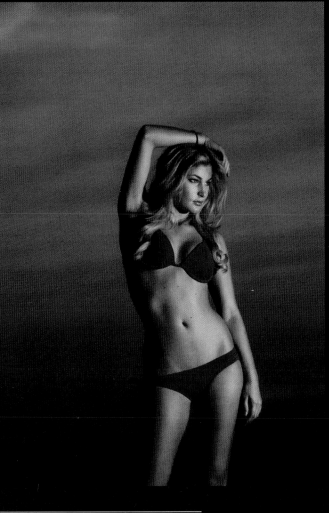

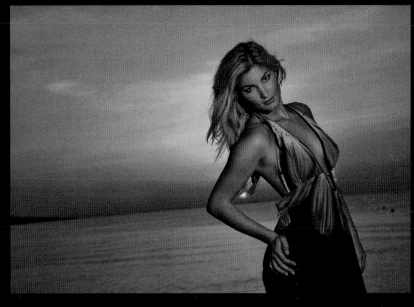

Two	**Nikon D200**
The sky lit orange as the sun rose higher, but still wasn't breaking the horizon. We chose a blue swimming costume to stand out against the warm colors of the sky.	**ISO 800** **f/2.8** **1/800 sec** **SB800 fired TTL**

Three	**Nikon D300**
When the sun emerged it produced a more even glow across the sky, which worked with the fashion look we wanted. It's important to keep the sky always a little underexposed in order to create that richness of toning, so I changed down the ISO to keep up with the increasing light.	**ISO 200** **f/4.2** **1/800 sec** **SB800 fired TTL** **+0.7**

OVERVIEW

Notice how in the first two images everything is constant apart from the shutter speed. I was using my 70–200mm lens to make use of its wide-open aperture of f/2.8, and in the five minutes between these images the ambient light had increased by around six stops. This is one of the true values of working with TTL flash— once you have your angles and composition set up, you can work quickly without having to re-evaluate with a light meter.

Four

Two minutes later, and the sun was scorching the sky. I boosted the power output of the flash again and went for a more glamor look.

Nikon D300
ISO 200
f /4
1/4000 sec
SB800 fired TTL
+1.7

OVERVIEW

These examples illustrate five quite different looks, all using the flash unit slightly differently. Even though I took two to the shoot, I only used one in the end.

Five

By now the sun was climbing into a hazy blue sky and all the color toning had been lost. This time I used the sun to backlight Vivienne and appear on the water as a reflection. I used my flash unit with no modifier and as a fill flash from camera right. I didn't want it to be the main light, but just to add a little pop to Vivienne's eyes and skin tones. The sand was bouncing a lot of the sunlight back onto her, acting as a natural reflector.

Nikon D300
ISO 200
f /4.2
1/3200 sec
SB800 fired TTL
-0.7

This shoot started at 5.30am, with sunrise expected at around 6.15am. I knew that the sun would rise from the left of the beach and that we were only likely to have thirty minutes of rich color in the sky.

I had my trusty bag with two camera bodies and lenses— my wide-angle lens to capture panoramic images and my 70–200mm. I also took two SB800 units fitted with RadioPopper receivers, one transmitter, a large reflector, a light stand, a grid, a snoot, and an umbrella. So, no such thing as traveling light, but I was prepared. Vivienne was similarly laden down with outfit changes, shoes, and makeup.

Gelled Flash

This shot was taken on a beach on a cold winter's day. I wanted it to look warm, so I put a tungsten-balanced full CTO (color temperature orange) gel over the flash unit to give a little warmth to the subject. She looked warm, felt frozen!

Look Beyond the Obvious

This image shows the strength of the sunlight during that early part of the day. I had Vivienne wade out into the shallows. I then metered for her torso, which made the sunlight go white behind her, lending itself perfectly to this Ursula Andress/James Bond-inspired black-and-white image.

In the Fields

Whether you live right out in the countryside or only venture out of the urban jungle once in a blue moon, it's worth having a brief understanding of the landscape around you. For example, if you intend to use the countryside as a setting, then a little knowledge of farming will help you prepare for shoots.

Fields form a major part of many landscapes and knowing when they are high with crops, cut, left bare, or ploughed can be of great benefit. My studio is on a farm and so I always have a changing landscape around me that I can use to my advantage.

A note of caution: do not walk into any field full of crops and start leaping around taking pictures. It could lead to damage of the crops and a heated meeting with a landowner. It's always best to seek permission when possible—it always amazes me what people will agree to when I ask nicely. The bonus is that if you know you are there with permission, and where you can and cannot tread, both you and your subject can relax and play around with different looks.

I like to use the leading lines of ploughed or cropped fields to guide the eye through an image, and I also use crops to shoot through and/or frame my subject. The decisions then are whether to underexpose the sky and bring out the detail there (if there is any), whether to use the natural light only, or backlight your subject with the sun and use flash to fill in the subject's features.

Often it's the drama of having my subject in a big, endless landscape with a heavy sky that I'm looking to bring through. I love the look you can create from adding a dab of flash to light your subject and underexposing everything around them. That is certainly the case with these images. All have underexposed the ambient light to a greater or lesser extent by raising the shutter speed from the optimum shown on the light meter.

I love playing around with figures in the landscape in this way and finding skies that match the treatment. I don't believe in slotting skies into an image later on in Photoshop. I would much rather use what is there and get the best from it in camera.

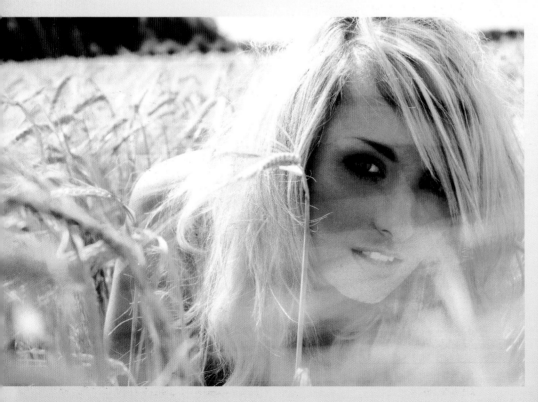

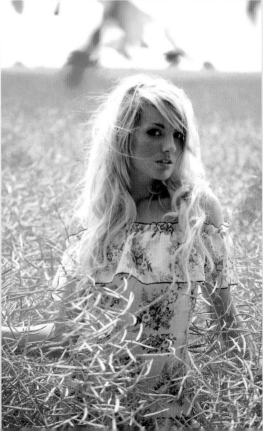

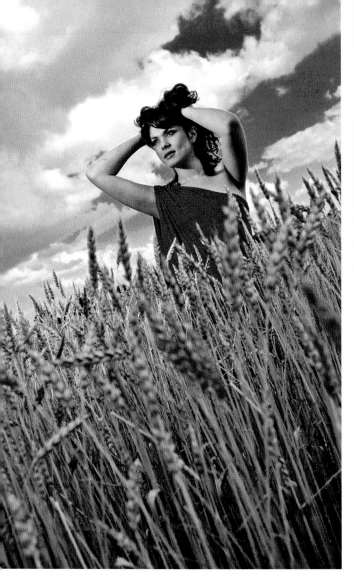

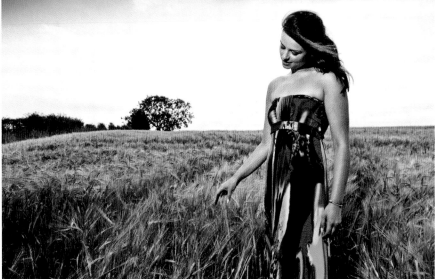

The image on the left required a different approach. The sun was to the side of my subject and there was lovely cloud and color detail in the sky. I didn't want the sky to be too overbearing and wanted some light on the foreground too. By turning Abbie so that she had the sun on her right I was able to bring a flash unit in on her left and cross-light her. You can see that the flash isn't overpowering the sunshine from the chin shadow on her left side. The cross light really lifts her from the setting, adding an almost cartoon-like feel to the finished image. The power was reduced to TTL -0.7, as I didn't want it to look too obviously artificially lit.

The above image was underexposed by a stop and although there was little detail in the sky, it has a moodier feeling reflected by Jenny's pose. The flash unit was dialed down again to TTL -0.7 to add a little fill on her front and placed just to the right of the camera.

In the two images on the far left, I used TTL flash at -1.7 to put a little dab of light onto Zoe Leigh's face. The flash unit was gridded to focus the light and eliminate unwanted shadows from the plants. When using flash in this situation it's very easy to create some very ugly strands of shadow on your subject where a bit of corn gets in between the flash and the model's face, so be aware and check your screen regularly. In both images I exposed for the field and allowed the midday sun to backlight my subject, using the flash purely as fill to lift her from the background.

Here I really turned up the shutter speed to darken the sky considerably. The flash was positioned in a similar position to the last image, high and to camera right. Flash units don't have endless power and I needed most of what it had to offer so no modifier was used, as inevitably they will weaken it a little. I turned the power up to TTL +1.3. I could have gone higher (up to +3), but this would have produced an overly flash-dominated image and strained the battery power too much.

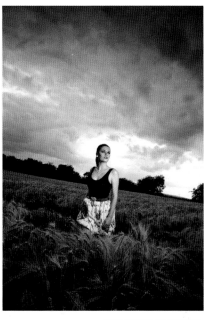

Nikon D300
50mm lens
ISO 200
ƒ/7.1
1/640 sec

Nikon D200
70mm lens
ISO 400
ƒ/2.8
1/2000 sec

Nikon D300
18mm lens
ISO 250
ƒ/7.1
1/800 sec

To the right is another example of using your flash unit to light from the front and allowing the sunlight to do all the hard work in the background. Here the sun was just penetrating the canopy of leaves and creating a little flare. I didn't want this to look like a huge star and so I kept my aperture wide at ƒ/4.5. Had I closed it down to ƒ/18 or so I could have produced a starburst-look coming through the leaves. I metered for this light coming through the leaves and then slowed the shutter speed a little to keep the color of the leaves, but burn out all the light. My flash was on a stand to camera left and unmodified at TTL. This gave me the pattern of light I wanted on Abbie's body. The dress was picked deliberately to compliment the colors of the trees.

Nikon D200
31mm lens
ISO 200
ƒ/4.0
1/8000 sec

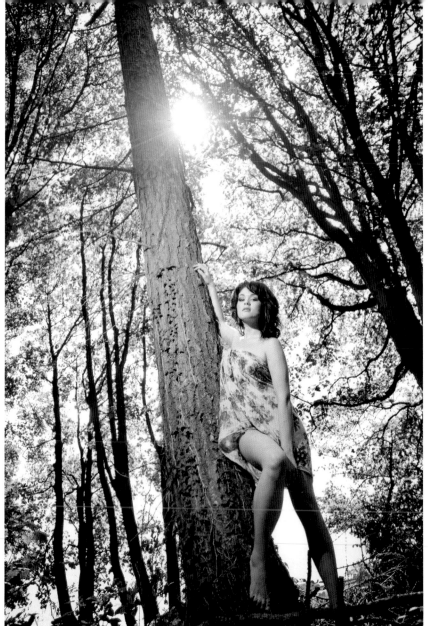

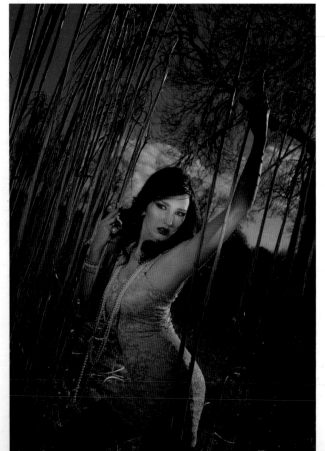

This second image required a little more placement of light. I had seen this elephant grass growing at the side of a wood as I drove to the studio. I liked the look of the collection of tall straight stems as they contrasted with the bent and twisted trees around them. Unfortunately, when I went back to work there the sun's position didn't allow me to combine the grass and trees as I had envisioned. However, I posed Carla with the sun striking the side of her from camera right. That meant I had to stand deep in the grass to get the shot. More misfortune occurred then, as I couldn't position my flash to hit her without stems getting in the way and casting shadows across her face. I could have trampled the stems down, but this is a valuable biofuel crop and given that I'd asked the landowner's permission, I didn't want to abuse it. So I had to rethink the shot and chose to grid my light to put a little splash of light onto her face and chest. At TTL -0.7 this was just enough to make her ping from her surroundings. The sunlight provides the modeling along the side of her body, and the flash is set to match it for intensity.

Down in the Woods

Woodland is a fantastic place to work in. Whether it's ancient twisted boughs, modern plantations, or towering forest there is a particular nuance to the light you encounter amongst the trees. At different times of year the leaves will add their own white balance to the scene. Usually there will be a green glow to the light, but visit in fall and there will be a dazzling display of warm tones; in mid-winter there may be no leaves at all, just the starkness of the trees themselves.

You can use the shapes in the trees to echo the shape of your subject, to frame them, to shield them from hard light. You can allow the natural light to filter down through the leaves like laser beams and add mystery and depth to your image. Basically, you can have fun and be inventive.

The principles of lighting are the same as in other environments. Look at the ambient light, decide how much of it you want to allow into the camera, and then use flash to add accent where required. The particular challenge I often find working in woodland is that I can't always place my flash unit where I want as there's a tree or nasty patch of bramble growing just where I'd like to put my stand. Also, if leaves are in season then they will move, which will cause the light to flicker and my exposure to constantly change. Despite all this I love the challenge.

Before I talk through a few images, it's worth going through a few practical points on working in the woods, such as having a basic appreciation of the type of plants and bugs you may encounter. You don't want to position your subject in the middle of a very attractive patch of foliage only to discover that their legs are now covered in blotchy marks and there are beetles eating their shoes. Also be aware that some woodland is privately owned and it's always worth getting permission to be there.

So, once you know you're not going to get shot at by over zealous landowners, or eaten alive by ravenous insects, go for it and have fun.

Finally, here are two images from a shoot I did last autumn. Katy and I had been driving around looking for good locations when we happened on this avenue of trees. The day was a little cold and misty, but there was some weak sunlight coming through. The mist had hung around in the trees and leant a dreamy quality to the light.

In the first I chose to let the flash fire from the same direction as the sunlight to enhance the glow on the edges of the trees and to allow a little of it to hit Katy.

In the second I wanted to give a little, but not too obvious, lift to Katy as she walked through the trees. The flash was directly over my head and gridded to aim at her back. It was lowered to TTL -1.3 and added just enough accent to make her stand out from the background, but preserve the delicate light coming through the trees.

Urban Chic

The urban jungle can be a paradise for photographers, not least because of the incredible juxtapositions you find as you walk around: the old next to the new, squalor within sight of wealth, greenery next to concrete and chrome. It's easy to get beaten down by your own surroundings, not to see the beauty in things you see everyday. Next time you have a free day, take a walk around your own town or city. Try and do it with the mindset of a tourist visiting for the first time, and look at things. Lift your gaze from street level to rooftops. Investigate streets you don't usually walk along and find the beauty. There's always some to be found.

Even though I would describe myself as a country boy at heart, I do enjoy venturing into the city, having a look around, and then escaping back to cleaner air. I love the textures and colors you find in the city.

Security doors, metal shutters, garage doors—all offer fantastic possibilities to the urban photographer. This first example was screaming to have its picture taken, and luck had it that I was there with Catherine in her red dress. The backdrop is a metal concertina door over a warehouse front. It was a late summer evening and the place had long closed, so it was pulled right across. It's the type of backdrop you'd pay a fortune to have in your studio and yet, right there on the street, it's available for nothing. The warm sun was streaming along the street from camera right. I chose to override it so that it just registered on the side of Cat's arm. This underexposure also made the colors in the background even warmer. I had her stand about eight feet from the door to throw it out of focus even more and stop light splashing back onto it. The flash was to my left and pumped up to TTL +1.7.

I wanted it to be the primary light source in the image and have the sunlight just acting as fill. It did the job beautifully at 1/8000 sec, ISO 200, and ƒ/2.8. I love the colors in this image. Since then this building has been pulled down and replaced with a faceless apartment block.

The below image was a real test of mixing natural light with flash. There was strong sunlight coming from behind Fredau, creating fantastic patterns as it shone through the ironwork of the bridge. I wanted to preserve those with the ambient light exposure, which meant that Fredau was registered as a shadow. Had I exposed for her, then the bridge patterns would have vanished. Using one flash unit mounted to camera right and as close to Fredau as the cropping of the shot would allow without the light stand popping into the shot, I zoomed the head of the flash tight to 105mm, and turned it to portrait orientation to put light along the length of her body. It was important to have the light placed almost on the axis of her nose to prevent ugly shadows being created on her face.

Catherine in her red dress with backdrop of metal concertina door.

It's always important to be alert to possibilities. A pile of builders' rubble outside an office conversion wouldn't automatically appear as a perfect photography location, however, Carla was styled like a rock chick and so I thought the look and attitude would suit the setting. There wasn't too much ambient light around, and so a relatively slow shutter speed of 1/320 sec got rid of even more of it. I wanted a pool of light centered on Carla, so I gridded the flash unit, placed it camera right, and got it as high as possible. I wanted the background to drop out of focus and so chose a wide aperture of f/3.5. A little cross-process toning in Lightroom and I had a very satisfying fashion image.

Nikon D200
85mm lens
ISO 200
f/3.2
1/500 sec

Finally, another example of a shot location that isn't immediately obvious. On a very beautiful street in Cyprus I found an abandoned house. It was slowly falling to bits and appeared to be only visited by vagrants and incontinent dogs. Undeterred, I gathered my students and model around it. I love this shot of the beautiful bride in less-than-perfect surroundings. The sunlight was allowed to flare into the lens as it crept over the roof of the house. The flash was providing the illumination on Vivienne. As for its placement, there are a couple of clues in the image with the reflection in the door and her shadow!

Nighttime in the City

Now it probably hasn't gone unnoticed by this stage that I spend much of my time blending light sources together and quite often getting rid of the natural light altogether. So it is often remarked that my natural inclination would be towards working around a city at night. Well, yes and no. Certainly there are always some interesting light sources to play around with and locations to play in. It's great for shooting fashion, but I'm rather too fond of my sleep to start working night shifts on all my shoots.

However, I have been known to break this rule, and I always get a buzz from the experience. One of my favorite workshops involves taking a group of students out at night and showing them how to light the darkness and get fantastic images in difficult conditions. As always, if you understand the capabilities of your camera and flash combinations you will get some outstanding results.

Nikon D300
150mm lens
ISO 800
f/2.8
1/50 sec

Nikon D300
70mm lens
ISO 800
f/2.8
1/50 sec

This first image is potentially a real test of your skills, but if broken down into component parts it's relatively simple. I was attracted to this location by the small lights that were hung in trees in the distance. I knew that if I could frame the image to include them at f/2.8 they would render as these abstract blobs of light and color. I set my exposure for them so they were the brightest part of my image, and at ISO 800 I was getting 1/125 sec—fast enough to handhold my 70–200mm lens, even in the cold of a winter's night. I took a test shot to make sure the background was thrown out of focus as I wished and then moved my model into place. Rebecca would appear as a black blob in the foreground if I didn't light

her separately, so I introduced my flash to camera left but kept it fairly close to her. I twisted the flash head to portrait orientation and left it on straight TTL. Now my only problem was that I was so far back from Rebecca I couldn't see her properly to focus or to see where the shadows were hitting her. For this reason I carry a small torch. I find it easier than the focus assist lights on the camera. I hold it against the lens, focus, then turn it off and take my picture. I ask the model to hold position, check that the flash isn't casting weird shadows on their face, and correct as required. It took three shots to get the one that I had in mind and I was delighted, as it was the last shot of a long and very tiring day's shooting.

This shot shows how you can make use of the ugly sodium lighting that dominates so much of our night vision and turns the world a dubious shade of orange. It was a freezing cold night with snow in the air and it was testament to Katrina's professionalism that she was working well despite the conditions and it being two in the morning. This walkway ran along the riverside and I had been attracted to it earlier when scouting locations, but by the time we got there it was pitch black. There were no lights around, which worked in our favor, as it gave me more control. I turned the sensitivity of the camera way up to ISO 1600. I knew that I'd have to work hard for the light and wanted the streetlights in the background to come through in the image. My flash was directly over my head, which I used to add light to the foreground. I wanted it to highlight the metal sides of the walkway and Katrina, but not too much. I set the power to -0.3 and at f/4 got an exposure of 1/80 sec. The first shot looked too "flashed," so I added a grid to the flash head and turned it to landscape orientation, which meant that although gridded there would be a more horizontal spill of light. This got the shot, and not a moment too soon as we were both freezing and ready to go home.

Nikon D300
38mm lens
ISO 1600
f/3.8
1/13 sec

4

This image is cheating a little as it wasn't quite nighttime, but it was getting there. And as the sun dropped below the horizon the whole sky lit up as though on fire. The colors were spectacular, but I was aware there was only a minute or so to appreciate and capture it. We raced Tamara-Marie into position by the ornate street lamp. I chose a high shooting position that wasn't ideal for composition but allowed me to get as much as possible of the sunset in the image. My exposure was based around the setting sun, which at ISO 200 gave me f/5 and 1/200 sec. There was no time to finesse the position of the flash unit and so I put it to camera left which is what causes her shadow to stretch unnaturally towards the light source in the image. The flash was set to TTL and we got the image just as the last orange light disappeared from view. The light wasn't actually turned on, but see pages 114–115 later in the book for a little Photoshop cheat that can overcome such minor difficulties.

Nikon D200
38mm lens
ISO 200
f/5.0
1/200 sec

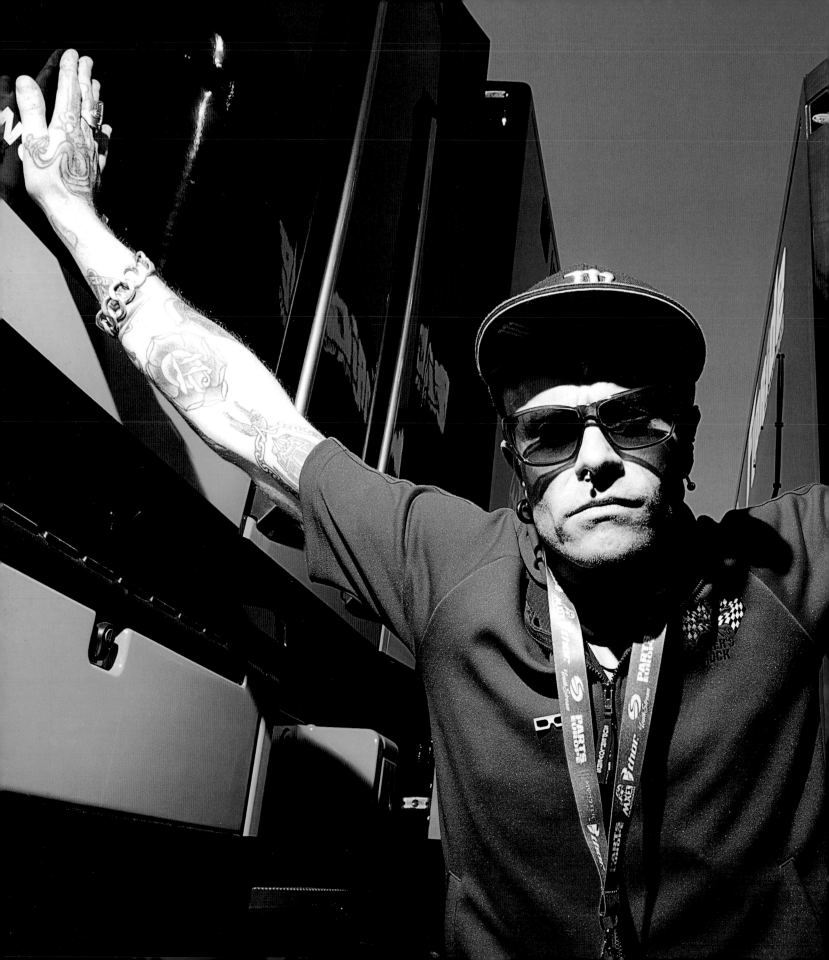

GENRES

From portraits and fashion, to sport and buildings, there are very few photographic subjects that can't benefit from a splash of flash lighting, either to augment the ambient light, or provide the main light itself. Each genre offers different challenges. For example, it may be the speed and portability you need to cover a fast-paced wedding, fast flash duration to freeze action, or lots of power to compete with sunshine on a bright day. In this section we look at how best to use flash to get the best results from a variety of different subjects.

Weddings

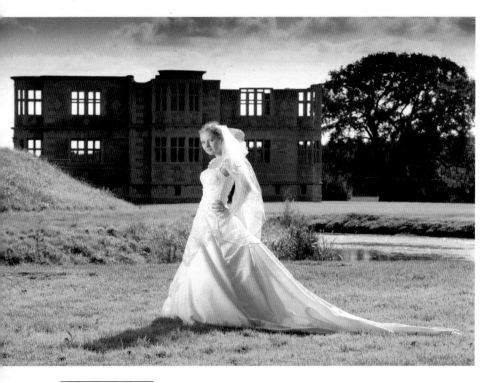

Nikon D3
135mm lens
ISO 200
f/13
1/250 sec

The ruined Elizabethan house and moat of the venue were important features of this bride's wedding, so capturing them was vital. The sunlight came from behind and to the right of the bride, lighting her veil and the back of the dress beautifully. Her face and front was lit by a single but powerful flash shot through a white softbox just out of frame to the left. A 70-200mm telephoto zoom lens at 135mm was chosen to compress the perspective of the scene and make the house look bigger in relation to the bride.

Weddings are often said to be the happiest day of a person's life, but for photographers, they can end up being one of the most stressful. As well as the pressure to deliver every shot that the bride and groom could possibly want, you are performing as a reportage photographer, beauty photographer, still life photographer and "people person" all rolled into one. All this as well as the fact that if you get it wrong, then you are in a whole world of pain, as a wedding is a one-off event.

Wedding photography has changed greatly over the past decade. Years ago, the photographer would often use a medium format film camera and arrive at the church to greet the bride when she got out of the car, then shoot a few photos inside the church. This was then followed by a handful of formal group shots outside, and a final photo of the bride and groom being driven off to the reception.

This traditional type of coverage has largely fallen out of favor, and many brides don't necessarily want photographs that look just like those of their parents.

The advent of digital photography means there are no huge film costs, and camera sensors are amazingly sensitive to low light nowadays, all with the turn of an ISO knob rather than having to change rolls of film. This has revolutionized how wedding photographers work, as well as the results that brides expect.

One popular style of wedding photography is reportage, the purest sort of photography where everything is recorded as naturally as possible. Pure reportage means no interaction between the photographer and wedding party, and shows the day as it truly is. No rose-tinted glasses: just pure documentary—and certainly no flash.

However, the majority of brides today want a combination of reportage—so that the day isn't interrupted constantly—and also all the details of the whole day captured, right from shots of the bride's shoes and veil, to the ceremony, speeches, and dancing. There are often some formal group shots, but mainly the guests are captured informally, interacting with each other rather than looking at the camera.

This coverage usually involves some setup shots of the bride and groom where you try to capture the love, fun and tenderness they have for each other, while making everything look as spontaneous as possible. This is an ideal time to use flash to deliver shots similar to those that brides have typically seen in wedding magazines—especially bridal advertisements which have been beautifully lit and posed by fashion photographers.

The basic rule when shooting a wedding day is to keep it

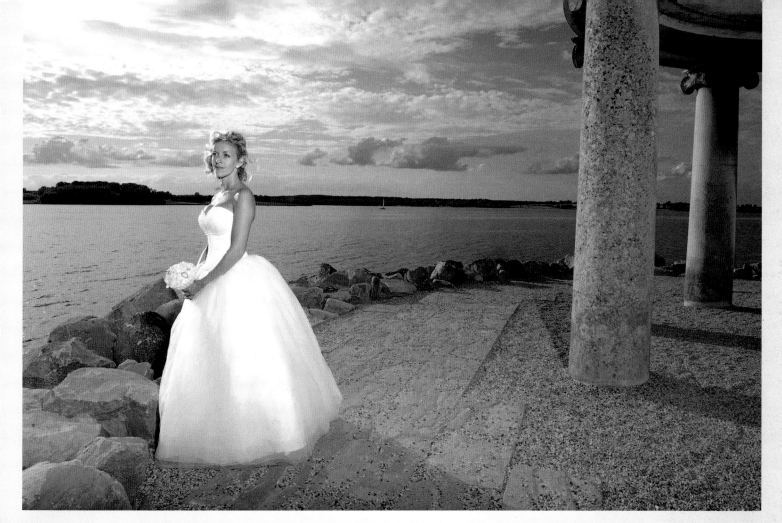

Nikon D3
24mm lens
ISO 200
f/14
1/250 sec

Neo-classical pillars on a man-made jetty overlooking a lake was a beautiful setting for this bridal portrait. The sun provides rim lighting to the bride's face—you can see the direction of the sun from the shadow of the bride on the floor. A bare flash mounted on a lightstand to the right of, and slightly above the camera, prevented the bride's face and dress from falling into shadow.

simple, and don't try to experiment. The most obvious use of flash at a wedding is not when it's raining or dull, but actually when the sun is shining. Many brides want photos taken at their wedding venue to show it off, which means on a sunny day, you can't move them into the shade of buildings, as this would defeat the purpose.

The easiest thing to do is to place them with the sun itself providing some backlighting or rim lighting—in other words, position them so that the camera is pointed toward the sun. This means that the subject isn't squinting into direct sunlight, though it does mean that they could come out in silhouette. It's often best to use your camera on manual exposure, as white dresses, dark suits, and strong backlighting are a camera's exposure nightmare. Use your camera's metering system to guess at the exposure, then take a test picture and check the histogram. If you are

happy with the settings—which should be for a properly exposed background, not subject—then set these manually on the camera.

Now you have to use your flash to put enough light into the subject until they are exposed correctly. One way is to leave your flash on your hotshoe and let the camera's TTL system take care of the exposure, but strong backlighting can easily fool a meter, so you may have to dial in some compensation. Manually setting the power gives more consistent results.

Best of all is to take the flash off the camera and put it on a lightstand off-axis, ideally with the subject facing towards the light at about 45° to the camera.

Nikon D3
24mm lens
ISO 800
f/10
1/60 sec

The cathedral where this bride got married was a key part of the day as it had been her regular place of worship all her life, and she loved the stained glass windows. By placing her in front of them and using a wide-angle lens, it was easy to include her in the scene. To maintain a shutter speed high enough to handhold, as well as to get the girl and the windows sharp, I needed to use a relatively narrow aperture. This meant pushing the ISO to 800. This left the bride as a dark silhouette, so she was lit using an off-camera Nikon SB800 held by an assistant. A Honl honeycomb grid was fitted to direct the light into a beam and avoid the flash filling the whole area in light which would have ruined the atmosphere.

Then simply dial up the exposure manually on the flash unit—or TTL if you're using a more advanced system—until the subject is correctly lit.

If you have a powerful enough flash, you can shoot through an umbrella or softbox to make the light even more flattering. The reality of the situation is that if you're outdoors trying to juggle flash power settings and an umbrella on a lightstand, you'll need an assistant to help you and speed up the process.

This process not only works for portraits of the bride, but can also work well for formal group shots, though you will probably have to move the flash back a little to get even illumination at the cost of power and recycling time for your flash battery. You may wish to consider a more powerful flash or an external battery pack to speed up the recycling, as waiting several seconds between shots can feel like an age, and groups quickly get bored.

Taking a bride outside for some dramatic portraits also works if the wedding venue isn't particularly photogenic. By finding an area where the bride can be predominantly framed against the sky, then manually underexposing so the sky becomes very dark and moody, any unsightly areas in the background are rendered very dark. Then, to provide light for the subject, use an off-camera flash held high to mimic the effect of sunlight. If you're really underexposing the sky, you'll need a lot of flash power, so may not be able to use a softbox or umbrella as these cut available power down.

Alternatively, using a flash indoors can also give lovely results. Off-camera flash fitted with a softbox or umbrella can give a lovely soft quality of light to formal group shots. A shoot-through white umbrella will make the light "bounce around" more, so can be an advantage over a softbox—as long as there aren't any strongly-colored surfaces for the light to reflect off.

But sometimes restricting the light to a dramatic beam can give greater results. Using an off-camera flash fitted with a honeycomb grid to channel the light can create great drama—especially in a dark church in front of stained-glass windows. Using manual exposure on the camera, once again expose for the background—in this case the stained glass windows. Then get an assistant to point the flash unit at the subject who is picked out in a pool of light. Instant good results on days when it may be too sunny or too rainy to venture outside.

Even on-camera flash has its uses at weddings—to reduce contrast by filling light into harsh shadows outside, or to put a bit of sparkle as a catchlight into the eyes of a bride. Just try to avoid using a flash at full power indoors or else the subject will be lit, but the background very dark. To try to keep some semblance of atmosphere, it's best to push up the ISO so the ambient light still registers. Then the flash is less obvious.

Nikon D3
24mm lens
ISO 200
f/13
1/250 sec

A bright sunny day and the couple stealing a quick kiss in the vintage car before being driven off were the ingredients for this fun picture. But the sun, coming from behind the groom's left shoulder, put the couple's face in shadow. An assistant on the other side of the car (out of frame to the left) held a single Nikon SB800 flash unit to reduce the contrast.

Nikon D3
24mm lens
ISO 250
f/9
1/250 sec

A small Nikon SB800 flash unit was fired through a white shoot-through umbrella to provide the main light on the kissing couple on the opposite page. Dialling in a little bit of underexposure on the background made the sky appear darker than it really was.

Fashion

Fashion photography comes in many different guises. Some of it is very commercial, where it is vital to see the clothes well, how they fit, and pick out any interesting details in order to tempt potential buyers.

Some fashion photography is very editorial—typically that in high-fashion magazines—where the images are more about portraying a mood or feeling. Very often, only a small part of the clothing is in shot. This is because the magazine is not as concerned with people actually buying the individual garments, but more with picking out key trends and creating a visually interesting "story" around the new looks for the season.

Both types require different approaches, but mastering the use of flash is vital for a fashion photographer, who could be shooting indoors in a studio, indoors on location, or outdoors at the mercy of the weather.

Of course, the photographer can use natural light and reflectors for a very natural feeling on some shoots—depending on the look the fashion editor is trying to achieve, and whether there is the right sort of light at the location on the given shoot day. Conversely, some shoots seem to use a truckload of lights—typically big-budget productions from the high-end magazines or brands which use some of the world's most famous photographers.

There really is no single way to successfully shoot fashion, but armed with a single flash, some light modifiers and reflectors, you can produce truly professional results. Many professional shoots are shot exactly in this way.

As we've seen in previous chapters, soft light from a large light source such as a softbox or umbrella can be very flattering, as the diffuse quality fills in any imperfections such as wrinkles, making it ideal for portraits, and therefore also for many fashion photos. However, soft light is flattering, but harder light often gives more dramatic results and is far better for picking out textures on fabrics, which is something you may want to do in a fashion photograph. Also, if you're working with professional models who tend to have more angular bone structures, as well as stylists and hair and makeup artists, and your work is being properly retouched afterwards (as is the case for all fashion photographs) there is much less of a need to produce softly lit, highly flattering portraits. So harder light is often used to pick out details of clothes and give more dramatic results. Not every bit of shadow area needs filling in, as shadows give depth and three-dimensionality to photographs.

Nikon D3X
70mm lens
ISO 100
f/8.0
1/200 sec

Shot in exactly the same place as the shot on the next page with the same light but on a different day, this shot has a different feel for a different reason. By moving the model away from the background, the shadows are out of frame. But they do highlight the ruffles on the side of the dress—one of its key features.

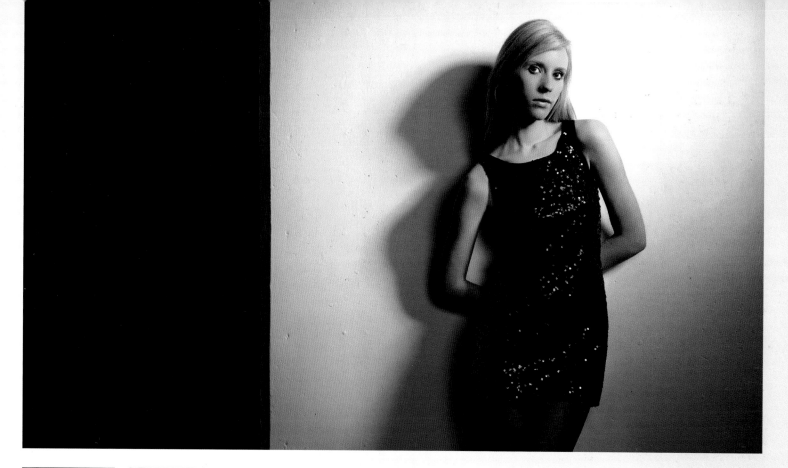

Canon EOS 5D Mark II
40mm lens
ISO 100
f/5.6
1/160 sec

A flash fitted with a beauty dish was high up and to the right of camera, at about 45° to the model for this shot. Our model was carefully positioned to show the length of the dress, as well as its shiny sequins catching the light. A reflector behind the camera position, which reflects back some of the light that has bounced off the background wall, reduces the contrast on the subject.

If you're shooting fashion outdoors, the one big factor affecting your lighting is the ambient light. Is it bright and sunny? Where is the direction of the light coming from? Is it flattering and diffuse on a cloudy day? If it's bright and sunny, can you change the time of day of the shoot so the sun is lower? Or perhaps can you move your subject into the shade of a building.

You should also be considering the location of the shoot, the poses, and the sort of style you're trying to achieve, which is often led by the client. Or if you're shooting for yourself, consider what sort of look you're trying to achieve. Are you shooting floaty summer dresses outdoors in the late-afternoon sunshine, bikinis by the pool, or evening dresses in the foyer of a hotel? Or is it street fashion with grungy models with tattoos, or men's business suits? Only by taking into consideration the desired result, the location, and the ambient lighting can you work out how you should use your flash.

If you're working in a studio or studio-type environment, then there will be very little ambient light, so your single flash will be the main light source, which means it's important to get it off camera and made softer by using a light modifier like a softbox. However, by also using reflectors—either purpose-made commercially bought ones or even just bits of white cardboard, tinfoil, or a nearby wall—you can produce some good results.

In our shot of the model in the tight red dress we only used one flash unit and no reflectors to get the desired effect. The flash was positioned on a lightstand to the left of the camera, and a small beauty dish was used to make the light a little softer. By turning our model's face towards the light source, the light on her face was a traditional short lighting pattern, which is flattering. But it does produce some reasonably harsh shadows, which could be filled in with a reflector. However, this harder light falling across her body highlights one of the key details of the dress—the ruffles that go all the way along it.

Using only one light, you have to be careful where the model's shadow goes. If she were too close to the background, the shadow would be visible, which may be distracting. If she moves too far away from the background, the flash—which is the only light source in the photo— would have been much less intense, so the wall would have gone a muddy grey. Shooting fashion lets you experiment by moving the lights around and trying a variety of poses and light positions.

By doing just that, we managed to get a very different shot of a different model in the same location using the same light, this time wearing a short, sparkly black dress. The main light is still high and off at around 45°, but this time the model is leaning on the wall itself. This makes a feature of the shadow on the wall, as well as highlighting the sparkly sequins on the dress and the fact that it's very short. As we have moved further back, you can see the dark area of the rest of the studio to the left of the shot. Compositionally this echoes the black of the dress and helps the shot obey the rule-of-thirds.

When using flash outdoors you have the added benefit of the ambient light to help you, rather than just using a single light source. For our picture of our blonde model in a short, pink summer dress, we took her outside to a meadow on a bright, sunny day. The exposure was to manually underexpose the sky, making it darker, to offset the bright shiny pink of the garment. A single flash, still using the same small beauty dish, was high up and to the right of the camera to provide the main light on the dress. The relatively hard light source not only gave its own specular highlights, showing off the sheen of the fabric, but is actually more like the hard light you would expect outdoors on a sunny day.

Matching the light output from the flash to the ambient conditions was also in effect on the overcast day when we shot our model in the red dress. Leaning against the pillars of a grand house that had fallen into disrepair, the unkempt bushes, the model's wistful gaze, and her lack of shoes gives the feeling of faded grandeur slowly returning to nature.

The flat ambient light was augmented by a flash firing through a large umbrella just out of frame to the right. This put a soft, diffuse glow on the model, and also picked out some of the leaves on the bush to her left so they don't disappear into the darkness of the bushes further away in the background.

Nikon D3
125mm lens
ISO 200
f/14
1/250 sec

This shot was all about creating a mood with the clothes, lack of shoes, gaze, and location all adding to the wistful feeling. The overcast light was augmented by light from a flash fired through a large umbrella to make it softer, more diffuse, and less obvious.

Nikon D3X
38mm lens
ISO 100
f/18
1/250 sec

A low angle and a reasonably wide-angle lens is not normally very flattering as it can make legs look wide, but with a very slim fashion model you can get away with a lot more. The hard light from the flash echoes what the light from the sun would look like—bright and relatively harsh.

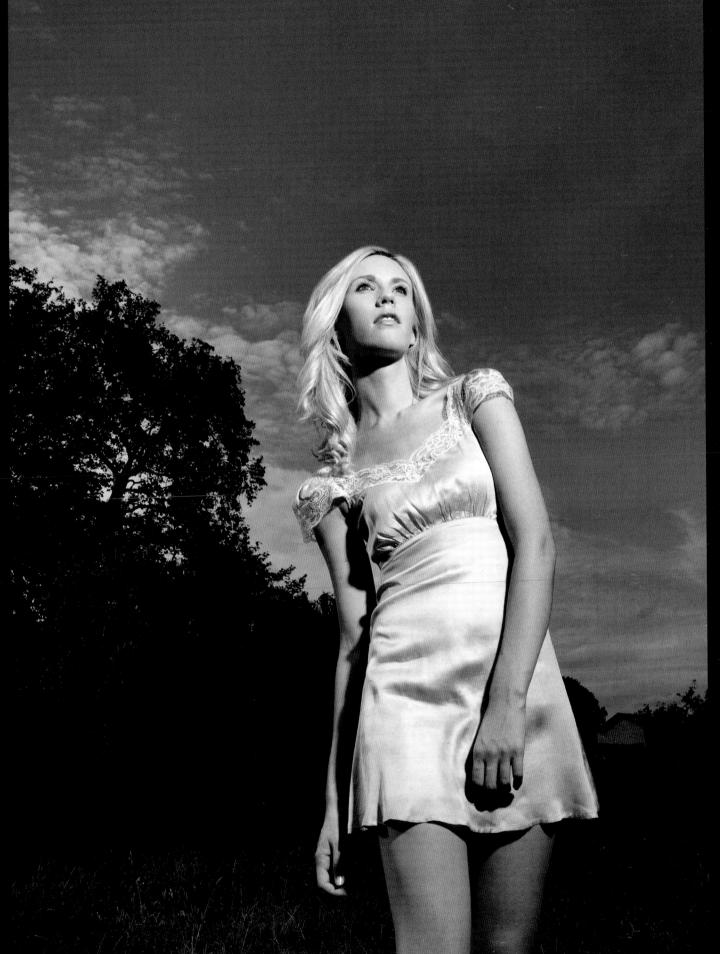

5

Lifestyle

Lifestyle photography can be similar to some sorts of fashion photography, except it is mainly shot on location rather than in a studio—unless the studio has a properly built set. Instead of the clothes being the stars, as in fashion photography, you're trying to sell a vision of the lifestyle a person is leading or an experience they're having.

It is usually an idealized situation and is often posed by models, with every detail of the clothing, hair, and makeup all worked out to fit in with the location. And the best lifestyle pictures also go some way into portraying an emotion. Like a businessman jumping for joy after clinching a life-changing deal, a pretty girl cycling along a beachside cycleway, or a retired couple driving into the sunset in their vintage convertible car.

In lifestyle photos the environment and the props are just as important as the subject, as they all have to work together to portray a particular lifestyle or moment in time. They are often idealistic, selling a dream of a better or different life. For that reason, the lighting is crucially important. Hard summer sun or harsh light from an on-camera flash just doesn't cut the mustard as it looks too false and unflattering.

The majority of lifestyle shots have carefully positioned lights that try to emulate natural light—only a nicer, more flattering version of it. For that reason, large softboxes or umbrellas are often used to modify the light from flash units. And these light sources are often as close to the subject as possible, to create as soft an effect as possible.

Unlike some of the earlier shots where we've underexposed the background to make it disappear or the sky look more dramatic, many lifestyle shots have a much lighter feel.

An easy way to do this is to place your subject in some shade, but try to angle your camera so that the background is more brightly lit. This provides a lovely, soft, high-key background that's just a bit more "dreamy" than reality.

If you make the background the "correct" exposure, then it will look perfectly normal, your subject will be in shadow, and the effect will be lost. Alternatively, if you alter your exposure so the subject is correctly exposed, the background will be so overexposed that it will go far too light. The key is to set the exposure so the background goes just light enough, but does not lose all detail. Then, using your flash with an umbrella or softbox, carefully light your subject with soft light so it looks more natural. You're really balancing the flash with the ambient light to make a natural-looking photograph.

Nikon D3
130mm lens
ISO 200
f/2.8
1/250 sec

When shooting under trees, you have to be careful not to let the light on your model be too green. In this case, a flash was fired through an umbrella directly over the model's head. This replaced the natural greenish light with more neutral, softer, and brighter light to give a more airy feeling.

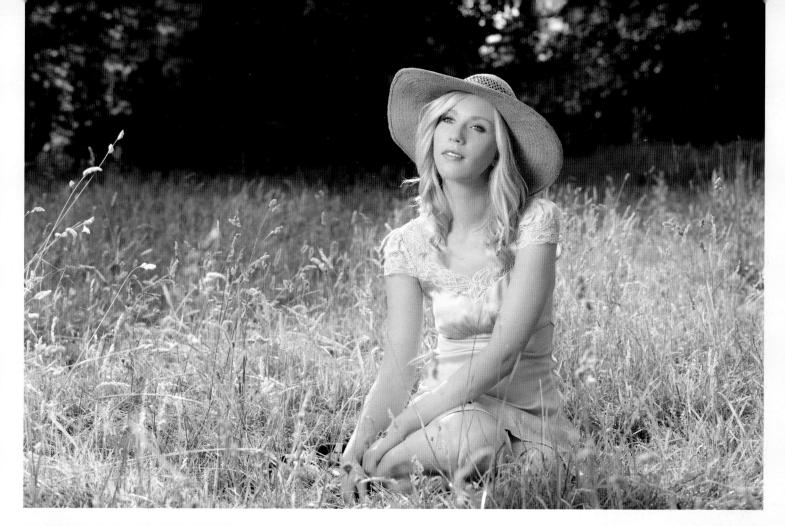

Nikon D3X
85mm lens
ISO 100
f/6.3
1/250 sec

A light pink dress, a pretty girl in a straw hat, and a summer meadow—ideal for a lifestyle shoot. The harsh overhead sun was made more flattering by lighting the model's face and body with a large softbox.

In our shot of the girl in the hammock, the location was chosen to look like a great place to spend a lazy summer day, so the light on the background—dappled light streaming through the trees—was allowed to be overexposed.

A flash fired through a white umbrella held directly over the model provided the fill light to her face—and took away the green cast of the light there which had come through the leaves of the tree. The result is a light, airy photo that sells a feeling of a lazy summer day in the shade in a hammock.

The second shot of the girl in the meadow used a similar technique, except this time the sun was behind the model. This meant her face and body was in the shade, thanks to the brim of her hat and the position of the sun. A flash fitted with a large softbox was just out of frame to the left of the camera, and fills in the shadows with soft light.

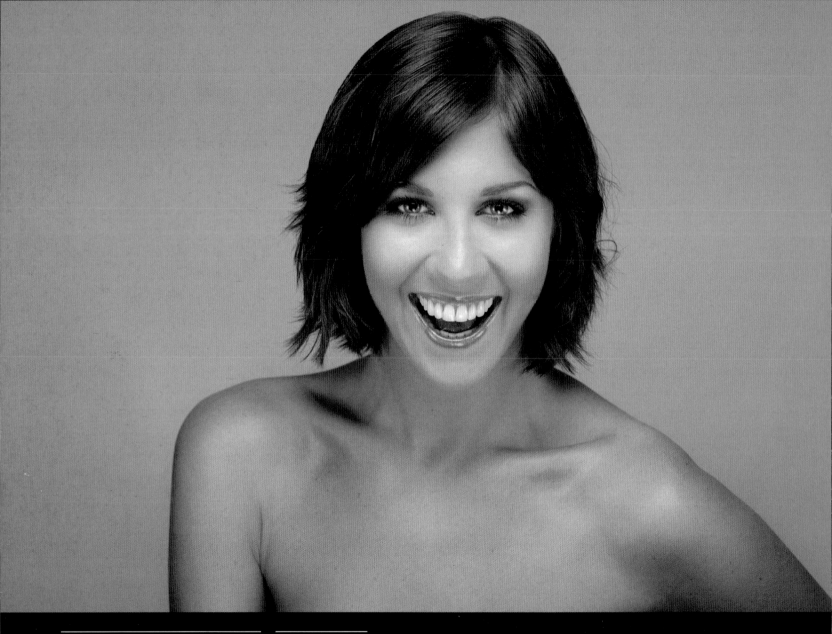

A classic beauty setup using just one flash in a softbox with a tri-sided reflector underneath. The background is a white wall, but it renders as a pleasing mid-gray as the model has been moved around eight feet away from the wall and the light source is only around two feet from her face. It's the inverse square law at work. Note the lovely highlights on the girl's lipstick that the Triflector setup has produced.

Nikon D3X
85mm lens
ISO 100
f/6.3
1/200 sec

Beauty

Beauty lighting is used to sell everything from skin care to makeup, lipstick, cosmetic treatments, and even perfumes. It's lovely, flattering lighting that works just as well for regular portraits. It's often a very technical sort of lighting where multi-point lighting setups highlight small areas of, for example, the hair or the lips. But it doesn't have to be like that, and armed with a single small flash and some lighting modifiers you can easily replicate what the professionals spend thousands on in terms of kit.

Virtually all beauty lighting setups involve a main light directly over the model's face, angled downwards so that the main shadows go downwards. When we see light like that, our brains automatically think everything is normal—unlike horror lighting where light from below is used to make the viewer feel uneasy.

Lighting where the main light is above the subject is sometimes called butterfly lighting, as the shadow under the nose is said to look like the shape of a butterfly. The harder and smaller the light source, the more pronounced the effect. Top professionals usually use a large beauty dish for this lighting, although a medium-size softbox gives a similar look for a lot less money.

This sort of lighting gives a lovely sheen to the hair, and lights the skin very well—although it can show up imperfections. That's why real beauty photographers use top makeup artists and retouchers. However, with just one overhead light there can be shadows in the eye sockets, under the nose, and under the chin, so these shadows need some light refilling to reduce the contrast.

Some professionals use a second light source underneath the camera position, set to be less bright than the main light. But an easier and cheaper way is to use a reflector to bounce back some of the light from above. The strength of this fill light can be altered by moving the reflector up or down, or by changing its size or surface finish. White reflectors give a softer effect, silver a much crisper look. You can also use a three-sided adjustable reflector which uses one panel under the chin, then one on each side of the face to curve up slightly.

The only issues with lighting like this—which is often called "clamshell" lighting—is that there are several distinct catchlights in the eyes. Some people don't like this, so they have to be retouched out. As this lighting is predominantly a studio technique, using only one light means that the sole light source also has to light the background—making a pure white background virtually impossible to achieve. If your model is in front of a white wall, you can affect the tone by moving the subject and the lighting rig closer or further away from the wall. Moving it closer makes the wall go lighter, and further away, darker.

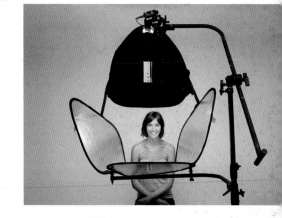

Here's the setup used to take the main picture. A Nikon SB800, triggered by a Pocket Wizard, shot through a Lastolite Ezybox softbox. A Lastolite Triflector with a silver surface bounces the light back in to fill the shadows. The frame is a special bit of kit to hold both a reflector and softbox in this exact position.

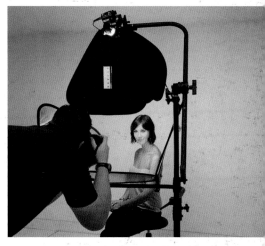

The photographer shoots through the gap between the top light and the bottom reflectors. This is why it's called clamshell lighting.

Kids

Using flash to shoot kids brings the same challenges as shooting any sort of environmental portraiture, but with one added issue—children are harder to control than adults, and have much shorter attention spans. To most kids, being photographed is a chore that keeps them from having fun.

It's no wonder that many photographers just use natural light and let the kids run around and play, often using shallow depth of field and telephoto zoom lenses to crop into the action and isolate their subject from the background. But with one flash and a bit of planning, you can get some truly wonderful photos that families will treasure for years.

If you leave your flash on your camera's hotshoe—or use the built-in flash if your camera has one—then you can get some pleasing results as the flash can be set to automatically balance with the ambient light and produce a balanced result. But it's often not very special. Far better is to take your flash off camera and modify its output into something a bit softer, like using an umbrella or softbox. A softbox requires more direction and therefore a bit more precise in its setup, which is not ideal for kids who move around a lot. But it will give even more stylish results if used well.

One option is to show the kids where you want them to stand, and move the light source a good few feet away. This makes the light more even, and means the kids can move around a bit without hugely affecting the exposure. It's the inverse square law at work.

However, the further away the light is the harder it becomes, and the more it affects anything else in the picture, like the foreground or background. And if it's further away you'll either have to increase the power—and suffer slow recycling times—or remove the modifier and use it bare.

For more stylish results, use a softbox and get it in as close as you dare. It's best to set your camera exposure manually—often underexposing the background by up to a couple of stops to darken the sky and any other distracting background elements. Then either set your flash manually or control it using a sophisticated TTL system to get the exposure correct on the subjects.

It's best to use an adult as a stand-in model to get the lights set up, then when you're ready, get the kids in position and start shooting. This way, they shouldn't get bored too easily and you're more likely to coax a reaction or expression from them.

A single, large softbox as close to the subjects as possible provided the soft lighting for these portraits of a young boy and his pregnant mother. By using a room with a plain wall and the drapes closed, all the light was provided by the softbox and the flash at full power. As the room was predominantly white, lots of light bounced around the walls and ceiling to provide some natural fill light.

Nikon D3X
50mm lens
ISO 100
f/11
1/200 sec

Group shots

Using a single flash unit to light group shots brings a new challenge—that of power and evenness of coverage of the flash's output.

Simply put, to light a group photo the flash needs to be far enough away so that it lights each member of the group as evenly as possible. If the flash was just out of frame to one side of the group, for example, then the person nearest the flash would be too bright, and the person furthest away would be too dark. By moving the flash further away, its coverage becomes more even. Most group shots done with just one flash don't have the flash too far away from the main axis of the camera for this reason.

However, if the flash is right next to the camera axis or just above it—like on-camera flash—then the light from the flash unit is simply providing a flat, frontal light. This may be fine if you're outdoors and it's acting as a fill light, but if it's the sole light and you're shooting indoors, it gives a very flat result.

The best solution is to get the light higher than the camera, so there are some shadows under the chins and noses of your subjects. But it's a game of trial and error. Move the light too high, and the eye sockets fall into complete shadow. Too low, and you lose the three-dimensionality that off-camera flash brings.

The second issue about moving the flash away is that it has to put out more power to light the scene. This affects the recycle time—which can be an issue if you have to try to keep the interest of a group of people while your flash takes a few seconds to recycle after every shot. Or it may mean your flash isn't powerful enough—especially if you are trying to modify the light by using a softbox or umbrella. If you're indoors, it's not normally too much of a problem. But in an outdoor setting where it's very bright, it can be quite an issue. You may have to use the flash unit bare, or look for some shade.

You will also need to check your camera's LCD quite often to ensure the shadow of one person's head doesn't go across the face of another. If this is happening, then maybe rearrange the group slightly. It's trial and error, as you can't see the effect until you trip the shutter and look at the photo on the screen.

Nikon D3
28mm lens
ISO 200
f/13
1/250 sec

When you're outdoors on a sunny day, a flash unit has to work hard to provide enough power to light up the shadows. In this shot, a Nikon SB800 was used at full power to light up the faces of the bridal party who were turned with their backs towards the sun to avoid them squinting. The sun also provides a lovely natural rim light.

Nikon D3S
27mm lens
ISO 200
f/18
1/200 sec

For this group shot of a motocross racing team, the main light was a single flash unit above the camera on a lightstand fitted with a shoot-through white umbrella. The light had to be far enough back to light not only the front member of the group but also the rider at the back. That's why the light is not as soft as you'd expect from an umbrella. A Photoshop plug-in from Nik called Bleach Bypass was used in post processing to get the contrasty effect.

Environmental Portraiture

Location, location, location! That's the key to getting a successful environmental portrait, where you use the surroundings and props to give visual clues to what a person is like, or what they do.

More often than not, this means you'll be in a real location and will have to use the ambient light to provide the lighting for the majority of the scene—usually the background.

The key is to make the background a key part of the shot, but not so dominant that it takes the focus away from the subject. This is a portrait, after all.

Nikon D3X
29mm lens
ISO 100
f/14
1/200 sec

Bright sunshine is often best used as a backlight or rim light, as it has been in this photo. The over-the-shoulder glance, location, and clothes were all to suggest a menacing side to the subject of the photo. The main light on his face was an off-camera flash out of frame to the left of the camera position.

One way of doing this is by using a lens with shallow depth of field to make the background and foreground slightly soft, but leaving the subject sharp.

If you're using flash, there is an alternative. By playing with the exposure settings on the camera either manually or by using exposure compensation, you usually underexpose the ambient light to make the background slightly less dominant. Then you use your flash to correctly expose the main subject of the picture—the person in it.

If you're using high-speed sync, you can actually combine both of these techniques at once, although this can be problematic if it's a bright day as the power of a high-speed flash is far less than a flash at normal sync speeds.

Our shot of the man in the suit was a magazine commission to shoot a portrait of a former athlete-turned-TV-commentator. He'd always been squeaky-clean, but the magazine wanted him to show a different side of the man—out of his corporate logo-covered polo shirt and a bit more moody, gritty, and potentially a bit underworld. So he was shot outside a factory unit, with a Jaguar car—often the transport of a British gangster!—subtly in the background.

The sun gave harsh backlighting, leaving the subject's face in shadow. So a single bare flash unit used on full power, out of frame to the left of the camera, was used to light his face. If you look carefully, you can see there are two distinct shadows on the ground. The main one left by the sun, and the second from our flash. A Nik Bleach Bypass Photoshop plug-in was used to achieve the more contrasty effect.

The second shot of a motorcyclist in front of the famous Menai Bridge in Wales uses a similar technique. The motorcycles in the background, the bridge that leads from mainland Wales into Anglesey, the beard on the rider and the leather jacket all tell a story. This was a man on a marathon round-Britain motorcycle ride and the strain was starting to show. Bright sunshine, similar to the first picture, meant a bare flash was used to get enough power to light the rider effectively.

The final shot of a WWII soldier made use of natural rim lighting from the sun, while off-camera flash picked out detail on the ammunition slung round his neck.

Nikon D3X
14mm lens
ISO 100
f/18
1/250 sec

Hard light from a bare flash is not usually the most flattering sort of light, but when you're photographing a bearded biker then that isn't a huge problem. And the hard light produces really nice highlights on the jacket, showing that's it's a leather jacket rather than just a black canvas type. All clues telling the viewer about what's going on in the picture.

Nikon D1X
30mm lens
ISO 100
f/10
1/160 sec

An off-camera flash shot through a softbox to the right of the camera provided the relatively soft light on this actor playing the part of a WWII soldier, while the rim lighting was the sun itself streaming through the forest.

Nikon D3
130mm lens
ISO 200
f/6.3
1/250 sec

Using off-camera flash to capture the action means setting up the flash and pointing it at where you expect the subject to be. In this case, a small jump was an obvious place where the rider would be in mid-air. The rider was also partly in shadow, so image ghosting was less of an issue as the flash freezes the action.

Canon EOS 5D Mark II
40mm lens
ISO 100
f/16
1/200 sec

Shooting at the camera's maximum sync speed—in this case the 1/200s of a Canon EOS 5D Mark II—at f/16 means the background and ambient light on this model was underexposed. A splash of flash from the right of the camera through a Lastolite Ezybox provides the lovely soft light on the girl's face, and goes some way to freezing her hair blowing in the wind. The blur of the hair is due to the ambient light registering, which gives a great impression of movement.

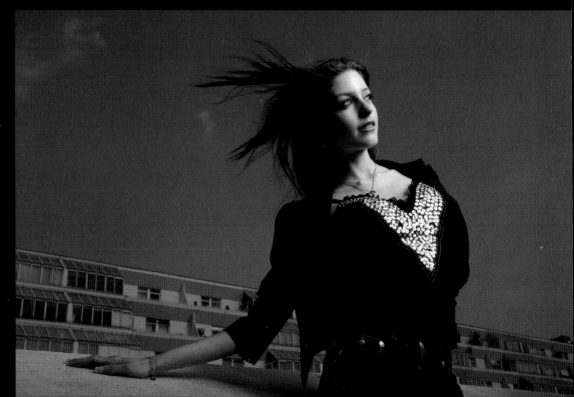

Action

One of the huge benefits of using flash is that it's just so fast! Although the camera's shutter may be open for, say, 1/250 sec, the flash itself is much quicker than that. Sometimes around 1/8000 sec. That makes it ideal for freezing action.

If you're in a dark environment with virtually no ambient light, then a tiny blip of flash at 1/8000 sec is enough to freeze almost anything, including a droplet of water.

But for most people, using flash to freeze action is about using it where there is a significant amount of ambient light—either indoors in a well-lit sports arena, or outdoors in the great wide open.

In these cases, once again there is a delicate balancing act between recording the ambient light to show the environment, and using the flash to freeze the subject.

Using dedicated flash units, most cameras sync conventionally up to around 1/250 sec. At this sort of speed, the flash will go some way to freezing a fast-moving object, but there will still be some blur present. Occasionally this looks like a bit of ghosting around the image, and can be a pleasing way of showing some movement.

Our shot of the mountain biker in a forest was shot just like this. The camera was set to its maximum sync speed of 1/250 sec and the camera set to shutter priority so it would work out the correct exposure. This turned out to be f/6.3 at ISO 200. The flash, a Nikon SB800, was set on a lightstand out of frame to the left of the camera, pointed at the position where the biker would be in mid-air over this little jump. As soon as the rider took off, I hit the shutter and let the flash freeze the action. The shot has the rider perfectly frozen and his face well lit, but there is still some movement in the wheels to show he is actually moving.

Sometimes, being limited to 1/250 sec can be a bit of a problem as it's just not fast enough to properly freeze the action. That's where high-speed sync can come in.

Sometimes called HSS or Auto FP, this uses the flash to pulse many times as the shutter opens and allows you to set high shutter speeds. You can't see the flash pulsing, but it does. However, this robs the flash of lots of its power, so can be of limited use if it's a bright day or the flash has to be some distance from the subject.

In our shot of the flying motocross rider below, it's quite a dull day and the camera is positioned very close to the rider. In fact, a 24mm wide-angle lens was used to give you an idea how close he was.

In situations like this, HSS can work well. The flash was on a stand to the left of the camera, and the shutter speed was only set to 1/640th. The flash had just enough power to freeze the biker without any ghosting, yet to still have some movement in the tires.

Nikon D3
24mm lens
ISO 200
f/9.0
1/640 sec

A small jump was set up and this rider flew almost over the head of the photographer. He almost fills the frame of the camera's 24mm wide angle lens. As he's so close, the flash can also be close by, and also the day wasn't too bright, which means it's perfect for high speed sync to work.

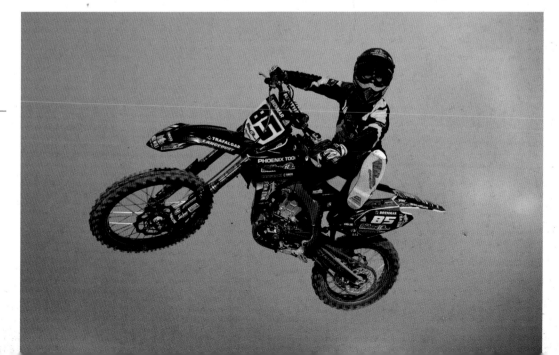

Slow Sync

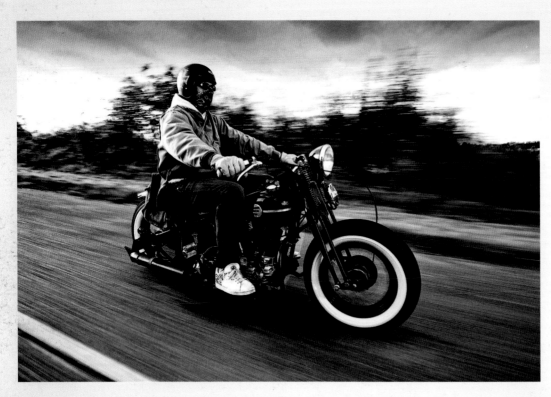

Nikon D3
19mm lens
ISO 200
ƒ/8.0
1/25 sec

A slow shutter speed of 1/25 sec gives a great impression of speed in this shot, and a small burst of flash helps keep the biker pin sharp. Taken from a moving vehicle alongside, the flash was held in front of the bike on a boom arm. And yes, it was on a private road without any traffic!

While flash is great at totally freezing action, it can work even more effectively when combined with a slow shutter speed.

That way, the slow shutter speed can give loads of blur to really give the impression of something moving fast, and a burst of flash can be used to lift the ambient light and freeze the important part of the photo—the subject.

Most cameras can be set so that the flash can either go off at the start of a long exposure—called first curtain sync. Or at the end of a long exposure which is called second curtain sync. The main difference is that with second curtain sync, the blur tends to be behind the subject rather than in front of it. Therefore, it looks more natural and real. First curtain sync can often give the effect that the object is actually travelling backwards.

The shot of the motorcyclist uses off-camera flash to freeze the bike while keeping the background blurred. The shot is called a tracking shot, as it was taken from the side of a vehicle moving along the closed road at the same speed as the bike. The photographer was harnessed in, shooting out of the side of a moving truck at around 20 mph. The shutter speed of 1/25 sec gave plenty of blur to the road and roadside hedges, with the bike relatively sharp. But to really get the bike sharp and give a little light to the rider's face, a burst of flash was used.

If the flash had been on top of the camera, it would have frozen the spokes of the wheels which would have looked odd. So instead of this, a bare Nikon SB800 flash was mounted to the end of a monopod and an assistant in the front of the truck held it out in front of the biker. This way, the light hit the front of the bike and not the side of the wheels.

The photo was then processed using Nik Bleach Bypass Photoshop plug-in for extra contrast, and the sky also darkened using the gradient tool.

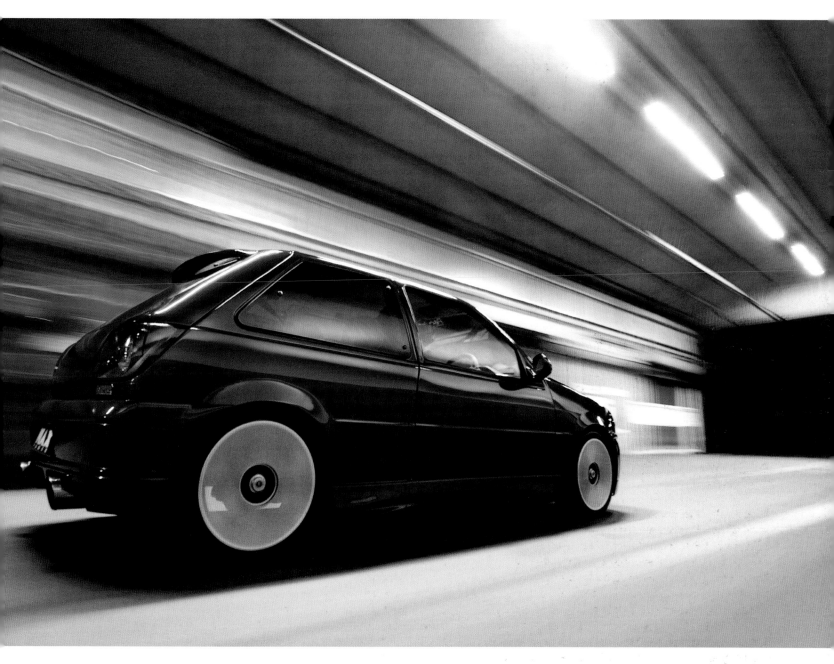

In the shot of the car, a small flash is used inside the car to add a little bit of light to the steering wheel. The car had a huge boom arm attached to it, with the camera mounted on the end so that the camera moved at the same speed as the car.

To avoid vibration, the car was moved very slowly, and the rig digitally removed in post processing. At the end of the eight second exposure, the flash inside the cabin went off to put a little bit of light on the steering wheel. It's subtle, but sometimes the best use of flash is not to be too obvious.

Nikon D3
20mm lens
ISO 200
f/8.0
8 sec

Just because you're using flash doesn't mean it has to illuminate the whole of the subject. Carefully used, it can illuminate small parts of it. In this shot, a strobe is hidden inside the car just to put a bit of light on the steering wheel and inside of the cabin. The rest of the light on the car is from the lights in the tunnel.

Nikon D3X
24mm lens
ISO 100
f/8.0
1/250 sec

With so much light bouncing around, you'd think the salt flats of Utah would be the last place you'd need to use flash! But a burst of flash from just outside the frame to the right of the bike gave an extra "lift" to the chrome of the frame and the wheels, and put a rim of light on the front tire.

Nikon D3X
25mm lens
ISO 100
f/8.0
1/200 sec

A bright day meant the landscape and bike was reasonably well lit, but shadows made the engine of the Yamaha V-Max motorcycle hard to see. A single flash, fired from the right of the camera and focused in on the bike itself, gave detail to the engine and put pleasing highlights on the saddle.

Vehicles

Lighting a whole car may be tricky using a single small flash, but that doesn't mean a strobe is of no use when photographing vehicles.

When used as a fill light to fill in the shadows of a car that is backlit by the sun, a small strobe can be an ideal tool. You just have to watch out for reflections in the bodywork, as cars are notorious for showing up the reflection of the light source on lots of different panels. Far more suited to using a single strobe is to use it to light parts of a vehicle, or motorcycles, as there are far less obvious places for reflections to catch you out.

When placing a flash to light a reflective subject, you always have to be aware of reflections, so you have to be careful where you put the light. And regularly check the camera's LCD screen to see if there are any nasty reflections of the light in it. If there are any, they may look good, or distracting. It's down to personal taste and on a shot-by-shot basis.

The photo of the black bike with the rock uses just one flash, on a lightstand just out of shot to the right of the camera. It was a bright day with the sun overhead, so the detail of the bike's engine and seat were lost in darkness. To combat this, a bare Nikon SB800 flash set to underexpose by a stop using exposure compensation pushed some light into the engine and saddle of the bike, and didn't give too unnatural an effect.

A single off-camera flash was also used to shoot the bike on the white sands of Bonneville. It's pretty easy to take good pictures on the salt flats despite the bright overhead sun, because the white salt reflects the light back up for you. It's like an automatic reflector. However, a slash of flash has improved the picture by putting a little line of light on the outside edge of the front tire and making the frame rails and the chrome front wheel really glisten.

Bonneville in summer is so bright that the flash had to be just out of shot and on full power to make a difference. As it's so bright, a polarizing filter was also used to make the colors even more saturated.

Nikon D3X	*A black-and-chrome car interior shot at*
56mm lens	*dusk is a big challenge for any photographer.*
ISO 100	*Using a bare strobe shooting in through*
f/11	*the passenger door showed the texture of*
1/200 sec	*the leather, chrome of the dashboard, and*
	aluminum of the gear lever.

Lack of light and lack of space to move was the big issue in shooting the interior of a restored Jensen Interceptor car at dusk. With the car doors open, I framed the steering wheel and chrome dash, and used a single flash on a lightstand outside the passenger door. Of course this caused reflections on the chrome, but it does show the material off, and also produces nice specular highlights on the leather of the steering wheel, highlighting its texture too.

Interiors

The fashion for shooting building interiors is to try to retain the atmosphere of the room, using a mixture of any artificial lights in the room and the natural light that floods in.

Taking successful interior shots means carefully choosing the right time of day and right sort of weather so that the ambient light from outside neither overpowers the interior light—like on a bright sunny day. Or fails to register at all—like at night.

The size of the windows, whether the room is north or south facing, the time of year, the intensity and type of artificial lights inside—all of these variables have a huge effect on the finished photograph.

More often than not, the biggest problem is the contrast between the outside and the inside. If the inside is correctly exposed, the outside is often totally bleached out. One alternative is to frame your photograph so that there are no exterior windows showing. But this limits the angles you can shoot at, and including windows to the outside world gives the picture some breathing space and context.

Professional interior photographers can spend hours waiting for the right light, and carefully putting color correction gels on any strongly colored artificial lights, such as green-tinged fluorescent tubes. They also frequently combine exposures in Photoshop, merging several different exposures.

It can be very technical, but you can get decent results using just one flash. The key is to subtly use the flash to lift the overall light levels inside the room so that the contrast to outside isn't so great.

For the shot of the restaurant, arranging the shoot at a different time was not possible as it was open every day from breakfast through to dinner. The shot had to be done at a certain time on a set day.

The light outside was very bright, but by pulling the canopy down outside the restaurant, which you can just see in the picture, it cut down the contrast a bit. The exposure was carefully managed so that the outside windows were overexposed—which masked the traffic outside. Then a single flash was aimed into the ceiling of the room from behind the camera position. As the ceiling was white, this provided a natural-looking fill light.

A similar technique was used in the hotel bedroom. To reduce the contrast to outdoors, the blind was pulled down over the window, then the exposure set to retain some shadow detail on the bed, while overexposing the window area. A flash was bounced into the far right hand corner of the ceiling to lighten up the bed area slightly without killing the atmosphere in the room.

The shot of the kitchen used a flash shot through an umbrella to raise the light levels in the room. This meant the strongly colored artificial lights didn't overpower the overall scene.

A bright, airy restaurant with light-colored walls had to be shot at a given time of day, meaning exposure was tricky. A bare flash was fired high into the ceiling so that the light bounced down and looked as natural as possible.

Phase One P 40+
28mm lens
ISO 100
f/11
1.0 sec

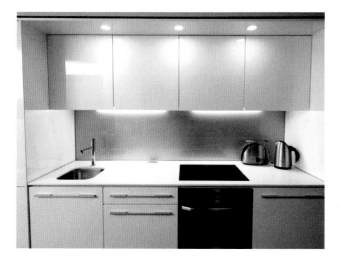

Phase One 645DF
28mm lens
ISO 100
f/11
1/20 sec

Phase One 645DF
28mm lens
ISO 100
f/18
0.6 sec

Shooting interiors is often a delicate balance between capturing the ambient light and the artificial light. This shot, done with the camera firmly on a tripod, was predominantly lit by the mix of natural light and electric light fittings in the kitchen. But a flash was fired through a white umbrella to raise the overall light of the scene.

Green walls and drapes, aubergine colored bed cover, and a brown carpet were meant to give this hotel bedroom a dark, moody feel. So flooding it with light would have killed the effect. A small flash fired into the right-hand corner of the ceiling reduced the contrast but retained the mood.

Food

Food photography can be a very technical subject, with specialist photographers having studios built to include kitchens in them so the dishes can be shot within seconds of being cooked.

They carefully control the lighting via an armory of studio lights, and even have special tricks like using varnish to make certain foods glisten. Or using mashed potato instead of ice cream so it doesn't melt so fast. It's an art and a science that can take years to master and to pick up all the tricks.

But in recent times there has been a shift away from food photography like that to a much more natural look with real, just-cooked food. Using natural light, reflectors, and a lens with a wide aperture for a shallow depth of field can work wonders in making great food look even better.

However, if the light is poor, you have a restricted location, or you just want to get everything sharp, a single flash can be an ideal tool. Most of the time, a flash using a big softbox to replicate window light coming from slightly behind the subject is a sure-fire winner—especially if it's used to enhance the ambient light.

If there's too much contrast, a reflector can help push some of the flash light back into the subject. And one of the key benefits of using a softbox is that any shiny parts of the food—like a sauce—will show a reflection of the light source. When shooting a car this can be a problem, but in food it can look positively delicious!

Locking down your camera on a sturdy tripod, then carefully checking focus and composition are key issues to making your food shots great. As is working quickly, as food loses its just-cooked appeal very quickly.

One of the benefits of using small, dedicated flash units so close is that you can use high-speed sync to choose the aperture and shutter speed you require while controlling the affect of the ambient exposure. You aren't limited to shooting at the maximum sync speed, as you would be with studio flash.

Nikon D3X
105mm lens
ISO 100
f/20
1/125 sec

Detail shots like this are often as important as photos showing the whole dish. A careful choice of camera position and placing of the softbox makes the dessert stand out against the background. And again the softbox is reflected in the chocolate sauce on top, making it glisten.

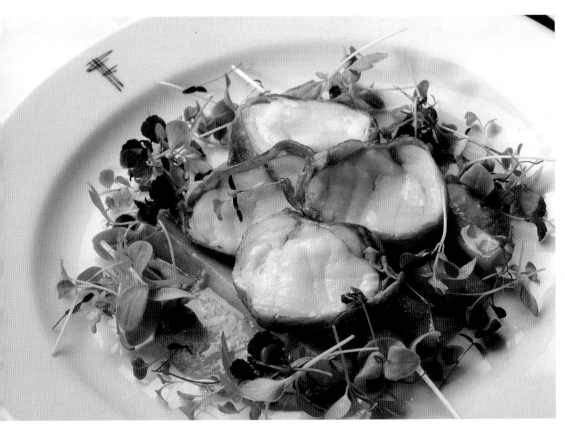

Nikon D3X
105mm lens
ISO 100
f/18
1/125 sec

Natural window light, combined with light from an overhead softbox, give a lovely soft look to this fish dish. And the softbox really helps put a sheen on the oil drizzled on top.

Nikon D3S
105mm lens
ISO 250
f/3.2
1/60 sec

Using a 105mm macro lens to get in very close and an aperture of f/3.5 for a shallow depth of field gives a modern look to this shot of a tart. Light from a single softbox gives specular highlights on the berries, making them glisten.

Nikon D3S
38mm lens
ISO 100
f/22
1/160 sec

A large softbox directly over the table setup not only makes the food look delicious, but provides glorious reflections of itself. You'll see it in the three blobs of sauce on the plate, the top rim of the wine glass and on top of the cruet set.

POST PRODUCTION

Getting your photo right in camera is what most photographers strive to do. After all, you can't change the lighting, composition, focal length or viewpoint after you've triggered the shutter, no matter how good you might be with post-production software! In this chapter, we look at the essentials of working digitally. From file formats and storage to workflow and various post-processing techniques to help you manage, maintain, and enhance your images.

Backups and Storage

There are two sorts of hard drives: Those that have failed and those that are about to fail! That may sound like a pessimistic scenario, but the hard drives where pictures are stored are made of electrical and mechanical components which will, eventually, fail.

Sometimes a virtually brand-new hard drive will fail, and sometimes they will last for years. But one day, you can be certain something will go wrong and you will lose your precious photos if you don't have back up copies. It's a sobering thought.

There are some companies that specialize in retrieving data from broken components, but they can't guarantee to get everything that is vital to you back and their services can be pricey. Plus there's the inconvenience, too. If you start with this doomsday scenario of a broken hard drive, then it helps focus the mind on effectively working out a system to back up your images.

An effective back up can start when you are taking your photos. If you use one of the few cameras with dual card slots, like Nikon's D3 series, then you can write each picture to two separate cards so you instantly have a copy. That way, if a memory card fails, or you lose one, then you have an instant backup. That's as long as you don't keep them stored together in a pocket and lose both! It's worthwhile having a well-practiced system of looking after your cards when you've taken them off the camera, like storing one card in your pocket and the matching card in your bag, for example.

Failed memory cards are relatively common and software like Rescue Pro can often retrieve data, so all may not be lost if a card does become corrupt. The golden rule is that if a card does seem to have an issue, take it out of the camera immediately and use a new card. That gives the best possible chance of being able to retrieve the information on the computer later.

This Nikon D3X takes two CF cards and can write identical images to both at the same time. It's an instant backup of your files.

Hard drive

This Lacie hard drive stores 8TB of info. The glowing blue light on the front of the drive gives an indication of how full it is, and shows it is in full order. If there's a problem, it glows red.

Some photographers like to make an instant backup of their cards out in the field, using a purpose-built photo hard drive device like Jobo Giga-Vu, or even a laptop or iPad. Essentially, the more copies of your files that you have straight away means a greater chance of not losing your images.

When back at home or the studio, it's time to properly download the pictures to the computer that you use for imaging. If you just download them to the computer's hard drive, especially if it's a laptop, then the hard drive will soon fill up.

Many people use a separate external hard drive to store their images, which stops thousands of photos clogging up the main drive of the computer. Huge external hard drives are available, storing around 8 terabytes of data in a series of internal hard drives. The best ones can be setup as a RAID, which means a Redundant Array of Independent Disks. Essentially this means the hard drive is split into two (or more) sections and you can set it up so that each image gets written to one of the internal hard drives, then immediately copied over to a second, mirrored drive. That way, you instantly have a copy should one of the drives fail. Of course, some photographers go even further, having a second separate hard drive that they keep a complete copy of everything on. This is often stored off-site in case of a fire, flood, earthquake, or burglary.

Good brands to look for include Lacie, Western Digital and Seagate, but lots of others are available. Some of these external hard drives come pre-loaded with some backup software, set to make copies of files at regular intervals that you can set. If you use Apple Mac computers, you can also use their Time Machine software so that the entire contents of your computer, or just specific parts of it, are backed up virtually constantly. You can specify the time between backups, and which parts of your hard drive you want copying. Apple also sell a specific Time Capsule hard drive that you simply plug in and it will do everything for you.

Other data-copying software is available, such as SuperDuper, for not very much money. It can be a worthwhile investment for added peace of mind.

Several of the better hard drives also come with a "cloud" storage system. This means that copies of your photos are stored online. However, the amount of space that's offered free is usually very small and is aimed at tempting you to buy much more space. It can be very expensive and the times to transmit your photos to the online data cloud can be long, depending on your Internet speed. However, they are one of the most secure ways of storing your photos as these cloud services are also mirrored, usually in several locations. There are lots of different cloud storage systems, so shop around. It's probably also best to use them to store your best or most important photos due to the cost and time it takes for data transmission.

Some photographers also write a further copy of their files to writable DVDs or Blu-Ray discs, too. This has largely fallen out of favor in recent years as the lasting power of these discs is not yet known.

Color Management

This color checker is an ideal way to calibrate the images from your camera so that you can get faithful reproduction. Holding it in front of your lens, like this, before a shoot allows its own software to setup a full calibration.

When everyone used to shoot film, color management was not normally a huge issue for the vast majority of photographers. As long as you matched your film stock to the lighting conditions—daylight film for most circumstances, tungsten-balanced film for tungsten lighting—or gelled your camera appropriately, then color was not a massive concern. Experienced printers or high-tech printing machines used to make a decent attempt at making colors look natural.

However, with the advent of digital, it's the photographer who is totally in charge of making the colors in their photographs as accurate as possible. The key area for this is in skin tones, which are often the biggest problem areas for photographers who try to get their finished prints looking just like the original scene.

With digital photography, the image-maker is usually in charge of every step of the process—from taking the photo, to the camera settings used, right through to the post-processing procedure to the final output for screen or print. At each step of the process, there are variables that need to be considered in the bid to get natural colors.

It starts with the taking of the photograph, mainly concerning any in-camera processing and white balance. Many cameras have a range of default color settings, such as Vivid, Saturated, Neutral or many more. These ascribe a certain response to the various lighting configurations and alter the tonal response of the finished image. For complete control, though, the experienced photographer doesn't rely on the in-camera settings and compression.

Usually these settings are only applied to a JPEG image, not the original Raw file. It's far better to record everything in Raw then apply any tonal shifts in post processing.

Raw files are the camera's own format, which has to be converted to a usable format. Setting in-camera JPEG means the camera itself does this using a variety of parameters that a user can set manually or by using some of the default picture types, like Vivid, for example.

It's better to use a dedicated Raw converter on the computer, as you will have far more control and will always have the original Raw file to return to. Raw files contain all the camera's data recorded from the chip without any alteration. The downside is that they are much bigger and therefore slower to process, but the advantage they offer in terms of quality, adjustability, and dynamic range shouldn't be ignored. Using Raw indicates a serious photographer who wants to retain control of their color output.

A second issue is that of white balance. If you're shooting JPEG, then you really need to get the white balance right in camera at time of taking as it's very difficult to change effectively afterwards. To do this, it's best to take a custom white balance reading for each session off a purpose-made balance card. Your camera's manual will explain how to do this, but usually it means taking a piece of neutral card, illuminated by the same light source as the subject of the scene, filling the frame of the camera with it, and using it to take a white balance reading. There are also commercially available white balance discs that screw in front of your lens like a filter to help you get the correct white balance.

If you shoot Raw, then you can change the white balance later in post processing, which is a huge benefit. In this case, it's often better to either set your camera to Auto white balance or to select a white balance setting that most approximates the main lighting on your subject, such as flash. Then your camera's LCD screen will give you an approximation of the setting, which you can fine-tune later in post processing.

When you import your photos into your Raw converter, the software will usually recognize the camera and assign a certain color profile to it automatically. This may not be the ideal profile, so you can usually select others to compare it to. However, the best way of working is to make a custom profile for your own camera, ideally under a variety of lighting situations. This can be an afternoon well spent, as once it is done you have a very clear and accurate profile for your particular camera setup. And for really important jobs, you can re-calibrate on an individual basis.

The easiest way of doing this is to use a Color Checker Passport made by X-Rite. This is a handy device featuring a multi-colored pattern which you photograph in front of your subject in an initial test shot. The supplied software then analyzes the colors and makes a special profile that you set in your Raw converter. It's perfect if you use different cameras on a single shot as it makes the output as consistent as possible.

But this is all useless if your computer screen is not properly calibrated; adjusting the brightness of your screen will obviously cause your photos to look different. Also, be aware that LCD screens also need time to warm up. If you've just turned the computer on, it's best to wait for a few minutes to avoid photos processed at the start of a session looking different an hour later.

Screens also lose their color accuracy by a tiny amount each day, so some professionals recalibrate their screens daily. So it's certainly worthwhile to do so before starting to process a major batch of photos. Screens are calibrated using a calibration device that sits on top of the screen and takes a series of brightness and color readings as a pre-determined test program runs on the screen. It only takes around five minutes and is time well spent, and is the only way of getting a true representation of color.

This Spyder is taking a reading off a green panel on the computer monitor in a bid to calibrate it fully. The software displays a range of colors and tones for the device to take readings from.

Lightroom Workflow

Adobe's Lightroom program has taken the photography world by storm in just a handful of years. It removes lots of the complexity of a program like Photoshop and adds lots of different and easy-to-use functionality.

Where Photoshop is designed for graphics artists, 3D modelers, filmmakers, illustrators, and web designers as well as photographers, Lightroom was designed from the ground up to be ideal just for photography use. It doesn't have all the more advanced features of the more pricey Photoshop, but it does offer some that Photoshop doesn't.

At its heart, Lightroom is an advanced Raw converter and Digital Asset Management (DAM) tool. That means it helps you import, catalog, add metadata, and search through the files stored on your hard drives. But it also has powerful editing tools, allowing photographers to do many of their image tweaks in Lightroom without ever touching Photoshop unless they need some precise or specialist finishing.

Lightroom also has great modules for making slideshows and for exporting images or galleries to websites or even to a printer. In many ways it is similar to Apple's Mac-only Aperture software, but works on PCs as well as Macs.

Lightroom has five distinct "modules" which take you right through from importing your files to tweaking them, then outputting them for use in a slideshow, in print, or on the web. The Library module is where most images start, offering a view of all the photos you have in your catalog—either Raw, TIFF, or JPEG. With a new batch of images, you then import them and can assign a whole host of import settings such as metadata, keywords, or copyright information which is tagged to each photo.

It's at this point that the software reads the Raw file and prepares to convert them into files that can be exported as usable formats, such as JPEGs or full-size uncompressed TIFFs.

The Raw file itself is never changed. A software like Lightroom lets you make alterations to a file, but these are only ever applied when a file is exported. The original file is always left untouched. The Library module also shows you all the camera's EXIF data, such as focal length of lens, ISO, shutter speed, and even precise time of capture.

This module is ideal to browse through your shoot, and you can rate or select your favorite shots ready for further post processing. You can assign a star rating—five stars for the very best, perhaps—or flag up images with color labels.

So for a wedding shoot, for example, you could select the very best as five-star images. You could then tag before-

Lightroom in action. This is the library on the Develop module.

ceremony pictures with a red tag, the ceremony as blue, bride-and-groom shots as green, and so on. This way you can quickly see groups of pictures together. You can also create virtual "collections". So, for example, all your best bridal portraits could be added to a "Bridal Portrait" collection. The files are never moved, it's just so Lightroom knows where they are and can display them for you in a collection quickly.

With your shots ready to be worked on, you select the Develop module. This is where all the adjustments are made to your images. Here, you can easily crop or rotate your image as required, and set white balance using either the eyedropper tool on a neutral area, or select a white balance preset. Then onto other adjustments such as exposure, recovery, fill light, contrast, saturation, and more. This is the Raw converter part of the software, and by using sliders such as Recovery you can attempt to put some detail back into areas of the photo where the highlights have blown. This is one of the key benefits of using Raw files, though it can't work miracles.

As well as changing subtle tones and colors, you can also apply adjustments to compensate for lens aberrations. You can select which lens you were using, and the software applies corrections automatically, or you can apply manual corrections too. That's ideal if your lens isn't listed, or you wish to make tweaks. You can correct for vignetting, fringing, and chromatic aberration. You can also add grain, apply noise

The Print module allows the user a variety of contact sheet options.

reduction, and even use a graduated filter effect, which is particularly effective to get detail into lifeless skies.

The latest version of Lightroom also has cloning tools and red-eye reduction. However, these are not as precise as those in Photoshop. It's far better to do any cloning in Photoshop if you need to. Photoshop also has better tools for sharpening; while Lightroom does offer sharpening, it's not as advanced or as controlled as that in Photoshop.

The Develop module also allows you to convert your image to black and white, and there are lots of presets either included with the software, downloadable free, or paid-for to help you make some funky changes. Infrared effects, cold tone, split tone, and lots of different mono effects are all available on the Presets panel. And of course, you can always tweak the final look using the manual controls, too. Then save this as your own preset, if you like. For many people, this is as far as they need to go in Lightroom. You then export your images—singly or in batches—using the Export option. This allows you to select a destination folder, file size, and file quality. For printing, a file size of 300 DPI is the most-used resolution, while 72 DPI is a common resolution for screen use, such as on websites.

There are three more useful modules in the program. The first is Slideshow, which allows you to make slideshows of your images and control how long they are on screen, add transitions, and music to accompany them. This is ideal for showing clients or friends, especially if projected on a big screen. You can also export your slideshow as a video file to use on a website.

The Print module allows you to control your print output direct from Lightroom, as well as making contact sheets for printing or printing multiple images on a page. You can also manage your color profiles from here, too.

The final module is Web, which has a variety of customizable templates so you can export a web gallery in either flash or HTML for use on your website. It can export directly to your FTP site, too. The software also offers an easy Publish feed direct to your Flickr, Facebook, Smugmug, or other website of your choice.

Photoshop Workflow

Photoshop is the giant among image-editing programs. Available as a full version or a "lite" version called Photoshop Elements, it's a professional package designed for ultimate control over your images.

Many users, even those who use it every day in their working lives, only scratch the surface of what it can do. It's vital to get together a workflow that works for you, then use Adobe's online support and knowledge base to help you delve into the more complex areas.

Many photographers nowadays use Photoshop in conjunction with Lightroom, as both Adobe's packages work seamlessly together. Often, Lightroom is used to import and convert Raw files. This includes making white balance alterations, plus any color changes and highlight recovery, or fill light tweaks. The photo is then exported as a TIFF or JPEG, then opened in Photoshop. Here, the dodging, burning, and cloning that Lightroom does offer is available in far greater control, as is sharpening for output. One of the key benefits of Photoshop is also working in layers, which Lightroom doesn't offer. If you don't have Lightroom, much of this Raw conversion functionality is available in the Adobe Camera Raw program which comes packed with Photoshop. This is actually the program that exists within Lightroom to manage Raw conversions anyway, except in Lightroom it is hidden so you don't notice it.

When you attempt to open a Raw file in Photoshop, Camera Raw automatically opens up first. This is because a Raw file firstly needs to be converted to a universal file format like JPEG or TIFF. In this Camera Raw window is where, like Lightroom, it's best to make any white balance tweaks and any highlight or shadow adjustments. Once finished, the photo then opens in Photoshop proper.

The tools for making image changes, such as the Crop tool, Clone tool, Healing Brush, and Erasure, are all on a little tool panel that opens up usually on the left side of the screen. Photoshop is totally customizable, though, so you can move this anywhere or even change its size. To make many of the global adjustments, you pull down the top toolbar test that says "image" then select one of the adjustment options such as Adjustments, then Levels, Curves, Exposure, or Brightness/Contrast. These can be used to change the overall look of the photo, from tones to exposure to contrast, and more. But it does apply to the whole photo. The beauty of Photoshop is being able to apply adjustments like these to local areas of the image. This is done by using layers, which are like

Photoshop

The ultimate in control for manipulating and correcting your images.

transparent copies of the image underneath it. You can then select parts of the image and make changes to just those parts. You can adjust the opacity of this layer so the effect can be complete or subtle. Then when you flatten the image, you'll see those changes on top of the original images.

Using layers means you can paste in parts of other photographs and do all the funky things you could ever imagine! Photoshop offers lots of different ways to do many things, from how you select parts of the image to using the red, green, and blue channels to work on selected color channels. There are whole books written on the subject and so here we just give a brief rundown.

In the File menu are the save options. This is a key part of the procedure, as unlike Lightroom when you save your photo then you can't go back and resize it. It is here where you set the DPI, image height, and width. For web use, 72 DPI is best, and Photoshop does offer a unique "Save for Web and Devices" option. For print, most photos are saved at 300 DPI

Capture One

Phase One's excellent Raw converter and DAM software gives amazing results.

Nik Color Efex

Bleach Bypass is a useful Photoshop plug-in.

at their native size, then resized at the moment of printing to the precise size that is needed. Photoshop also offers a range of filters, which do everything from stylized finishes to liquefying the image—essentially warping it to alter the shape of the subject within the image.Inside this Filter menu you'll also find a range of plug-ins. These can be commercially bought and offer a whole range of interesting looks or changes to your files.

Two of the most popular are from OnOne and Nik. OnOne's range offers a variety of effects. From a plug-in that can resize your image to an even bigger size at the highest quality to one that can make a wild selection of frames and border effects, recreate a tilt-and-shift lens effect, or fine-tune skin tones. Nik's packages include some amazing mono conversion software called Silver Efex, and a range of different color finishes in Color Efex. Bleach Bypass is one of my most-used plug-ins. It is based on an old technique from color-print processing where the bleach stage was bypassed in order to increase contrast and change the tone of the image. Nik's Bleach Bypass allows you to not only replicate this but tweak it endlessly to make the picture truly your own.

Working with other software is one of the key benefits of using Photoshop. Instead of converting Raw files using Adobe Camera Raw, some photographers prefer to use the camera manufacturers' own Raw software such as Nikon View NX, Capture NX, or Canon's Digital Photo Professional software. These packages have a reputation for being slightly slower than Adobe Raw engines, as well as a bit more

fiddly to use, but some users say they generate a file of a higher quality.

If quality is of the most concern and speed not an issue, one possible workflow is to convert Raws in these software packages then open the exported file in Photoshop for manipulation. A third option is to use an alternative raw converter that's not brand specific, like Capture One. Although it doesn't offer Raw conversion for as many cameras as Adobe, Capture One does convert the files from most of the popular brands like Canon, Nikon, and more.

Originally designed for Phase One's digital backs, Capture One is used by the majority of professional photographers who like to shoot tethered—where the camera is linked to a computer using a cable so the images are downloaded directly to it. Lightroom now offers this for some Canon and Nikon cameras, and more will follow. Capture One is a top-quality Raw converter where final tweaks—especially localized adjustments—are best made in Photoshop.

Retouching for Beauty

Loads of megapixels, super-sharp nano-coated lenses, huge screens, and the ability to zoom in at 100 percent to peek at pixels may be all well and good for lots of photography, but what it also does is make any imperfections really stand out—especially on portraits.

Years ago in the era of film, portrait photographers often used to select their lenses for their softness rather than their razor-sharp resolution. And then often used to degrade the image even further by using a Softar filter—essentially a filter you screwed on the end of your lens to make the image slightly soft. This dreamy look went out of fashion a long time ago, but great-looking skin didn't!

The advent of Photoshop now means that subjects often expect any stray hairs or pimples to be gone, for their teeth and whites of their eyes to glow and perhaps even for their bodies to suddenly take on a slightly different shape. The general public now have an awareness of retouching, and photographers need to learn the basics in order to improve their images.

The easiest way for beginners is to purchase a dedicated program that will take much of the strain. Products like Portrait Professional have got a good reputation, as well as Photoshop plug-ins like Topaz, or OnOne's Photo Tools. And Capture One Pro has some good controls for skin, too.

However, all these time-saving programs are far from perfect. A proper retoucher will have spent years learning their trade, and will spend hours or even days at pixel level on the most important images. Magazine covers, billboards, movie posters, and adverts are all extensively tweaked, albeit made to look as natural as possible. Pro-retouchers keep most of their techniques a well-guarded secret, preferring to work on individual red, green, and blue channels, using frequency separation and tiny healing and cloning while not obliterating texture. And of course, taking a model down a dress size, tweaking sticking-out ears, flabby arms, and droopy eyelids are common tasks too.

Getting realistic-looking skin is the key to effective beauty retouching. There are lots of different ways of achieving this, and everyone develops their own. The most basic method is to create a duplicate layer, then make a blurred copy of the image below. Then, using an Eraser tool, rub through to let the sharp pieces of the image such as teeth and eyes

These before-and-after photos show how retouching in Photoshop can transform an image.

Nikon D3X
85mm lens
ISO 100
f/11
1/160 sec

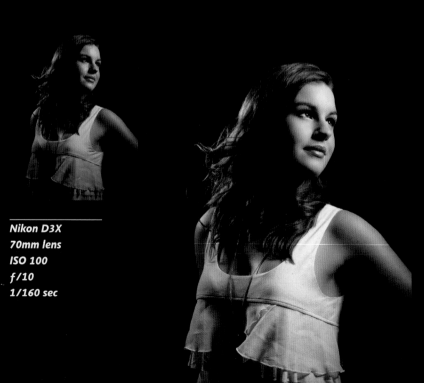

Nikon D3X
70mm lens
ISO 100
f/10
1/160 sec

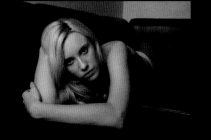

Nikon D3X
40mm lens
ISO 100
f/7.1
1/160 sec

show through. This produces skin that looks like it's made of plastic. The effect can be tweaked somewhat by reducing the opacity of the blurred layer, but it is still very obvious.

A better way is to clean up problem areas like spots and marks using the Healing Brush tool. While you're at it, this is a good time to use the Cloning tool to get rid of any flyaway hairs or anything else that you want to tidy up. Then it gets more technical.

Click on the image and create two copies of the image by going to *Layer › Duplicate layer* twice. Name the top layer Dark and the second Light, then highlight both layers and create a group by selecting *Layer › Group Layers*.

Turn off the Dark layer by clicking the eye icon next to it. Then select the Light layer, then go *Filter › Blur › Gaussian Blur* and start by setting Radius to 4 pixels. You can experiment with different settings if you like. The image will now look slightly blurred. Change the Layers mode from Normal to Lighten, and change Opacity to 80 percent.

Then select the Dark layer and click the eye icon again to make it visible. Go *Filter › Blur › Gaussian Blur* and start by setting Radius to 2 pixels. Change the mode to Darken and Opacity at 40 percent. Now click on the Group icon, and change Pass Through mode to Normal. Then click on the Group's eye icon and turn it off, so you're now looking at the original background image.

Select the background layer. Now using the channels palette, click on the red channel and go to *Image ›*

Calculations. Make sure both Source Layers are set to Merged and set Blending to Overlay and Result to Selection, then click OK.

Now activate your Group layers, and go *Layer › Layer Mask › Reveal Selection*. Then select *Layers › Group Layers* that will create a new group called Group 2 containing all the layers. Finally, go to *Layers › Layer Mask › Hide all*. Change your Foreground color to white and select a soft brush. Now use this to "paint in" softened skin, taking care to avoid areas you wish to remain sharp, like eyes, teeth, eyebrows and hair.

When you're happy with your image, flatten the layers by going to *Layer › Flatten Image*.

This is just one way of dealing with skin softening; many others are available. Always remember, the key in beauty retouching is subtlety.

6

CREATING THE DARK LAYER

Under Gaussian Blur, start Radius at 4 pixels, then change as you like.
Select Darken mode, set Opacity at 80 percent.

CREATING THE LIGHT LAYER

Under Gaussian Blur, start Radius at 2 pixels, then change as you like.
Select Lighten mode, set Opacity at 40 percent.

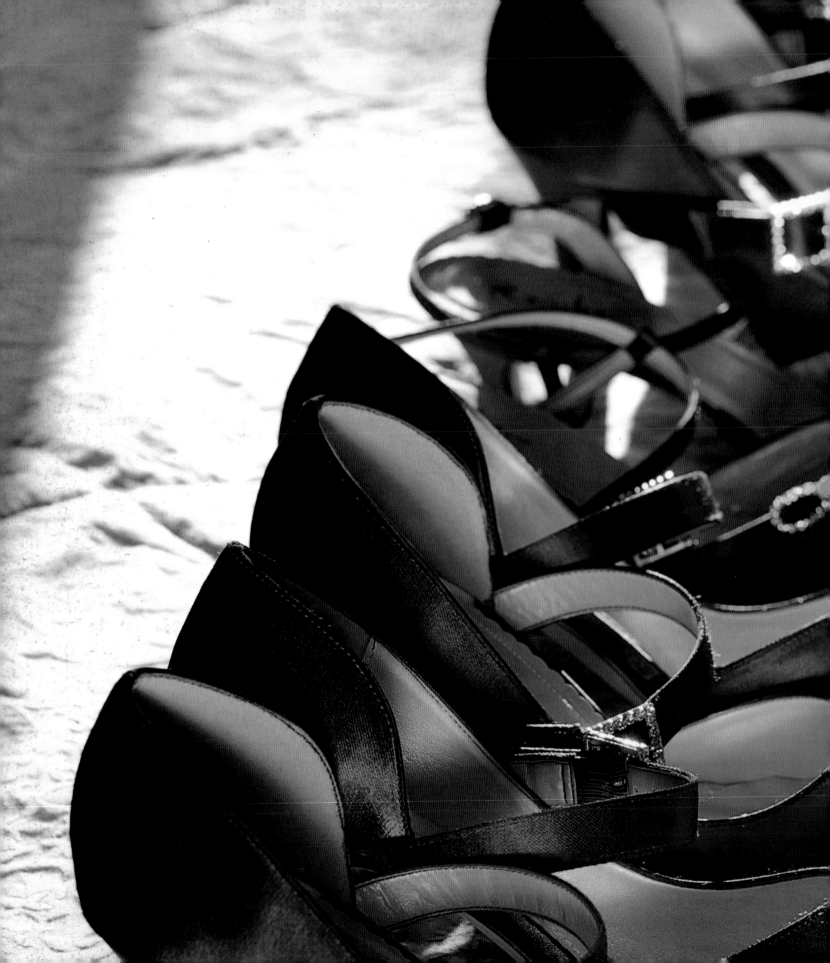

NEXT STEPS

Once you've got confident using off-camera flash techniques to turn ordinary images into something a bit more special, you'll soon be wanting to take your image-making even further. From multiple flashes to using more powerful flash heads, or alternative light sources, there's always something new to try. Plus we tackle how to use the Internet to source a whole team to help you carry out your creative vision.

More Powerful Flashes

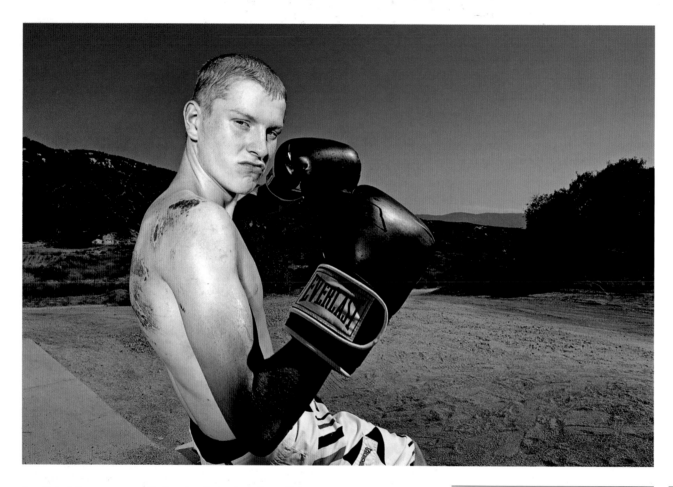

Small, hotshoe-mounted flash units do pack an incredible punch for their size and weight. Indoors, outdoors in shade, or when used close up to the subject, there's little point in using anything more powerful.

But if you're trying to use them outside in the blazing sun, perhaps with a modifier like a softbox or beauty dish, then they start to have their limitations. Especially if you have to move them away from the subject for fear they'll show up in the frame.

Even if you can get the desired output from a small flash like this, then the recycle times become very long. And if you keep popping off a flash at full power time and again, then often a built-in heat sensor stops the flash from firing and you have to wait for up to ten minutes for it to cool down. Or worse still, if you have an advanced unit and use the menu to disable the heat sensor, then it's pretty easy to get a flash

This extreme sports athlete—complete with horrible scars and scabs on his recently-injured shoulder—trains by sparring in the midday heat of a Californian desert. Even using ISO 100 at the camera's maximum sync speed of 1/250 sec, the aperture had to be dialled down to f/20 in a bid to get the background dark and moody. So a powerful flash was used to light the subject—in this case an Elinchrom Ranger Quadra.

Nikon D3X
24mm lens
ISO 100
f/20
1/250 sec

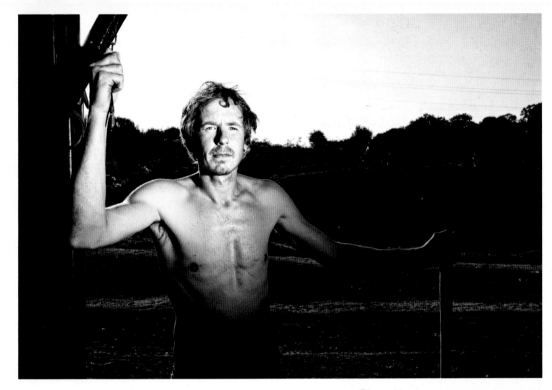

Nikon D3
35mm lens
ISO 200
f/14
1/250 sec

Taken at the end of a hot summer's day, the low sun was used as a strong backlight to separate this shirtless worker from the silhouetted background. A powerful Elinchrom Ranger was fitted with a small beauty dish which also had a honeycomb grid on it to produce a narrow beam of light. The power was then adjusted up to light the face of the subject. A small flash just wouldn't have been powerful enough.

so hot that it physically melts. Which not only ruins your shoot, but can be dangerous and will be expensive. This does happen, and the Internet is awash with stories of disgruntled photographers who disabled the thermal cut-out then melted their flashes.

The next step up is to use professional-style flash heads that come with their own portable power pack, usually a sealed battery that you recharge from the mains.

These pack systems used to be very big, heavy, and pricey. And the hugely powerful units from firms like Profoto still are.

But in recent years there have been many more affordable units on the market from a range of manufacturers. They may not have the ultimate power of the bigger units—which tend to take full-size studio head attachments like softboxes or beauty dishes—but they are several times more powerful than hotshoe-style guns and usually have an easy way of being used with softboxes and other light modifying tools.

Typically you get hundreds of full-power flashes out of a full charge, and some come in kits with a spare battery, too. The more advanced ones—like the Elinchrom Ranger Quadra—have built-in radio receivers and come with a transmitter so the power of the flash can be altered from the camera. Other similar systems to look out for are made by Lumedyne and Quantum, which even offers full TTL control even though the system isn't quite as powerful. Apart from the Quantum Q-Flash, these flashes are controlled manually, so your camera really needs to be set manually, too.

The benefits are huge though, meaning you can underexpose the background of a photo significantly, even in bright daylight. The flashes themselves have lots of power so you can either use them with a softbox or beauty dish, or

Nikon D3
14mm lens
ISO 200
f/11
1/250 sec

Sometimes it's not just the light levels that mean you need a more powerful flash, it's often the distance from the subject, too. To capture these newlyweds by the lovely lake surroundings, they were placed with the sun backlighting them. To pump enough light into the subject to stop it being a silhouette needed a powerful flash, far enough out of frame. An Elinchrom Ranger did the trick.

move them far enough back so their light output is very even. This can be important if you're lighting a big subject like a group of people or even a car.

The downside is that they are more expensive, the majority don't work with your camera's TTL setting, and of course they are bigger and bulkier. But there are times when they let you take photos you simply couldn't get with smaller flashes.

James May is one of the presenters of the TV car program Top Gear, but he's also a bike nut. This shot was an editorial shot about the contents of his garage, showing him with one of his bikes outside the garage doors.

 The main light was a single flash, higher than head height, to the left of the camera. If you look at James' shadow on the wall and the shadow of his bike, you can see the direction of the light. A second light, fitted with a grid, was right next to the doors, just outside the frame. This was aimed towards James' hair and has also put a bright highlight on the side of his face. The shot was post processed using a Nik Bleach Bypass Photoshop plug-in filter.

Nikon D3
35mm lens
ISO 200
f/11
1/250 sec

Multiple Flash

Using flash can be addictive. So addictive, in fact, that once you've got into the habit of using a single flash unit then your obvious next purchase is to buy an additional one. Then maybe more!

But it's not always about more being better. It's very easy to just put up lights and blast away with them, filling in any shadows with light just because you can.

Using multiple flashes allows you to highlight certain areas of a scene for dramatic effect. Or by using them as rim lights to put a line of hard light on the back of a subject to separate it from a dark background and really make it look three-dimensional. Or even just use two flashes next to each other for twice the power, which gives a single *f*/stop increase in exposure or helps you run your flashes at half power and speed up the recycle time.

The key to using multiple light sources is to always work out which is going to be your main source of light, then build up the others around it. Even though you're using flash, the main light still could be the ambient, with your flashes providing little bits of fill light or accent lights to pick out various parts of the scene. Such as using one to put a hair light on a model, or a rim of light to make the model stand out from the background rather than blending into it.

Alternatively, it could be that you may wish to underexpose the ambient light, or use it as a hair light or separation light or even fill light. In this case, your flash will be acting as the main light. And any additional lights can be used to pick out parts of the scene or even come from the same direction as the ambient to increase its intensity.

In each case, it's best to start with one light and build up the scene from there, carefully checking the exposure and looking on the camera's LCD screen each time you put in an additional light or change the power setting or exposure.

Unless you're working in a dark studio or at night, the key issue will be the ambient light. If this is the main light, then expose correctly for it. If it is to be a fill light or background light, then alter your exposure to suit, either by using exposure compensation, or controlling the aperture and shutter.

Nikon D3X
24mm lens
ISO 100
f/10
1/250 sec

This may look like a simple photo to take, but there were three flashes used to get this effect. Firstly, the camera position was chosen and the ambient exposure set to be a stop under the ideal setting to bring some detail into the sky. The sun is to the rear and right of the frame, which put a nice highlight on the girl's hair and left arm of her jacket.

The main light on the girl was a flash fired through a beauty dish to the left of the camera position and slightly above her head height. You can see a reflection of this light in her shades. A second light, fitted with a honeycomb grid, was set out of frame to the left and behind the girl. This hard light source illuminated the very edge of her wet-look leggings and arm of the jacket to avoid this area disappearing into the background. A third light was a bare flash out of frame to the right, set to illuminate the motorcycle.

Phase One 645DF
55mm lens
ISO 100
f/3.2
1/400 sec

This may look like a simple shot, but is actually quite technical to achieve. A wide aperture was needed to blur the background, so a medium-format camera with leaf shutter lens was used. This allows the sync speed to be as high as 1/400 sec with a corresponding wide aperture. The main light on the model was a flash fired through a softbox to the right of the camera. The lovely golden rim light looks like it was from the sun. But it was actually a Nikon SB800 fitted with an orange warming gel hidden behind the model.

Nikon D3S
70mm lens
ISO 400
f/9.0
1/200 sec

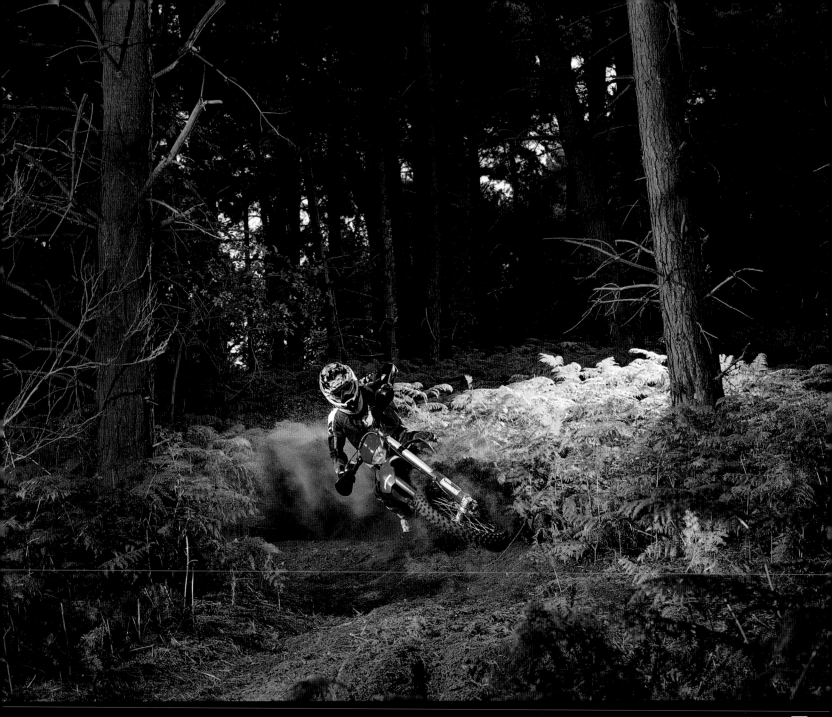

If you go down to the woods today, you're in for a big surprise: A motorcycle lit by four flashes! On a dark and overcast day, the woods themselves were very gloomy and the light levels impossibly low to capture some action without cranking up the ISO hugely.

So no less than four flashes were used to light up part of the scene. And two of the flashes are actually in the frame, but hidden by trees so you can't see them.

The first flash is just outside the frame to the right. This is the main light on the rider and aimed directly at him. A second flash is hidden behind the big tree on the right, aimed to light up some of the ferns and the left hand side of the rider.

A third flash is hidden behind the big tree trunk on the left, aimed so that it illuminates the plume of dust kicked up, and a fourth flash placed out of frame to the left to illuminate the bush in the foreground and large tree also on the left.

The shot was achieved by first parking the bike and rider **in situ** then adjusting the power of the lights until the relative exposure was right. When it was all set up, the rider then rode around the corner, kicking up dust at the prescribed spot just as the shutter was released.

Alternative Light Sources

Nikon D3
40mm lens
ISO 400
f/2.8
1/320 sec

A tungsten-balanced video light, matched to a white balance set to Tungsten on the camera, means that the skin lit by the light is largely the right color. But the surrounding areas, lit by the light of dusk, takes a very blue tinge. It's a creative treatment than can be effective.

Flash units aren't the only source of artificial light you can use for creative effect in your photography. Everything from candles to flashlights, builders' halogen lights to car headlights, and everything in between can be used to add a bit of sparkle to a shot.

But for the majority of photographers, the most used sources of artificial light (apart from flash), are continuous light sources, the kind you're more likely to see used in video. And with many of today's DSLRs now coming equipped with high-quality HD video capability, plus amazing response at high ISO for stills as well as moving footage, then video lights are likely to become more prevalent.

For many years, the majority of photographers learned their skills in the studio using tungsten studio lights, despite the huge amount of heat they kick out. The benefit of using continuous light is you can see the effect it's having right in front of you. The downside is that they simply don't have anything close to the power available from a flash, and there are lots of issues with color temperature. When flash became more affordable, it left tungsten far behind—although some still photographers continue to use it.

A more modern alternative is to use a cool-running video light, such as an LED light panel which has the benefit of being daylight balanced. However, unless you're doing close-up work or are in a dark studio with a camera mounted on a tripod, they're of little use.

Far better is a purpose-built video light, powered by a battery pack. Lights like the Lowel iD light are ideal, last for around an hour on a charge, and have a Fresnel lens on the front. This means that by moving a lever, you can adjust the beam of light from a flood effect to a more focused spot. Some lights also have a dimmer switch, too.

The Lowel still uses a warm tungsten-balanced bulb. You can get filters to put in front of the light to correct this, but they do kill the power output somewhat. As any video light doesn't have much power, they are best used either indoors or outdoors when light levels are low. They are ideal for weddings or interiors.

If you're using one in a room that has lots of tungsten-balanced light anyway- such as regular household bulbs—then the video light output matches and you can use them as a fill or highlighter. However, real magic happens when you mix them with a small amount of ambient light. By setting your white balance to Tungsten on your camera, anything illuminated by the video light will have the correct color.

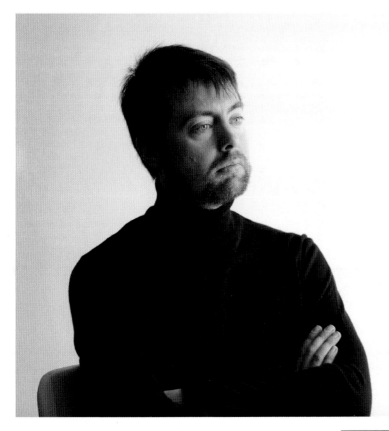

Nikon D3S
200mm lens
ISO 800
f/2.8
1/160 sec

A huge HMI video light bounced off a white flat panel was the main light for this shot of an actor. It has a lovely quality and as it's continuous, you can see the effect it's having. But even though the light was around 10 feet away, the ISO had to be ramped up to ISO 800 just to get an exposure of 1/160 sec at f/2.8. Even huge video lights aren't that powerful compared to flash.

However, anywhere that's illuminated by the ambient alone will go blue. It's ideal to make skies go even more blue than they are in reality.

With any video light, you will more than likely to have to increase your ISO and use a wide aperture simply because their output is so small compared to a flash. The most powerful video lights are right off the movie set and are called HMI lights, which stands for Hydrargyrum Medium-arc Iodide. These lights are big, require a huge ballast pack with them, and are frighteningly expensive. For the price of one big 12–18 K HMI Mol-Richardson light, you could buy more than fifty of Nikon's top-of-the-range SB900 flash units.

Huge HMIs have found favor with some of the world's best-paid fashion photographers who praise their focusable Fresnel lens, cool-running, nearly silent performance, and consistency. But even so, they're still not very bright compared to a flash. Some companies are now making much smaller HMIs at a fraction of the cost. These are daylight-balanced and have a lovely quality of light, but still don't have a huge output. But like the Lowel video light, these are ideal in dark studios or for use when the ambient light is low.

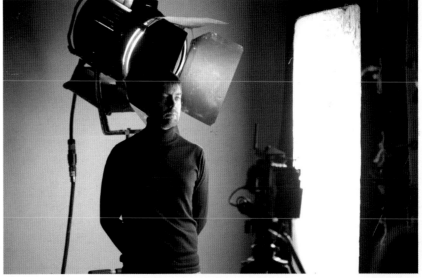

This gives you an idea of the size of the light used—it's vast! The main portrait was taken when the actor moved 6 feet to his right and sat in a chair. What you can't see in this photo is the huge power pack the light also needs. Roughly the size of a large household microwave oven, the power it needs is right at the upper end of what a domestic electricity outlet can provide. That's why big movie sets have huge power trucks filled with generators just to provide the juice for the lights.

Nikon D3S
110mm lens
ISO 250
f/2.8
1/320 sec

Breaking the Rules

The rules that work in portrait photography have been fine-tuned over many years. Borrowing much from the world of painting—especially the Old Master realists of the 17th century like Rembrandt—there are some guidelines that work time and again.

Broad lighting, short lighting, butterfly lighting, beauty lighting—and of course Rembrandt lighting—work to a tried and tested formula. For years, skilled photographers armed with light meters have carefully calculated lighting ratios—essentially the difference in brightness between the main "lit" part of the face and the shadowy "unlit" part—that simply work.

However, you don't have to use soft lighting from the front in a two-to-one contrast ratio, a hair or separation light, and a background light to make a great picture. In fact, it's often better to break the rules and experiment. After all, there are no processing costs for trying new things in digital photography, unlike buying and processing film. And the results are instant. Try something new, see if it works, then use it or tweak it and try again.

The two pictures here purposely "break the rules." The first portrait, of the model flicking her hair, doesn't even show what she looks like! The hair behind her is bleached out to the point of having no detail, she is placed centrally in the frame rather than at the intersection of thirds. And the photo is a long, thin landscape format rather than a "portrait" format. All technically "incorrect," but the photo succeeds in portraying a sense of fun—a real "caught moment."

The lighting couldn't be more simple. The model was posed inside an all-white room, around 6 feet from the white wall background. Directly behind her is a Nikon SB800 flash unit fitted with its standard diffuser aimed at the ceiling and set to full power. She twists round to face the flash, then quickly spins round to the camera so her hair flicks out. Then the shutter is triggered. It's all hit-and-miss as to the results you get, but hopefully you'll manage to get a good shot before the poor model gets whiplash!

The second photo, of an art student studying a mannequin, is reduced to a graphic shape by the use of a single flash unit. This was just outside the frame to the left, and aimed to illuminate the large white wall behind the subjects. This light threw the student into total shadow, but does provide some wrap-around lighting on the curves of the mannequin. This photo looks like it was converted to mono but is actually a true-color shot. As the mannequin is silver, there is no color in the shot to show.

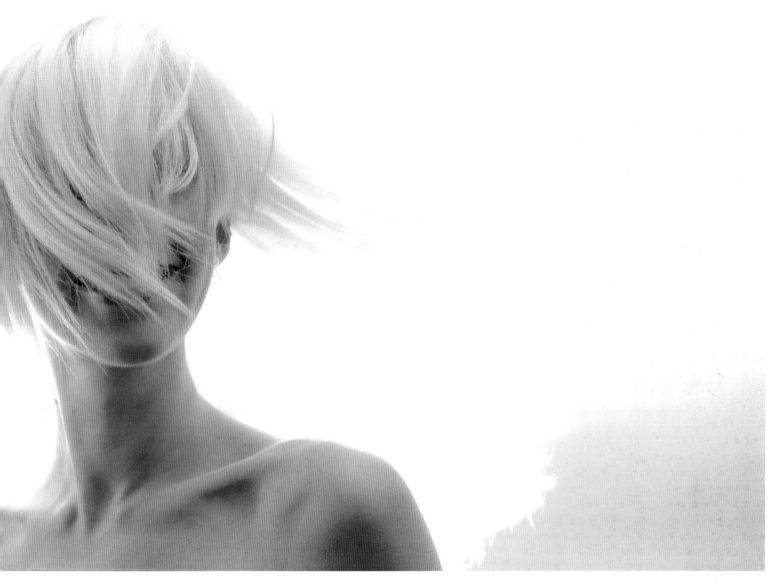

Nikon D3X
85mm lens
ISO 100
f/7.1
1/160 sec

Of around 20 pictures taken before the model got neck ache from spinning round all the time, this was the most pleasing. Light was a single bare flash unit right behind her, bouncing its light all over the white room.

Nikon D7000
32mm lens
ISO 100
f/18
1/160 sec

Sometimes you don't have to light the subject. Just light around it. This dramatic shot was done by using a flash to light a white wall behind the subject. It's the graphic nature of this near silhouette that works.

Using the Internet

For any artist it's important to find your own view of the world, your own style, reading of light, genre, angle, perspective, and point of view. But sometimes it's unbelievably difficult to do so. Have you ever had to take pictures of someone and stood there with not a single thought in your head other than "help?" It's not a pleasant experience. That's why it's important to expose your mind to a wide range of creative experiences, to get ideas from all manner of sources, to be inspired by the work of others, and then make it your own.

The Internet of course is a fantastic resource for seeking inspiration. Start with the classical art sources. You can never fully appreciate the scale and majesty of a huge oil painting when looking at a pixelated rendition on an LCD screen, but it's certainly a good start. Through the beauty of the World Wide Web you can look at the works in the Metropolitan Museum of Art in New York, take in a little from the Smithsonian, hop across to the Louvre and finish in London at the National Portrait Gallery.

The net is also a useful resource for looking at the work of other photographers. Just use a search engine to find their names, and have a look at their online portfolio. But what if you don't know the names of many photographers? A great place to start is a site like Flickr. It's essentially an online web gallery where you can upload your own photos, and set them so that anyone can see them or just people you specify can see them. The beauty is that once you're a member—and membership is free for a basic level—you can explore the works of literally hundreds of thousands of photographers across the globe. And if you see a photo you like, you can comment on it or even ask a question about how it was done. Most photographers are only too pleased to share information.

There are also lots of special-interest groups on Flickr, too. Some groups are interested in the precise sort of camera or lens you use, and are a goldmine of technical information on the kit. Some groups are interested in a specific technique or genre of photography. Like people who just take photos of chairs. I kid you not. Others are very location-specific, so you can join an online community of other photographers right near you. Either way, you'll find encouragement and help from like-minded photo enthusiasts who could be round the corner or at the other end of the world.

The net is also a great tool to help you plan your photo expeditions. Google Maps and Google Earth let you check out a location for your shoot, and other websites let you follow the weather, sunrise, and sunset times, or tide tables if you're near the coast. Use these resources to help plan an effective shoot.

There are also some websites set up specifically to talk about using off-camera flash. The most popular is called Strobist.com, which also has one of the biggest groups on Flickr, too. DP Review not only reviews kit in detail, but has huge forums where advice on lighting is freely offered. And don't forget YouTube, which nowadays is brimming with behind-the-scenes videos from photo shoots.

Sooner or later, you'll probably want to have your own website, especially if you want to be taken seriously as a photographer and perhaps book models or other creative professionals. It used to cost thousands to have a custom-built website, but nowadays mainly the professional photographer invests in sites like these. Unless you are a tech head, it's much easier to buy an off-the-shelf templated website to upload your portfolio to. Many offer easy-to-customize designs and accompanying blog sites, too, so you can update the world with your latest work.

Some photo-specific websites do more than just host portfolios. Sites like Photoshelter, Zenfolio, and Smugmug offer not only galleries, but lots of storage space for your image files. Many offer advanced features like access via FTP and e-commerce solutions so you can sell prints or digital files direct from your site.

And if you're really serious about selling your images, stock sites like Alamy will host your photos for you—as long as they reach their specific quality criteria—and sell them on your behalf to a worldwide audience. Taking their cut, of course. Do some homework, get yourself a website, and soon you may be the photographer whose name others are looking for!

The Internet is an amazing resource for photographers, from meeting other like-minded people, to getting technical information or just being inspired by the work of others.

Putting a Team Together

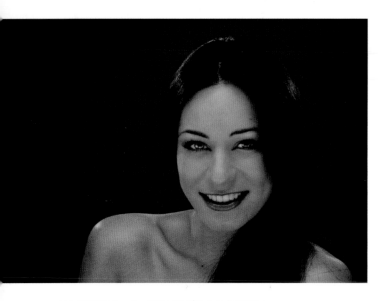

You can find some great models on online modeling sites, like Lydia here. She replied to a casting call on Model Mayhem.

You are bursting with ideas, you've got poses and lighting specifications coming out of your ears, and yet you can't find someone to pose for you. Your family all run a mile as soon as you get the camera in your hand, and all your friends are bored of your continuing obsession. How do you find models for your photography, and a team of stylists, makeup artists, and hairdressers to help you?

There are a number of sources and some are better than others depending on your stage of development and what genre of photography you wish to work in. Many amateur photographers who are finding their way with a camera start out photographing friends and family. Nothing wrong in that at all, but very quickly you will start to be frustrated as the shots aren't giving that edge that you're after, your models are not posing properly, or you spend so much time posing them you feel uncomfortable taking more time over your technical skills. So a good solution to this would be to book someone who knows what they're doing and let them pose whilst you concentrate on the techie stuff. It may mean paying them, but you get someone who is totally confident in their own body and has an awareness of what is required to get a great image.

But where to go to find someone with experience? Well, traditionally models have been booked through agencies. Agencies will promote their models, take a cut of their earnings, and ensure that they turn up for their bookings. However, the advent of the Internet means there are now loads of websites that allow models to market their talents

Online websites are ideal places to get ideas and make contacts with models, photographers, stylists, makeup artists, and everyone else you could need to organize a photo shoot.

directly to photographers and other professionals. Whilst you're unlikely to be able to book Tyra Banks through such a site you will encounter some incredibly talented and professional models. Working with them will improve your photography and understanding of pose and technique.

As you develop your skills, you'll see people walking through your local town and think "wow!" Now there are good ways and bad ways to approach someone to model for you. You could walk up and tell them they're gorgeous and that you want to take pictures of them. You might get the response you are after, but equally you may get slapped, punched, or visited by the police. Whenever I'm out and about I have a set of business cards with me at all times. If I see someone that I think I'd like to work with, then my approach is very simple. I introduce myself by name, tell them I'm a photographer. I tell them that I'd be interested in working with them on a shoot, give them a card, ask them to look at my website, and then get in touch if they're interested. Then I walk away. Over the years I've found that approach to work best as it means that if the subject does take time to get in touch then the chances are that they're really interested, they've seen my work, and will have already thought about what styles they're interested in working in.

I have also been known to use my wife as my agent at times, working on the basis that an approach by a woman can be potentially less intimidating than by a man.

Of course when they turn up for their shoot they may look good, but prove absolutely hopeless at being a model. There is far more to modeling than just looking good. That's where all the posing and movement skills you learn from working with professional and experienced models comes to good use. You can then steer, prompt, and direct with confidence to get the best possible results. If your new model does prove to be fantastically then you may have just launched a new career, and if not—well you've only wasted a couple of hours and can at least present them with some nice images.

That brings me to the final part of this section. How do you recompense your models? Whenever I work with someone I do so in one of three ways. They pay me, I pay them, or we treat it as a trade of talents, in which case we share the images. The first two are self-explanatory, but the latter option can cause problems. You will see models and photographers advertising TFCD or TFP shoots. Time for CD or Time For Prints shoots. This means no cash changes hands, but you exchange each other's time to create the images. You must agree with the model beforehand how many images you're going to hand over and then make sure you do.

I shoot TFCD regularly with professional models I want to work with to extend my skills and try out new techniques. One method is then to retouch the ones I consider to be the highlights of the shoot, and give them to the model on a CD. Some photographers give out every picture—retouched or not. Personally, I believe that neither of us can create an image without the other, therefore we should both share the fruits of our labor. That approach has led to me now having great contacts throughout the industry and a range of models from newcomers in the industry, to international stars that I can call on and ask for a shoot.

Sites like Model Mayhem, Purestorm, and Net-Model are also frequented by makeup artists and hair stylists. Many of these will also trade time for CD if they feel their portfolio will benefit from the session. It's always essential to agree with all parties who is going to get what, and any potential uses of the photos afterwards.

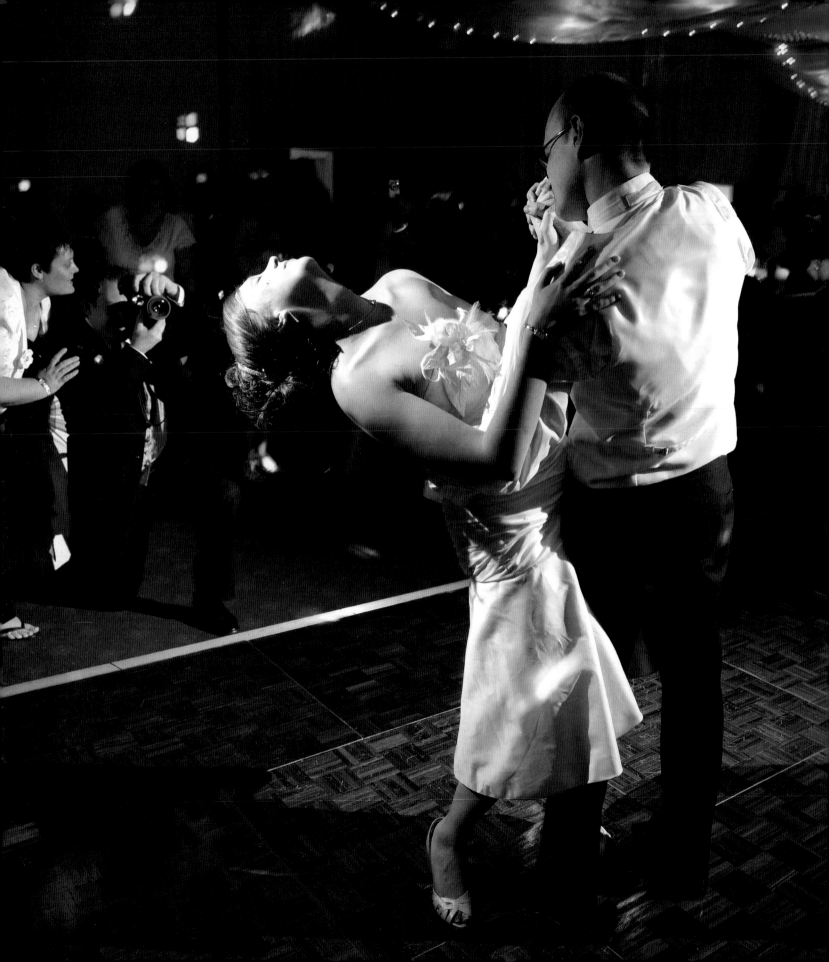

CASE STUDIES

Learning the theory is one thing, but seeing flash used in practice on real jobs is another. In this chapter we have looked in some depth at how commercial, editorial, fashion, portrait, and advertising photography has benefitted from the use of flash units in the studio, but have concentrated in the main on shooting on location. We also explain, with the help of diagrams and behind-the-scenes photos, exactly how each shot was achieved.

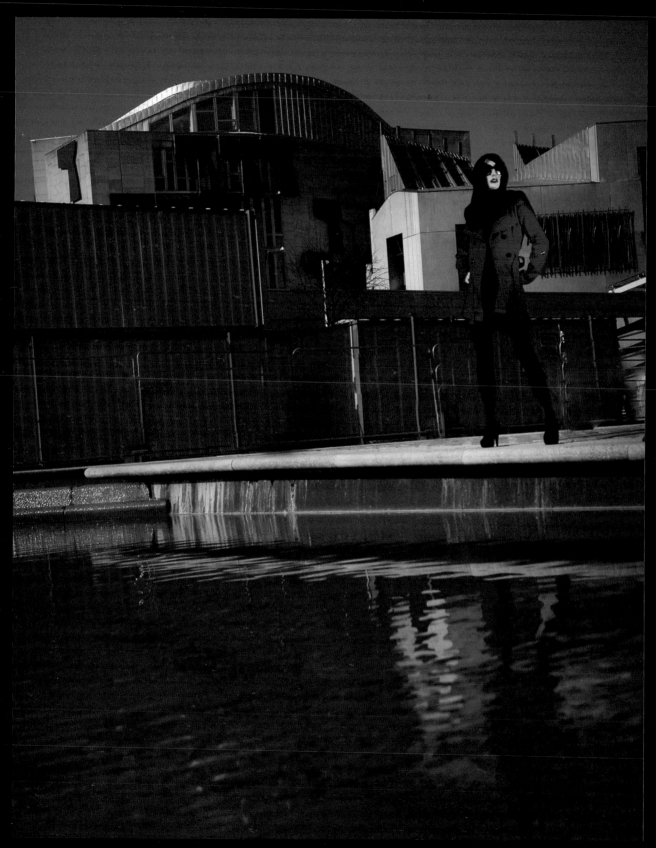

The flash was set
to TTL +1.3 to give
it more power to
overcome the strong
ambient light.

Nikon D200
ISO 200
f/4
1/6400 sec

Case Study 1: Scottish Fashion

PARLIAMENTARY BUILDING SITE

Model stood a little back from edge.

Flash at chest height to even spread of light over model and as far forward as possible to bounce light back towards camera.

WATER

I lay on the floor with the camera to get close to the water level.

This image came from a fashion shoot outside the Scottish Parliament building in Edinburgh. The day had started with a fine fog over the city, but by mid-morning that fog was burning off as the sun came through strongly.

The natural light was further enhanced by the concrete that has been widely used across the site and was acting as a huge reflector, bouncing the sunlight around beautifully.

I wanted to show a reflection of the model in the water feature and contrast the red coat strongly with the surroundings. Unfortunately, the parliament building was undergoing significant development and so the front was obscured by containers and fencing.

To overcome this and give the image a further fashion edge I chose to shoot with my camera's white balance mode set to Incandescent. This had the effect of rendering all the daylight blue. I underexposed the ambient daylight by about two stops and put a flash unit on a stand to the right of the model. The flash was gelled with a full CTO gel, which made the light coming from it orange, but when white-balanced to Incandescent it rendered the skin tones normal.

8

Case Study 2:
Darkness from Light

This image shows the power of a flash unit and its ability to overcome ambient light. The picture was taken in late afternoon in my studio. To the right of the model was a large window that was filling the room with light.

The flash unit was mounted on a stand with a 40cm (roughly 16 inches) square softbox fitted. The softbox was high and just out of frame to the left of camera.

The flash power was set to TTL without any additional compensation. In order to block out the ambient light

High Speed Synchronisation mode was selected on the camera so that I could use the high shutter speeds required.

In posing the model it was important to consider where the light was required to hit her and how quickly it would fall off. I wanted her face turned into full light and then a natural reduction as it fell down her body.

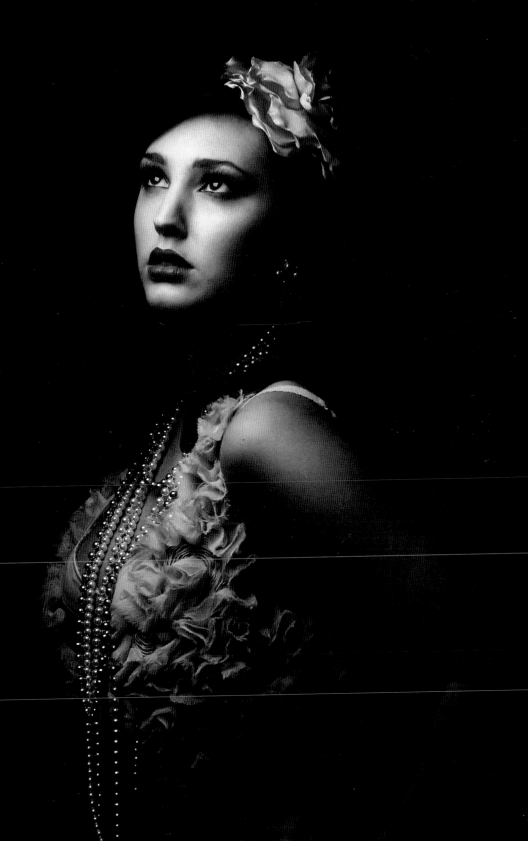

8

Case Study 3:
One Frame, Multiple Flashes

Lighting a whole car—especially a black one—with a single flash can be a problem. To get an even coverage of light you need to move the flash quite far away, which means the flash's power becomes an issue—especially if the shoot is on a bright sunny day.

This was exactly the problem I had photographing a black Dodge Challenger car in San Francisco as part of a road-trip feature for a magazine paying homage to some famous movie scenes in California.

Inspired by the legendary 1968 Steve McQueen film *Bullitt* that featured a similar-looking black Dodge Charger, one of the shots was to be in front of the Golden Gate Bridge.

It was almost midday and there was no option to change the time of the shoot, as we were on a road trip and had to be hundreds of miles away by the evening. I only had one flash with me, an Elinchrom Ranger Quadra which is more powerful than a small SB800 strobe—but still not powerful enough to light a whole car.

The car was positioned in a car park near the bridge and the camera mounted on a tripod. Using a 38mm lens and a tripod at roughly head height gave a pleasing composition with the car leading your eye through the frame to the historic bridge in the background.

Manual exposure was set on the camera, with the background underexposed to add some more detail to the sky. It meant the car itself was very dark, though.

A record shot was taken at this exposure, without any flash. The flash was then set manually to full power, and put outside of the left edge of the frame. A shot was taken, so that this light illuminated the headlight and part of the front grille.

Being careful to keep the distance between the flash and car constant, the flash was then moved so that next time it illuminated the right side of the grill. Then the front wheel nearest the camera, then the side of the car, then the rear wheel. In all, around seven exposures were taken, all with one part of the car lit well. Care was taken so that the flash didn't reflect back from the car into the camera lens.

The eight exposures—seven with flash and one without—were then combined using Photoshop. The "lit" parts of each part of the car were selected and pasted onto a layer on top of the original, unlit shot. By changing the opacity of the layer, the relative brightness of the lit part of the car could be adjusted. The file was then flattened into a single image.

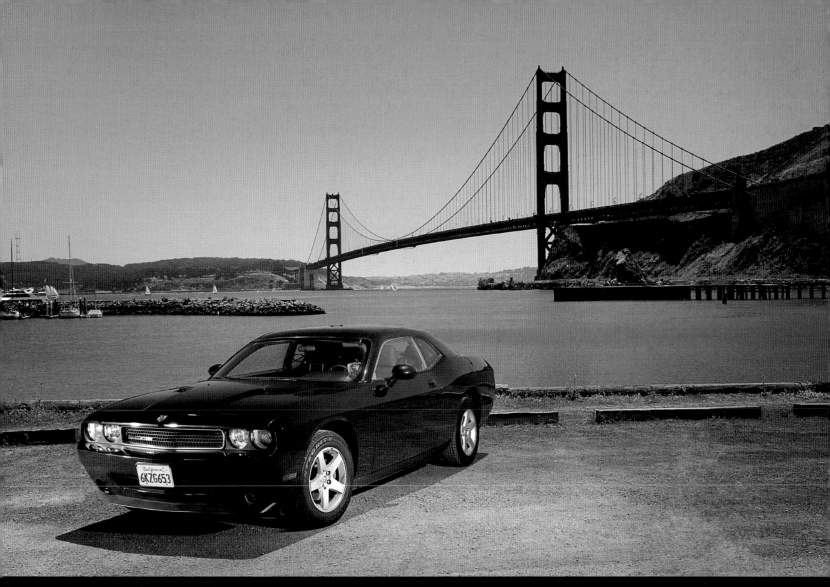

This photo may look like it was straight out of camera, but was in fact a combination of eight different photos. Different parts of the car were lit in each individual frame by moving the flash around between shots. The frames were then combined digitally in Photoshop.

Nikon D3X
38mm lens
ISO 100
f/10
1/200 sec

8

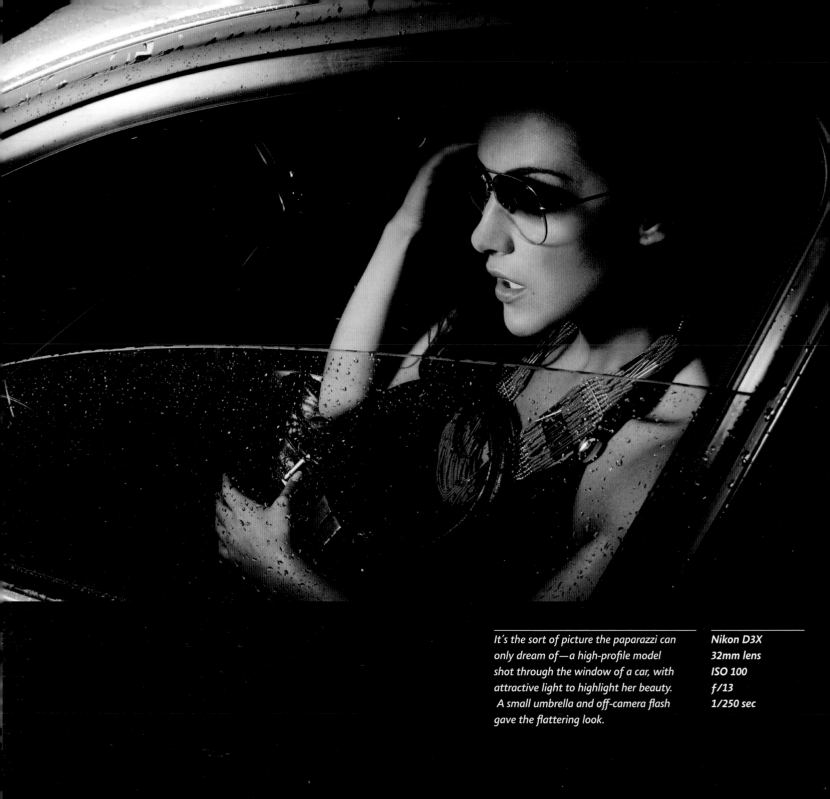

It's the sort of picture the paparazzi can only dream of—a high-profile model shot through the window of a car, with attractive light to highlight her beauty. A small umbrella and off-camera flash gave the flattering look.

Nikon D3X
32mm lens
ISO 100
f/13
1/250 sec

Case Study 4:
Paparazzi Style

Top British model Katie Green had been hounded by the tabloid press over a story she'd had a relationship with a high-profile politician. So it was decided to play on the story by photographing her clutching her bag and hiding behind her sunglasses on a rainy day through a car window, to make it look like she was being hounded by the paparazzi. In reality, it was a prearranged shot to produce publicity.

Unlike real paps who often just blast away with on-camera flash, we wanted the lighting to be far more flattering, and hence the light had source had to be more directional and softer. We used a Nikon SB800 flash connected by a cord to the camera's hotshoe to provide full TTL operation.

The flash was mounted inside a special grip handle which has an umbrella attachment on it, and a small white shoot-though umbrella was fitted. As the light could be held very close to the face, the relative size of the light source—actually the umbrella—was quite big compared to Katie's face so the light was soft and flattering. But as it was so close, the fall-off to shadow was extreme, giving her super-defined cheekbones with the added benefit of not lighting up the whole of the car interior.

Thanks to the handle grip, the flash and umbrella could be comfortably handheld. And as the flash was tethered via a TTL cord, the camera's own metering system worked out the correct exposure as the umbrella was moved around and Katie did a variety of poses.

By trial and error, we found the best position was with the umbrella virtually at Katie's eye level. Also, the most dramatic results were when the ambient light was virtually eliminated by shooting at a narrow aperture, which meant virtually all the light came from the flash itself.

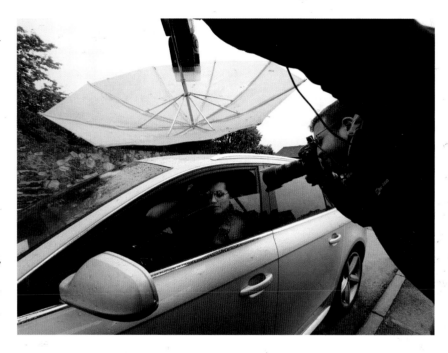

A small umbrella fired into by a Nikon SB800 flash provided the main light for the photo. By using a narrow aperture of f/13, the flat ambient light—clearly visible in this prearranged photo—was overpowered by the flash unit. The best photos came from when the umbrella was held slightly lower than it is in this picture.

Case Study 5:
Bringing Detail to Flat Sky

One of the perennial problems photographers have is how to deal with flat, gray, or white lifeless skies. They can make a picture looked washed out, and by their very overcast nature provide light that is often flat and lacking in contrast.

If you're armed with a flash unit, suddenly it's less of a problem. The thing to do is position your model so that there is plenty of sky showing in the background and not too many extraneous details. You are hopefully going to underexpose the ambient light, so these details are likely to go dark or largely disappear.

Trying to frame your model with the sky behind them often means you'll be shooting from a low angle, which can have the added benefit of making your subject look more dominant. If you don't want to give that impression, it's best to find a different angle.

For our shot of the model in the junkyard, we first took an ambient exposure reading and set that manually on the camera. We then experimented by keeping the shutter speed at the camera's maximum of 1/250 sec but used a smaller aperture to make the sky go darker and more interesting. We ended up at three stops less than the ambient exposure, at $f/16$.

Of course, this means our model was now also three stops underexposed, too. So to bathe her in flattering light, we used a Nikon SB800 inside a large Ezybox at full power. We moved the light in and out towards the model until the exposure on her was correct. The softbox was positioned higher than the model's face and was pointed slightly downwards. This was to avoid the softbox illuminating her legs more than her face.

Using a 24mm wide-angle lens let us include the model's whole body in the picture and turned the sky from being virtually white to at least having some tone and cloud in it. The softbox then cast lovely flattering light on the model's features.

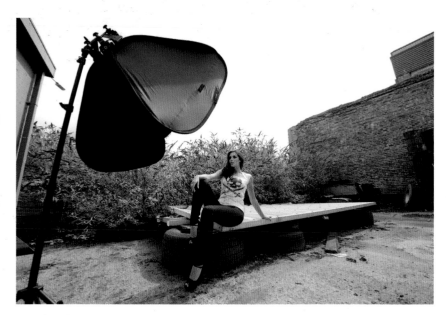

An ambient light shot shows how featureless the sky was and how the softbox was set up.

By shooting a second picture with a much tighter crop—done by moving closer and zooming in to 50mm—we managed to make the sky go even darker.

We moved the light even closer to the model so it was just out of frame. As it was set on full power, this made the model slightly overexposed. But instead of turning the power of the light down, we closed the lens down to $f/20$. This made the exposure on the model's face correct, but had the added benefit of making the sky seem even darker and more moody.

As the light was now closer to the bushes in the background, some of the light spilled onto these and lit up a small patch of greenery, too, which was not unpleasant.

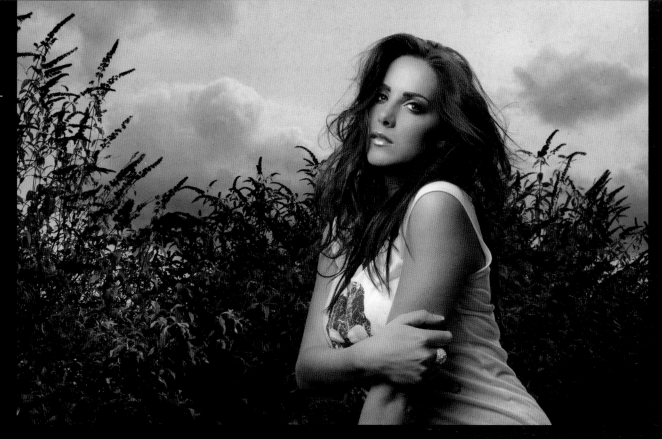

Nikon D3X
50mm lens
ISO 100
f/20
1/200 sec

Nikon D3X
27mm lens
ISO 100
f/16
1/200 sec

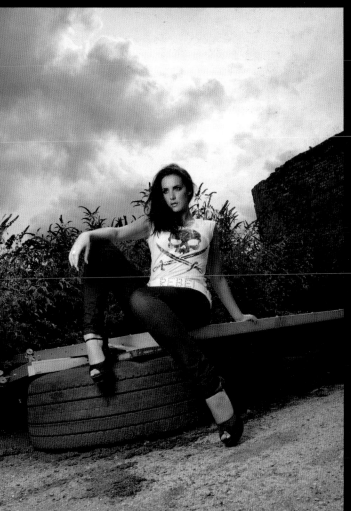

Moving the light closer to the model for a close-up shot meant the flash was too powerful. So by adjusting the camera's aperture, the lighting on the subject could be made correct. And it had the added benefit of making the sky even darker and more atmospheric.

A bit of old junkyard, a falling down wall, an old tire, a wild hedgerow, and a featureless sky don't seem to be the recipe for a great portrait. But by underexposing the sky to bring some tone and interest to it, and using a big softbox to light the model, the results can be surprising.

8

Case Study 6: Using a Gobo

A Gobo is a term from the movie film world, which means an item that "Goes Before Optics." In the movies, it's often a template that goes between the light source and the lens that projects it. In photography, it usually means something that goes between the light and the subject.

While that all may sound very technical, in reality it means that putting something in between your flash and the subject means it will cause a shadow or pattern in the light. The size of the light source, how far away the gobo is, and how far away the subject is all make a big difference to what the projected pattern looks like. Using a simple gobo and a small strobe shot into a softbox can make for some interesting results.

For the shots here, a Lastolite Ezybox Hotshoe softbox was used, but both the inner and outer diffusion baffles were taken out. They attach by hook-and-loop fastener.

Then, some thin strips of material with hook-and-loop attachments were placed in a pattern across the front of the softbox, which was set on a lightstand and pointed down towards our model. The model was standing in front of a plain white wall, and was told to angle her face towards the direction of the light source.

The strips cause an interesting pattern on the background, which can obviously be changed by moving the strips, using different thicknesses, or swiveling the softbox to a different angle. The strips can be bought, but it's very simple to make your own, or even use some black duct tape for a similar effect. Just be careful not to stick it too firmly to the softbox or it might leave residue when it is pulled off.

The only other issue to be aware of is that because the flash doesn't have an effective modeling light, it's difficult to visualize the effect until you actually take a photo and check out the results on the LCD screen. And you also have to be careful that your model's face doesn't fall too much into shadow. Essentially, if the model can see the flash tube with both eyes, it indicates the flash will light up her face.

Once you've got the setup working, try different crops and angles, as each shot will look different.

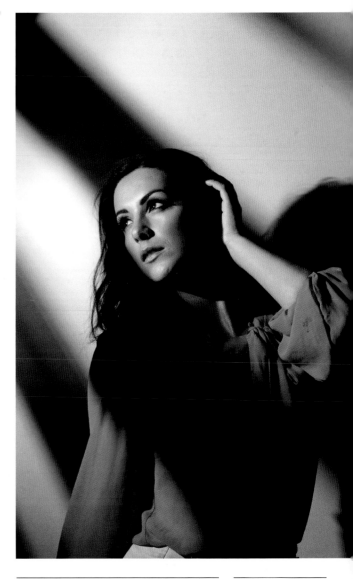

The same setup, a different angle of softbox, and the light source moved closer to the wall instantly gives a different look. In this shot, the inclusion of the girl's shadow on the wall makes the picture look more real.

Canon EOS 5D MarkII
58mm lens
ISO 100
f/10
1/160 sec

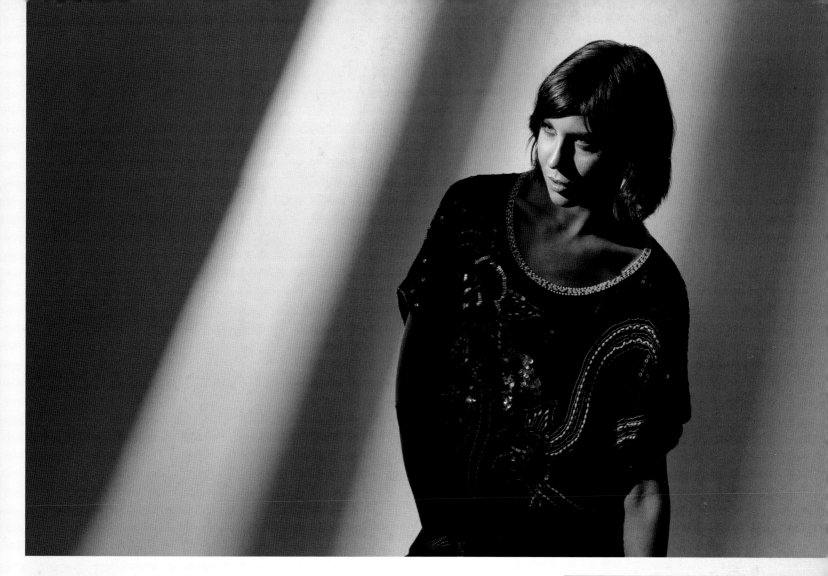

A simple set of fabric strips in front of a softbox have turned the light source into something far more interesting. It's almost like the model is in front of a window through which daylight is pouring. The triangle of light on the model's cheek furthest from the light source shows this is a typical Rembrandt lighting pattern, albeit one that uses quite hard light.

Nikon D3X
85mm lens
ISO 100
f/8.0
1/250 sec

You can clearly see the pattern of light projected by the gobo on the wall of this studio. There are lots of different crops that could work.

These fabric strips just fasten on with hook-and-loop fasteners. Or customize your own using tape or whatever else you have to hand. Controlling the beam of light is what makes interesting patterns.

8

Case Study 7:
Photographing a TV Chef

A more traditional portrait of the chef in his whites was also shot to give the client a choice of photos to use. The simple lighting and post processing gave a gritty look to a well-weathered face. Good eye contact and a fun expression show the lighter hearted and more approachable side of the man.

Phase One 645DF
80mm lens
ISO 100
f/4.0
1/125 sec

Chefs are almost always shot in kitchens wearing their whites. So when it came time to shoot a well-known TV chef who was looking at revamping a countryside inn with proper country food from the venue's own estate, it was a chance to break the mould. On a scorching hot day with bright overhead sunshine, the chef was persuaded to dress in normal casual clothes and go to a field right near the inn.

An old leather armchair from the venue was carried outside, and placed on a pile of straw so that the sun was coming from behind the subject so he wasn't squinting into the direct light. However, this did mean he was largely in shadow, which was made even worse when the camera was manually set to underexpose by two stops from the normal "correct" ambient reading. This made the field in the distance go darker and the sky moodier.

To get the chef properly exposed, a powerful Elinchrom Ranger flash was used high and to the right of the camera—pretty much exactly where the subject is looking.

This was fitted with a large white beauty dish attachment to provide a soft light quality with a distinct fall-off of light at the edges. You can see this effect as the straw around the subject is well lit, but the pool of light doesn't spread very far. It's almost like he was hit by a beam of light from on high.

These are situations where using a single strobe like a Nikon SB800 or Canon 580EX just doesn't provide the power and coverage needed, especially when shooting through a lighting modifier.

To get a second shot, the chef was moved back inside the Inn and sat in a high-armed chair in a tiny alcove barely big enough for him to get into. The walls on either side were dark red, and the wall behind him old stone—a nice rustic feature.

This time the light could be much closer, so a smaller, silver-lined beauty dish was used to give a harder light source. It's not as flattering as a softbox or white dish, and makes wrinkles and eye bags stand out a little more. But as the chef was well known for living the high life, showing a few marks of character was well within the brief.

Both photos were then post processed using a Bleach Bypass-type action in Photoshop to give them a slightly more stylized look.

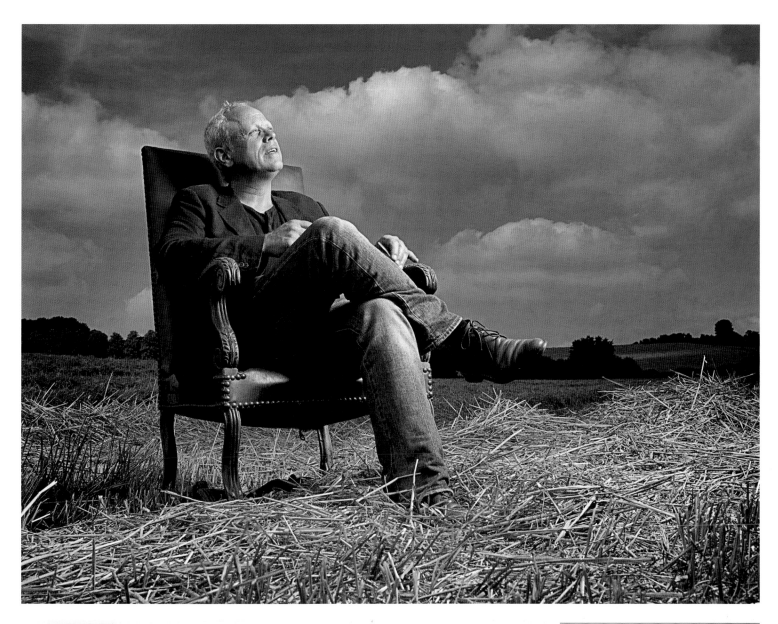

The subject was positioned with his back towards the sun. This stops him squinting and provides a degree of rim lighting.

A large, white-lined beauty dish modifies the light from a powerful Elinchrom Ranger flash head. It creates a pool of light around the subject, lighting up the wheat around his feet as well as the subject.

Once the chef was sitting in position and the light set up high and to the right of the camera, lots of photos were taken. In some, he was looking directly at camera, in others looking off into the distance. And this one looked a bit like he was looking to the light for some divine inspiration. This is the shot that the client liked the best.

Phase One 645DF
55mm lens
ISO 100
f/16
1/200 sec

8

BLINDS

Light coming in through the window blinds is a key part of the picture and shouldn't be underestimated. The whole exposure is based on getting this area correct.

A large softbox provides even key light which bounces around the white room and acts as a huge fill light, too. With the camera exposure set, the power is manually adjusted to provide the right exposure on the model.

An 85mm telephoto lens is used, from below head height of the model. Much fashion work is done from a lower camera height to give the model a more dominant look.

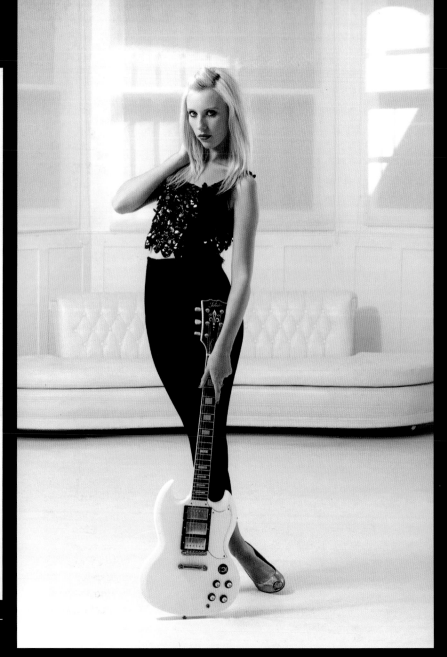

Canon EOS 5D Mark II
85mm lens
ISO 100
f/9.0
1/160 sec

Oh wow! A white Gibson SG Custom guitar with triple humbuckers! Soft lighting from a large softbox provided the keylight for this photo. And the white walls, floor, and ceiling helped the light bounce around and fill in the shadows.

Canon EOS 5D Mark II
85mm lens
ISO 100
f/9.0
1/160 sec

The same lighting setup as the guitar shot, this time with the main light moved lower as the girl is seated, provides a flattering look. Light streaming through the blinds gives a light, airy feeling.

Case Study 8:
Interior Fashion Page

If you want to shoot fashion shots in an inside location, then a large light source is your friend! For these shots taken inside a fabulous old house, the main light was an Elinchrom Ranger Quadra fired into a large softbox.

Because the power required indoors isn't that high, a standard hotshoe-style flash like a Nikon SB800 or a Canon 580EX would have provided adequate light. It's just the battery pack-powered Elinchrom recycles much faster which allows you to go with the flow of the shoot and keep shooting for longer, rather than having to constantly wait for the flash to recharge.

Some people also make the mistake of shooting their small flash units again the very nanosecond the "ready" light comes on. It's a little-known fact that this light glows slightly before the flash is actually at full charge, so firing it straight away can give inconsistent exposures.

The key factor in these shots was actually the light coming in through the window blinds. The camera exposure was set so that this light would register as natural-looking bright highlights. It would have been easy to have had the windows very bleached out by using too wide an aperture, or just plain white blinds if they had to be lit solely by the flash.

With the *f*/stop now set and the shutter speed at the maximum sync to avoid camera shake, the power of the flash was adjusted upwards to give the correct exposure on the model.

All these rooms have lovely white or very light-colored walls, ceilings, and floors. So the light coming out of the softbox not only lit the subject, but also bounced around the room and acted like its own fill light. There was simply no need for extra light or reflectors. The light was soft and flattering, and the rooms felt light and airy which certainly suited the set. If the shoot had been in a dark, oak-paneled room or nightclub, different lighting would have been used.

The main shot of the girl with the guitar was shot using a relatively long lens for doing full-length shots—and 85mm. This is because the room was large enough to get far away in to use such a long lens.

The light was mounted to the girl's right, slightly in front of her and slightly higher than head height. This means there is some light fall-off from her head to her toes. But we are used to this, and it looks quite natural to us.

A low camera angle and a wide-angle lens to exaggerate the model's long legs gives this shot a different feel. The room isn't as white as the other locations, and the fill light is noticeably less. The giveaway is the darker cheek nearest the camera.

Canon EOS 5 Mark II
24mm lens
ISO 100
f/10
1/160 sec

The same light and exposure conditions were encountered in the shot of the same model on the red couch. The exposure was set to take into account the ambient light outdoors, and the flash was positioned above head height to the girl's left. A short telephoto was once again used as it gives flattering perspective.

The final shot in the bedroom was done from a very low camera angle using a 24mm wide-angle lens. This was chosen on purpose to really elongate the model's long legs. The low angle meant the camera was looking slightly up at the girl's face, which made her look stronger and more dominant. It's not a sweet girl-next-door picture, but something a bit more edgy.

8

Case Study 9:
Faking a Shaft of Sunlight

When you start getting hooked on using flash, the biggest temptation is to always use big softboxes or umbrellas and just flood everything with lots of lovely soft light. It's a technique that can work well and give great results really fast.

But the more that you experiment with flash, the more you'll find that constricting the light into small, tightly-defined pools can give even more dramatic results, especially when merged with existing daylight to give the effect of a shaft of sunlight.

That was the exact scenario used to photograph this proud cigar smoker enjoying a puff on the street outside his favorite restaurant. The ambient light under the canopy was pretty flat and uninteresting. And it meant the plume of cigar smoke didn't really stand out very much.

To put a pool of light on the cigar smoke and the smoker's face was something I knew would lift the picture hugely.

There are two main ways of turning the light from a flash into a controlled beam. The first is to use a snoot. This gives a very hard edge to the beam and can look very unnatural. You also have to be very precise with where you aim the beam as the subject can easily move a few inches out of line and miss the pool of light entirely.

The second way is to use a honeycomb grid. I used the Honl grids as they're small, portable and effective. They use hook-and-loop fastener to clamp onto your flash in an instant.

Grids provide a similar beam of light to a snoot, but the edge of the beam is less defined. Instead of going from all to nothing, there is a more subtle gradation, or fall-off of the light pattern, which is a look I often prefer.

The flash was set out of frame to the right of the camera, and was set slightly behind the subject so that the smoke would effectively be backlit, which would lead to a stronger result. If you use TTL Metering on a shot like this, the camera often gets it wrong. It will try to light up the whole scene

WINDOW

TABLE

A flash unit fitted with a honeycomb grid provides a tight beam of light, aimed to light up the man's fans and provide some backlighting for the plume of smoke. The power was adjusted manually to avoid overexposure.

The foreground was lit solely by the ambient light which was underexposed by a stop to make it be less dominant.

using the power of the gridded flash, which often leads to lots of overexposure which kills the picture.

The camera was set manually to make the ambient about a stop under what the camera recommended. That makes the table slightly darker than what would be "ideal". But this way the white tablecloth and cup doesn't detract from the main subject.

The power of the flash is then manually adjusted upwards until the exposure on the face of the man is correct. Then all the smoker had to do was puff and exhale many times so I could try to get the best-looking plume of smoke!

A beam of flash light from a Honl honeycomb grid fitted to an off-camera Nikon SB800 provided the pool of light on the smoker's face and strongly backlit the smoke.

Nikon D3X
32mm lens
ISO 100
f/5.0
1/200 sec

Case Study 10:
Corporate Portraits With a Difference

Many photographers earn a living shooting portraits of businessmen in suits. And often it's hard to do anything that looks distinctly different.

But by treating the shoot more like an environmental portrait, it's possible to create something that's far better than the chief of the board smiling in front of a bookcase or plain background.

In this case, I was hired to shoot a famous car designer who'd jumped ship from BMW and Ferrari to join Formula One car firm McLaren in order to build their all-new road car. But he was still a gray-haired man in a gray suit in a corporate environment and, like other photographers from other magazines hired to shoot him that day, I had just 15 minutes to do it.

Photography isn't always about the techniques; often it's about building a rapport with your subject. Initially, I was to photograph the man in a boardroom which was very uninspiring. So I struck up a conversation with him, and quickly moved it off designing cars which he talks about all day. I found out he used to live in New York and race motorcycles, and I'd jetted in from shooting a motorcycle race in New York two days earlier. And a total coincidence appeared: I'd actually photographed an ex-racer he'd known 20 years earlier!

Suddenly we were talking on a level far deeper than he previously had with any other photographer, and after a little cajoling, he showed me inside his design room. After carefully moving any secret new designs out of the way, he allowed me to photograph him with the front-end sample of the new car in the distance, and also leaning on a cupboard containing scale models of the car in a range of colors. A fantastic scoop!

Not only that, but you can tell from the pictures that he had lightened up and was almost having fun, or at least wasn't too bored. After all, we were talking about his first love: motorcycles.

The lighting inside the design studio was relatively bright, but mixed in color. At one end was natural light coming in through frosted glass, tinged with the green-magenta of today's modern fluorescent light tubes, while the other end was lit almost entirely by the horrid fluorescents.

With only a few minutes to work, I had no time to play with different color temperature correction gels, so put an SB800 Nikon flash unit on a lightstand and fitted a Honl honeycomb grid to channel just a small pool of light onto the subject. I had to work fast, so I kept it simple and I knew the final colors wouldn't be truly accurate.

The shot of the subject with his arms out was using a very wide 22mm lens to make the setting look enormous. I upped the ISO to 400 and shot the lens wide open at $f/2.8$ to give me a shutter speed high enough for me to comfortably handhold. This ended up being 1/200 sec, and the flash was high and to the right of the camera, just adding a little pool of highlight to the subject'sface.

The shot with him leaning next to the model cars was taken at the other end of the studio, after some secret cars had been covered in dust sheets (visible in the far distance). To make the model cars more dominant in the frame I shot with a super-wide 14mm lens wide open at $f/2.8$—the same exposure I'd used minutes earlier.

As I'd adjusted the flash manually, I put it in roughly the same sort of place, off at 45° to the subject and higher than head height. And also at the same distance. This meant the exposure would be roughly the same, and it was. Two quick portraits, done literally within a few minutes, using one flash and a bit of charm! And probably better than the results the other photographers got.

I loved the room I was allowed to photograph this car designer in. It reminded me of something from a James Bond set, with light flooding in through the frosted glass. The mixed-color lighting was a problem, but with only minutes to work I had no option but to shoot what was there. I put a small flash and a honeycomb grid on a lightstand to put a little pool of natural-colored light on the subject's face.

Nikon D3
22mm lens
ISO 400
f/2.8
1/200s

WINDOWS

Frosted windows keep prying eyes out of the design studio, and let in diffuse daylight from outside. But the light is mixed with magenta-green fluorescent tubes.

A honeycomb grid on a Nikon SB800 provided a small highlight on the face of the designer in his studio.

A wide-angle lens made the room look bigger and a symmetrical composition made it look more formal, which contrasted nicely with the informal pose of the executive.

A super-wide angle lens from a low angle right next to the line of model cars made the cars look more dominant in the composition. The lighting was the same as the earlier picture as I was shooting against a real pressure of time. I just grabbed the flash on its stand and put it at roughly the same distance away from the subject as the first shot.

Nikon D3
ISO 400
14mm
f/2.8
1/200 sec

With a camera fastened to a magic arm on the front of the "winning" cart and fired by remote release, the photographer ran alongside holding a flash in the air to light the driver. Care had to be taken so that the shadow of the raised arm didn't go right across the face of the main subject.

Nikon D3
14mm lens
ISO 200
f/18
1/50 sec

Case Study 11:
Leg Power Flashes

This shot of a pedal-cart race is a great example of leg power in action, taken as I ran ahead of the leading car holding aloft a flash unit.

The shot was for a fun feature in a modified car magazine where two of the writers performed a monthly challenge. This time it was to have a quarter-mile drag race using pedal-powered carts. The participants first raced to decide who won "bragging rights," and then the finish re-staged for the photographs to be taken.

The camera was actually mounted to the front of the winning cart. Using a Manfrotto Magic Arm, one end was clamped to the front rail of the cart while the other held a Nikon D3 fitted with a 14–24mm super-wide zoom, set at its widest focal length. This way, the camera moved at the same speed as the cart, giving some blur to the road and the driver's spinning legs for an impression of movement.

The carts were moved into position to get the composition right, with the losing cart driver just crossing the line frustrated while the winner celebrated, punching the air.

The camera had a Pocket Wizard radio remote on its hotshoe, linked via Nikon's ten-pin cable to the camera body. When I pushed the test button on a Pocket Wizard, the camera fired. Pocket Wizards also work as transmitters and receivers; the unit on top of the camera sends one signal to the camera to fire, and a second signal on a different channel to fire off any other Pocket Wizards in range.

A third radio unit was plugged into a Nikon SB800, which I handheld as I ran alongside the winning cart, just out of frame to the left. This was fired bare and aimed downwards, angled towards the face of the winner.

Several photographs were taken in quick succession and the camera's LCD checked. Various different shutter speeds were also tried in order to get some blur in the driver's feet, though not too much or the whole cart woud appear unsharp due to the vibrations.

I settled on a shutter speed of 1/25 sec and the subjects repeated the action several times until, gasping for breath, they refused to try again. The drag-race surface is actually covered in sticky rubber so that the 300 mph cars that usually race there can grip, and as you can imagine this made pedaling the carts very tiring.

In the shot you see here, you'll also notice a little bit of ghosting around the winner's raised arm, which is because he was actually pumping his fist in glee. The ghost blur gives a subtle impression of movement. The photo was post processed using a Bleach Bypass-style effect in Photoshop, and the sky was burned in to go a little bit darker to add a bit of drama.

8

Case Study 12:
Wafer-thin Depth of Field

A popular technique used by many natural-light portrait photographers is to shoot a flattering, short telephoto prime lens at a very wide aperture. This means the depth of field is very shallow. It does mean precise focusing is critical, but if you get it right then the subject's eyes are sharp, but everything else in front of or behind the plane of focus is turned into dreamy softness.

That technique hasn't really been available to studio flash photographers, simply because big flashes put out lots of power, even at their minimum settings. They're simply too powerful to allow the camera to shoot at a wide aperture. There are some fixes, such as putting neutral density filters in front of the light source, but thanks to the modeling bulbs, these can get very hot and even melt. Or you can put a neutral density filter on the camera's lens, which degrades the quality slightly and makes focusing even more tricky. Not ideal.

One of the benefits of using small, hotshoe-style flash units is that their flash duration is very short and they can be adjusted to put out a tiny amount of light. This allows a photographer to choose a wide aperture for a shallow depth-of-field effect, and the flash will match it by putting out a small blip of light. Many flash units allow you to adjust power down to 1/128th of a second, certainly low enough to run the very widest apertures.

For the shot here, a Nikon SB900 was placed inside a medium-sized Lastolite Ezybox to the left of the model and slightly higher than her eyeline. This caused some shadows underneath her chin, so a reflector was placed underneath to bounce some light back in.

The lens used was a fast 85mm $f/1.4$ Nikon portrait lens, shot at an aperture of $f/2.0$. Some shots were tried with the lens wide open and the power of the flash even lower, but the depth of field was so shallow that just the eye nearest the camera was sharp, while the other eye was very soft.

At a slightly narrower aperture of $f/2.0$, the eye nearest the camera is pin sharp and the other eye is acceptably sharp. The effect means that the girl's far shoulder and hair are rendered with a softer, more romantic effect. And it really puts attention on her lovely eyes and eyelashes, too

It's also worthwhile noting that at a lens' widest aperture, the quality isn't as sharp as it is a stop or two closed down.

As small strobes don't have proper modeling lights, getting critical sharpness is not that easy—especially as you'll have to have a relatively dark studio in order to shoot at such wide apertures. It's important to take lots of shots to ensure a selection is sharp.

One technique you could use is "focus bracketing," where you take a shot at a point you think the lens is correctly focused to. Then, with the autofocus disabled, rock forward and backward slightly to take a sequence of more pictures. This will change the point of focus slightly, meaning you have a good chance of nailing the focus spot on.

A fast-telephoto lens shot almost wide open is a well-used technique for natural-light portrait photographers. But the extreme adjustability of strobe flash units means it's now an easy technique to master using flash, as in this picture.

Nikon D3X
85mm lens
ISO 100
f/2.0
1/200 sec

8

Case Study 13:
Channeling the Light

Honeycomb grids that simply fasten onto the front of small strobes are great tools for picking out details in a photo and highlighting the most important parts. We've already seen them used to augment the ambient light by putting the focus on a key part of the image. But they can also be very effective at being the main light in the picture, not just a useful highlighter.

Grids come in different sizes and lengths. Some are described by the size of the honeycomb "holes," and others by the angle of beam of light they produce. Either way, the difference is usually the spread of the beam and, to a lesser extent, the fall-off into shadow at the edge of the beam of light.

It's worth experimenting to see the difference between the various sizes, then getting to know which is best for which situation. Also, don't be confused into thinking that because some of the honeycombs are rectangular in shape to match the flash (like the Honl grid), that the beam will somehow be rectangular. The beam takes the shape of the holes in the grid, so a rectangular-shaped accessory will still produce a round beam of light.

Using grids is an ideal way to get an effective portrait when the location isn't that great. The shot of the design engineer was taken in an office that was full of clutter.

Giving the subject something to do—like talking to an assistant about a subject they are passionate about—always helps them relax and become more animated. The light was just one Nikon SB800, fitted with a Honl speedgrid, on a lightstand placed high and to the right of the camera. It was angled down towards the subject so that the shadow was lower than the subject himself.

The exposure was controlled manually as cameras tend to vastly overexpose when using small beams of light as they try to compensate and make the flash light up the whole scene.

As you can't really see the effect until the flash has gone off, it took several attempts to get the subject in exactly the right position so that the shadow of the desk lamp was pleasing.

The same technique was used with the Frank Sinatra-tribute singer at a wedding reception. A single flash fitted with a grid

was high and to the right of the frame, aimed at where the singer was doing his crooning. He's actually standing in front of the microphone stand on which he's hung his hat.

However, the gridded flash has not only picked up the singer's face well, but has projected a shadow of the mic stand and hat onto the background. Of course, this was an accident as there's no way of knowing in adavance precisely where shadows will be, where the singer will stand, or which direction he will look in. However, the more photographs I take using flash, the more good results I seem to achieve, and I credit this to a thorough understanding of the tool and how it reacts in any given situation.

Exposing manually and getting the subject talking added to the natural look of this image.

Nikon D3
48mm lens
ISO 200
85mm
f/8
1/125 sec

This wedding singer was also picked out using a single flash unit fitted with a honeycomb grid to turn its output into a beam of light. Without the grid, the shot would have been over-lit and far less atmospheric.

Nikon D3X
50mm
ISO 500
f/8.0
1/100 sec

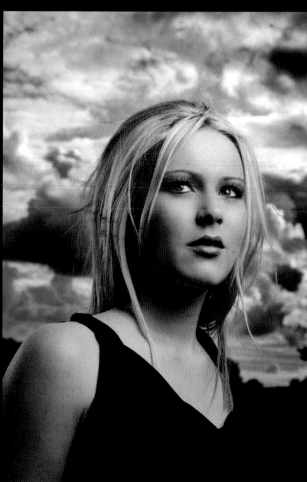

A winter's afternoon with a boring gray sky was made far more visually pleasing by underexposing the sky by three stops. Light from a softbox provides a flattering source, but I had to be aware of the shadow cast by

Canon EOS 5D Mark II
85mm lens
ISO 100
f/9.0

An amazingly dramatic sky, courtesy of a brewing storm, really helps make this picture. Some low sun was used as a pleasing backlight on the back of the girl's hair, and also on her right shoulder.

Canon EOS 5D Mark II
85mm lens
ISO 100
f/16

Case Study 14:
Soft Light to Flatter

Everyone needs a sure-fire technique that they can pull out of the bag when they need to take a flattering portrait quickly. Armed with a small strobe, a lightstand, and a medium-sized softbox or umbrella, this is a great technique to learn that is as close as you can get to a guaranteed winner every time.

It's all about de-cluttering the background of a photo, ideally framing the subject against the sky, and then underexposing the background to make it go dark, or at least darker than it looks at the time to the naked eye.

Then you put in a lovely soft light to light up the subject's face by putting the softbox as close as possible—ideally so it's just outside the frame. This way, the softbox will be relatively huge compared to the subject, and will bathe them in soft, diffuse light that does its best to fill in any imperfections and also leave a lovely catchlight to make the eyes sparkle.

Keep the softbox slightly higher than eye level and at roughly a 45° angle from the camera. Get your subject to turn their whole body to face the softbox. This way, you are not only using short lighting but also making the distance between their shoulders appear narrower. Most people want to look slimmer, and this often does the trick.

By getting the softbox in close to the subject, the flash will have lots of power. This means you can really underexpose the background if you want. You're in total control of the contrast between the subject and the background, just by altering your camera's aperture and the corresponding power of the flash.

The simplest way to achieve this is to set your camera to whatever auto mode you are most comfortable with, though Shutter Priority usually works best. You'll be wanting to work at or near your maximum sync speed as this will avoid camera shake and make it even easier to underexpose the background. You should also be at a low ISO setting for maximum quality and to help the underexposure you will now dial in.

Using your exposure compensation dial, crank in -1 or -2 stops of underexposure. Take a test shot to see what affect it has on the sky area. You may want to adjust even more. Or even better, transfer those settings manually to your camera. Remember, adjust the exposure here by changing the aperture as you want the shutter speed to remain high.

Once you're happy with your background exposure, it's time to bring in your flash. If you're working TTL, the camera will have a go at working out the power for you automatically. Take a test shot, and dial in any flash exposure compensation you need.

Alternatively, set the flash unit manually, take a test shot, and look at the result. Then adjust the power up and down, and try again until you get it right.

The benefit of this is that once the exposure is set, you can then focus on interacting with the subject rather than worrying the camera may be varying exposure in every shot. Both systems have their pros and cons, so work out what's best for you.

If you suddenly decide you want the background darker, adjust the aperture even smaller and flash power higher. If you want the background lighter, do the opposite. Or you could just slow the shutter speed down, being careful not to introduce camera shake.

Changing the shutter speed only affects the parts of the scene lit by ambient light. Changing the aperture or ISO affects all parts of the scene. This is a sure-fire technique to taking a pleasing portrait with the minimum of fuss and kit. Master it, be able to do it almost without thinking, and then you can use it as a solid foundation for more adventurous lighting.

8

Case Study 15:
Hard Light for Drama

Standing our teenager in front of the setting sun on a chilly winter's day then underexposing gave a dramatic background to this photo. A bare Nikon SB800 was on a lightstand to the right of the camera and held higher than the subject's face to provide a hard main light. It also picks up the texture on his leather jacket.

Nikon D3X
24mm lens
ISO 100
f/11
1/250 sec

Soft light from umbrellas or softboxes is flattering and easy to work with, but harder light from smaller light sources can give more drama. And it works really well when photographing men, especially rugged ones who aren't worried about the odd wrinkle or imperfection.

Harder light can be difficult to use in a studio situation, but outdoors is its natural home as it looks similar to the hard light from the harsh overhead sun.

For that reason, it's most effective when mixed with strong backlighting from a hard light source, such as the sun. Then when it is used to pick out the face of a subject, it leaves a contrasty, dramatic look which is ideal for some subjects.

It's also technically among the easiest to achieve, as a bare flash unit with no light modifiers is all that's needed. If you have a flash you can use off camera, you're ready to go.

The technique really works most effectively in full-length portraits when the subject is strongly backlit, and there are obvious shadows coming forward towards the camera. These often act as compositional lead-in lines to draw your eye to the subject.

This is exactly the composition in the full-length shot here of the skateboarder. In this case, a bare flash was mounted relatively high on a lightstand and aimed to illuminate his face. The light is high enough so that it makes a shadow under the subject's chin.

Harder lighting can also be successfully used in more tightly-cropped portraits outdoors, too—as in the shot of our subject in the black T-shirt looking upwards.

The harder shadows from the harder light source—in this case a flash fitted with a small, silver-lined beauty dish—give a real three-dimensional quality to the photo. The position of the light—high and to the camera's left—combined with the model's upwards gaze is typical of "hero" lighting that was popular in Hollywood in the 1950s, although those portraits were lit with far more lights!

Compare this portrait to the portrait of the same man on the previous spread. It is the same person, the same light, but shot with different modifiers that give a totally different look and feel to the portrait.

A spotless lens is what you need if you're going to include the sun in the frame, as in this picture. There is a blob of flare to the right of the frame, but it's not too obtrusive. A bare SB900 at full power just out of frame to the left lit the skater's face and arms. A gritty bleach bypass Photoshop effect and a hard vignette on the sky turned this into a stylish portrait.

Nikon D3
24mm lens
ISO 200
f/22
1/250 sec

A man indoors, in all-black, against a black background, may seem like a nightmare to light. But by using a flash through a medium-sized silver beauty dish, the results are directional, dramatic light. It's enough to make England Cricket Captain Michael Vaughan look every part the sporting hero.

Nikon D3X
55mm lens
ISO 100
f/13
1/250 sec

You'd hardly believe this was the same subject as in the photo on the previous spread. A harder light—in this case a small beauty dish replacing the softbox of the previous portrait—makes a huge difference.

Nikon D3
70mm lens
ISO 200
f/13
1/250 sec

8

Case Study 16:
Using Ring Flash

Ring flash is so called because the flash tube goes right around the outside of the lens similar to a donut. They were originally designed for medical and macro photography as they give shadowless lighting, ideal for doctors, dentists, and forensic photographers.

But soon fashion photographers began to press them into service, falling in love with the bleached-out effect a ring flash can have on a model's skin, rendering it flawless. The lovely circular catchlights in the eyes were also a unique benefit, as was the unusual shadow that went around the outside of the subject if they stood close enough to the background.

Soon a whole business was built up around huge studio-size ring flash units totally removed from the small medical units that began their growth. Different diffusers and light modifiers also became widely available to allow a photographer to change the harshness of the shadow and the size of the catchlight.

Pretty soon, battery-powered portable units came on the market which eventually dropped down to more affordable unit like Elinchrom's Ranger Quadra ring flash. Like the big studio units, these are manually controlled, so by moving the camera in and out from the subject means the exposure varies. So the key is keeping a consistent distance and regularly checking the histogram.

But now, there are a variety of accessories that turn small strobes like Nikon's SB900 or Canon 580EX into a ring flash unit. By using a series of mirrors and a large round tube that the strobe fits into, it's easy to get a ring flash effect at an affordable price. Various companies like Rayflash and Orbis make them, but more are appearing all the time.

The effect isn't quite as even as a true pro ring flash and certainly not as powerful, but it's a pretty good approximation. And unlike pro units, the camera's TTL system still operates, so there is much less hassle with exposures.

While a ring flash does give a very unique look, it isn't the only use of the device. A ring flash makes an ideal fill light, too, as the shadows it casts don't interfere with the main light source. Some of the larger ring flash units fasten to a camera's tripod socket and are then adjusted using

A girl in front of a gray backdrop, a ring flash fitted with a wide diffuser to soften it and you have an instant fashion-style portrait. The bleached-out skin is the telltale sign of a ring flash and can be very flattering.

Nikon D3X
62mm lens
ISO 100
f/11
1/200 sec

sliding rails to ensure the lens is right in the middle. Some photographers prefer to mount them on top of a lightstand or tripod, and handhold the camera through the center.

The converters that turn small flashes into ring flash units are sometimes mounted directly to the flash unit on its hotshoe, and others require the flash to be removed and held as a separate unit with the ring flash unit. In this case it's best to use a TTL cord between camera and the flash to retain full control.

A shiny purple wall background, old red leather chair, and a man covered with tattoos make an ideal candidate for the unique look of a ring flash. A bleach bypass Photoshop effect made the photo even more stylish.

Nikon D7000
42mm lens
ISO 400
f/10
1/125 sec

Wide-open red eyes, an unshaven chin and a gallon of coffee. This man obviously likes to live life to the full and needs little sleep. A ring flash really picks out the details. Note how the hand and cup is overexposed compared to the subject's face as it's so much closer to the light source.

Nikon D3
50mm lens
ISO 200
f/11
1/200 sec

8

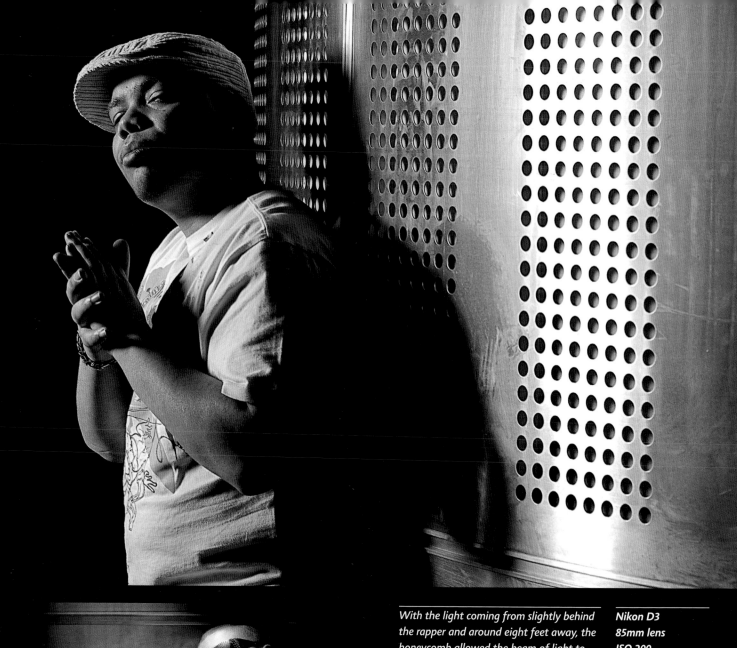

With the light coming from slightly behind the rapper and around eight feet away, the honeycomb allowed the beam of light to illuminate the metalwork, but not the ugly corridor directly behind the subject.

Nikon D3
85mm lens
ISO 200
f/9.0
1/125 sec

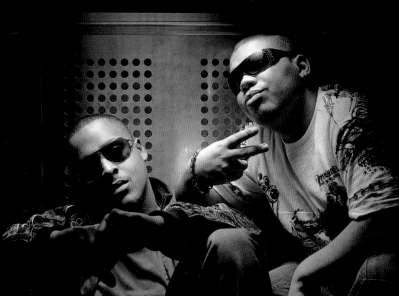

To illuminate two people, the softbox had to be moved further away and the flash power increased. The spread of light is more even, but still controlled. Note the reflection of the gridded softbox in one of the rapper's shades.

Nikon D3
85mm lens
ISO 200
f/9.0
1/125 sec

Case Study 17:
Control the Softbox

So far we've seen flash units and softboxes used for a lovely spread of soft, flattering light. And we've seen flashes fitted with grids to control a pool of hard light, to pick out details, or add drama. So what about combining the two?

Some softboxes can be fitted with grids that usually fit by hook-and-loop fastener onto the front. Just like conventional grids, some manufacturers like Chimera even offer these in a variety of grid angles so you can tailor the look to your taste.

A grid on a softbox means the light is still pretty soft and even, but instead of spilling out everywhere it can be used in a much more controllable way. This is ideal for when you would like to use some relatively soft light, but don't want the light from a bare softbox to flood the whole scene and kill the atmosphere.

The usual rules of light obviously still apply—the larger the light source and closer it is to the subject, the softer the light. The further away it gets, the harder the light becomes, as well as being less intense and less focused.

For these shots of two rappers, a single, small Chimera softbox was used, fitted with a grid called an Eggcrate which is specially made from fabric.

The location for the shoot was in front of a stylish metal elevator shaft in a modern building. By using a small, gridded softbox as close as possible to the rappers, a pool of soft light would be relatively flattering, and would only light up selected parts of the background.

By keeping the grid above the subject's head height, the shadows always go downwards. And as the softbox is so close, the intensity of light falls off quite dramatically which creates a more moody, atmospheric shot. This suits the moody, cool look of the subjects.

By carefully angling the softbox, the spread of light could be accurately controlled on some shots. This was done in order to light the background well. On others, the light was largely kept off the background so it was less dominant in the photos. A good variety of shots is always the key to a successful shoot, in order to give you a range of photos to choose from afterwards.

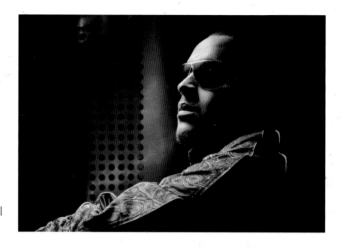

A softbox up really close means extreme fall-off of the light to give a more dramatic effect. The softbox was inches out of the frame. The grid means the light didn't spill much onto the background, keeping it relatively dark.

Nikon D3
85mm lens
ISO 200
f/9.0
1/125 sec

One of the key issues with a gridded softbox is that it can be clearly visible in any reflections, which some photographers may find unacceptable. In this shoot, the reflection of the softbox is clearly visible in the shades worn by the subject on the right in the opposite two-person shot. However, it looks like it could be the reflection from the overhead room lights and also mirrors the pattern on the background. For these reasons, I think in this situation it works.

Glossary

A

AUTOMATIC MODE A setting on the flash and camera where the exposure is worked out for you by the system's internal electronics. This can either work using the camera's own built-in TTL system, or via a cell on the flash itself.

AMBIENT LIGHT Or available light. Refers to the existing light, either natural like the sun, or artificial like household bulbs, rather than the flash output.

B

BACK LIGHT A light that separates the subject from the background. Sometimes called a separation light.

BARN DOORS Barn doors attach to the front of flashes and are intended to stop light spilling onto certain areas of the subject.

BEAM ANGLE The width of the pool of light that falls from a flash unit. Typically altered to match a particular focal length of lens.

BEAUTY DISH A parabolic reflector dish fitted with a central reflector. Usually used in beauty and makeup shoots. Produces light that's relatively soft and broad, but often harder than a softbox. Available in a variety of sizes and finishes.

BOOM An adjustable arm, usually positioned on top of a stand, that extends a light over a subject.

BOUNCE Tilting your flash head so the light is reflected off a surface like a wall or ceiling.

BOUNCE CARD A reflective piece of card that is fastened via hook-and-loop fastener to a flash unit for the main output beam to bounce off of.

BRACKETING Taking the same shot at different exposures to ensure one is "correct." Can used be used as "flash bracketing" where only the flash exposure changes. Bracketing is also good for taking images nor use in HDR (High Dynamic Range) photography.

BUTTERFLY LIGHTING A slightly high-angle, diffused light source, centered on a subject's face to minimize nose shadow and emphasize cheekbones and beauty.

C

CAPACITORS The flash tube is connected to one, or a series of capacitors which store large quantities of energy to be released when the flash is fired.

CATCHLIGHT The reflections of a light source in a subject's eyes.

COLOR TEMPERATURE This is the color of any light source measured in Kelvin. *See Kelvin.*

CLAMSHELL LIGHTING Typical beauty lighting, with an overhead beauty dish aimed slightly down, and a fill light or reflector directly underneath it. The photographer shoots from between the two.

CLS Creative Lighting System. Nikon's intelligent system for metering flash exposure. Can use an SU800 controller.

COLD SHOE A clamp that holds the base of a flash unit without any electrical contact.

CONTRAST The degree of difference between the light and dark areas of a scene.

CTB/CTO "Color Temperature Blue/Orange." Color correction gel that corrects daylight to tungsten light, or vice versa.

D

DIFFUSED LIGHT A softened light with less shadows and a more even coverage. Usually achieved by directing light through a translucent material, like in a softbox or a shoot-through umbrella.

DIRECTIONAL LIGHT Light that does not spill and is directional, soft light can be made fairly directional with a grid on a softbox.

DOME DIFFUSER A plastic diffuser that fits on top of a flash unit. Sometimes called a Stofen, a key brand.

E

E-TTL II Canon's intelligent system to metering flash exposure. Can use an ST-E2 controller.

EZYBOX A softbox made by Lastolite that quickly snaps open. Can be made especially for flash units.

F

FALL-OFF The size of the area on a surface where light and shadows merge. Soft sources produce a gradual transition, and a subtle gradation of tones. Hard sources change abruptly.

FILL LIGHT A secondary light source used to "fill in" the shadows cast by the main light.

FLAGS Flags are usually solid shapes of material or card. They are often used to block light from falling onto unwanted areas, or to soften or reflect the light. They can be held in front of a light by hand, on a stand, or via an arm.

FLASH DURATION This is the measurement of how long the flash fires for and is usually in 100ths or 1000ths of a second. A fast flash duration will give a more consistent color temperature and can be used to stop action more effectively. Small hotshoe flashes have very fast flash durations, and larger pack-powered systems tend to be slower.

FLASH METER A flash meter is designed to read the fast durations of flash light and can determine the correct exposure. The ISO and the correct camera sync speed are set, and then the aperture can be measured by the meter. When using two or more lights, a meter reading can be taken from each source to calculate contrast rations. Many people nowadays rely on the camera's LCD screen and histogram to check exposure, but of course this does not work out ratios.

FLASH TUBES The flash tube is made from quartz or Pyrex and is filled with xenon gas. When the power is released from the capacitors, the trigger circuit ignites the gas in the flash tube.

FLAT LIGHT The results of low contrast, close-to-the-lens lighting, or too much fill.

FRESNEL A convex lens, typically used to focus the beam of light in a continuous light source.

F/STOP A number relating to the size of the aperture set on the camera's lens which affects exposure.

G

GEL also sometimes called Filter Gel. A piece of colored gelatin placed over the flash to alter the color of the light output.

GENERATOR OR POWER PACK A generator is a large studio-type flash unit which features a power pack with sockets for external heads with flash tubes. It is powered by AC power although some battery-powered pack units are now becoming popular.

GUIDE NUMBER A rating of the power of a flash unit. Using the guide number, ISO, and flash-to-subject distance, you can work out the f/stop you need to set for the correct exposure. Divide your flash guide number (at a given ISO) by the distance to subject in feet to give you the f/stop.

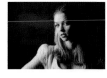

GOBO A Gobo is an object placed between the light source and the subject so that its shape is illuminated onto a background.

H

HAIR LIGHT An accent light limited to the top of the head.

HIGH KEY Lighting that results in predominantly mid-gray-to-white tones.

HIGH SPEED SYNC A flash mode in which shutter speeds higher than the usual maximum sync speed can be set. Usually achieved by using a flash unit that pulses. Can be called HSS or Auto FP.

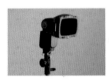

HONEYCOMBS A honeycomb or honeycomb grid looks like a bee's honeycomb with a series of small holes across its width. Used in front of a flash, it channels the light into small direct pools. Ideal for the portrait and product photographer.

HONL A line of light modifiers developed by photojournalist David Honl.

HOT SHOE A mounting port on top of a camera onto which an external flash unit or flash trigger fits. Most cameras use a standard size hotshoe, apart from Sony who have their own unique fitting.

I

INTENSITY Light level or output. The "strength" of the Incident Light independent of subject reflectivity.

J

JOULES Joules are a measurement of electrical energy that are rated the same as watt seconds. *See Watt Seconds.*

K

KELVIN The kelvin is a unit of temperature measurement. Degrees Kelvin, or color temperature, is used in color photography to indicate the color balance or spectrum of light emitted from a light source. Daylight is roughly 5600 degrees Kelvin and most flashes emit light at approximately this value.

L

LENS FLARE A ghosting effect when light is directed or refracted into the camera lens.

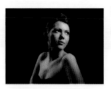

LOW KEY Lighting that results in predominantly gray-to-middle-black tones with few light areas.

M

MAIN LIGHT The primary light source. Can be the ambient light or an artificial source, typically the brightest light that causes the most prominent shadows.

MODELING LAMP The modeling lamp is a continuous light source which approximates the affect of the flash but is only available on lager pack-style systems. Some flashes, like Nikon's SB800, can emit a modeling-light effect from the flashtube for a few seconds.

MONOBLOC A Monobloc is a studio-style flash head that incorporates the flash tube, modeling lamp, and power, all in the same unit that runs from AC power. Converter packs are available so you can use them off battery packs.

Q

QUALITY OF LIGHT The attributes that affect the quality of light emitted and the overall look of lighting. Can be hard or soft, have high or low intensity, come from any direction in relation to the lens/subject axis, or have a certain color and beam pattern. All but color are affected by the light's size and distance from the subject.

R

RADIO REMOTE A wireless device used to trigger flash (or cameras). Popular brands include Pocket Wizard, Elinchrom Skyport and Radio Poppers. Often superior to infrared systems as they work over extended range and don't need line of sight.

REMBRANDT LIGHTING The dramatic emphasis of a few planes or features of the subject by using accent lights or shadowing devices that keep the rest of the scene very dark. Typically there is a small triangle of light on the cheek of the subject nearest to the camera.

RATIOS This is the split of light between the various lighting sources. A ratio of two or three to one means that one light will be two or three times the power of the other. This will create highlights and shadows that give a more three-dimensional look to a portrait or product shot.

RECYCLE TIME This is the time it takes a flash head to fire, or discharge back to ready, or recharge. The time is the time that it takes the capacitors to recharge themselves ready for the next shot.

RIM LIGHT Subjects appear to have seen the light, then turned their back on it. Sometimes several sources are aimed at the subject from wherever they can be hidden, more or less behind the subject.

RING FLASH Or ring light. The ring-around-the-lens electronic flash that provides an image without shadows or modeling.

S

SLAVE UNIT An electronic "eye" that triggers a flash whenever it picks up a flash from another unit. Typically a built-in light-sensitive system.

SOFTBOX A softbox is a box made from a rigid framework, with diffused material stretched over it and a piece of diffused material on the front. They are widely used because they produce an even spread over a large area. Softboxes come in different shapes and sizes, including square, rectangular, hexagonal, and round.

SNOOT An attachment for the front of flash units to channel the light into a small pool, often used as a hair light.

STROBE Really a flash used sequentially for special effects, but now shorthand for an electronic flash unit.

STROBIST A fan of using strobe lights! As popularized by the blog Strobist.com.

SYNC Short for synchronization, this is the connection from the flash to the camera. This can be via a lead into the camera's PC socket, or through the hotshoe. The circuit is used to fire the flash at the precise moment of exposure.

SYNC SPEED The maximum shutter speed a camera can be set to in order to get full coverage of the subject when a flash fires. At speeds faster than this, the flash doesn't cover the whole frame and a black line can typically be seen on the image.

T

TTL Through the lens. Typically, a camera measures the exposure of a scene by taking a reading through the lens. Can also be used to calculate flash exposures on dedicated systems.

U

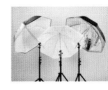

UMBRELLA Photographic umbrellas convert hard or broad lights into large soft sources. They can be shoot-through or reflective. Reflective ones also are available in a variety of surface finishes, such as gold to warm up a subject, silver to make the light more contrasty, or white for neutrality.

W

WATT SECOND/JOULES A watt second or Joule is the measurement of electrical energy used in flash systems to indicate the amount of energy in the flash capacitors. As it does not take into account the energy efficiency of the flash tube or its reflectors, it is not a reliable measurement to comparatively assess light output.

Index

Acknowledgments

This book could not have been put together without the help of a large number of people. You know who you are and if your name is missing please forgive us! Above all it has been our families that have given the space and encouragement to write and work. We thank you all.

JOHN DENTON

Beverley Bennett of Colorworld Imaging.

Carla Dyson of Makeup by Carla.

Kenn and Sheila Reay of Kenn Reay Photography.

Juliet and Phil Jones of the Society of Wedding and Portrait Photographers.

Paul Taylor of the Society of Wedding and Portrait Photographers.

Rob Summers of PromoFilms.

Roger Griffiths of Roger Griffiths Photography.

Vivienne Edge of Shameless Promotions Ltd.

Matt, Chris, Melanie, Mum and Dad—I thank you. Finally, there would be no Denton Photography and no book at all were it not for the love and support provided by my wife Liz, so if you enjoyed the book, thank her. I do.

Models Abbie Bulleyment, Carla Dyson, Catherine Brown, Charlotte Jarvis, Fredau Hoekstra, Henrietta Phoebe Dunn, Jenny Howson, Katrina Lenco, Kirsty Miller, Marika Zukovska, Natalie Walker, Tamara-Marie Woodhouse, Tanya Beetham, Vivienne Edge, Yasmin Clappison, Zoe Leigh Craddock, and Zoe Lockwood.

ADAM DUCKWORTH

Dave Beck, Chris and Emily Whittle, Louise O'Shea, Kev Treadwell, Brian Collier, and the crew at The Flash Centre.

Gary Astill, Mark Langley, and everyone at Lastolite.

Craig Calder at JP Distribution.

Nic Duckworth of Ameliorate retouching.

Bob Q. Martin of Bob Martin Photography.

John Owen of www.Phototraining.co/

Hardy Haase of Flaghead.

Ellie, Adam, Zara, Tara, and Natalia at Ilex for all their help and support.

Models Amie Field, Amy Kitchingman, Ashli Rosetti, Cassie McDowell, Chloe Ives, Clare Kohlweg, Don Paton, John Owen, Katie Green, Leah Hibbert, Lorna Dolan, Lydia Millen, and Olivia Oxton.

PICTURE CREDITS

Adam Duckworth: p6–7; p50; p56 (bottom); p63 (right); p65 (top right); p78–79; p80–81; p82–83; p84–85; p86–87; p88–89; p90–91; p92–93; p94–95; p96–97; p98–99; p100–101; p102–103; p104–105; p106–107; p116–117; p118–119; p120–121; p122–123; p124–125; p126–127; p128–129; p132; p140–141; p142–143; p144–145; p146–147; p148–149; p150–151; p152–153; p155; p156; p159; p160; p162–163; p164–165; p166–167; p168–169.

John Denton: p29; p39; p42–43; p45; p46–47; p48–49; p42–43; p54–55; p56 (top); p57; p58–59; p60; p62; p63 (left); p64; p65 (top left) (bottom left); p66–67; p68–69; p70–71; p72–73; p74–75; p76–77; p136; p138–139.

iStockphoto (www.istockphoto.com): p8–9; p14 (bottom); p15 (top and bottom); p16; p23; p34.

Fotolia (www.fotolia.com): p24–25; p26; p30; p31; p33; p37; p40; p41.

Equipment shots courtesy of Canon, Nikon, Sony, PocketWizard, Strobies, Interfit, Profoto, Lacie, X-Rite, Lastolite, and Colorvision.